JAPANESE *Graphic* ART

LUBOR HAJEK

鷺靜也水

First published 1976 by
Octopus Books Limited
59 Grosvenor Street, London W 1
ISBN 0 7064 0521 8
Printed in Czechoslovakia
2—99—66—51

Translated by Helena Krejčová
Revised by Vera Gissing
Graphic Design by Bedřich Forman
© 1976 Artia, Prague
Text © 1976 Lubor Hájek
Photographs © 1976 Bedřich Forman

Contents

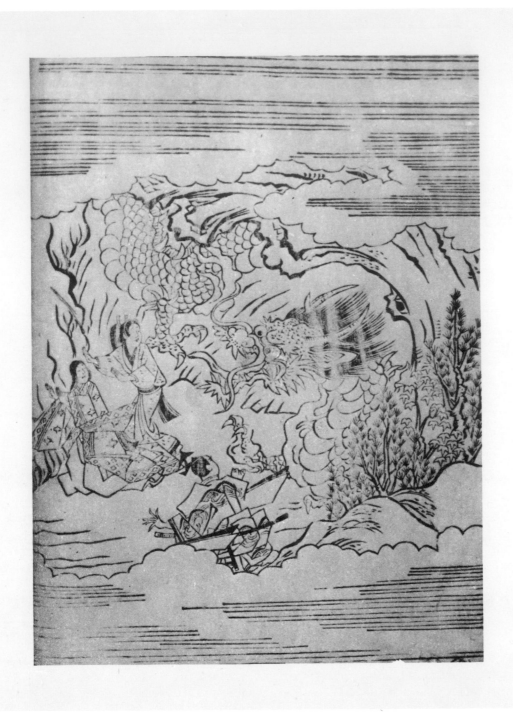

Anonymous author; c. 1677: 'The Tracing of a Serpent'

The fifth illustration from the eighth volume of the 'Tales of Heike' (Heike Monogatari) printed in twelve volumes. 40 sheets with 13 sumi-e pictures, 26×19.5 cm. Published by Shōshidō, in Kyoto, 1677.

Heike Monogatari is a classical romance describing the gradual decline of the warrior clan of Taira (or Heike), which involved a series of power-struggles and fierce battles with the rival clan of Minamoto (or Genji) in the second half of the 12th century. The tracing of a serpent illustrates an episode from the life of an ancestor of the Ōgata family.

Ars rediviva

Until recently it seemed Japanese prints would gradually fall into oblivion. Today it is however quite apparent there is a general revival of interest. In cultural centres throughout the world important exhibitions of Japanese graphic art are on the increase, and the numbers of collectors and accomplished scholars are growing. This also shows that the attitude to Japanese woodcarvings has not only changed, but matured and widened. As over a hundred years have passed since the first fortuitous encounter of several French artists and intellectuals with Japanese prints in the 'Chinese salon' of Madame de Saye, this was only to be expected. Generations of artists followed one another, and the one-sided attitudes and criteria displayed first by the adherents of Impressionism, then Expressionism, and next by the followers of Art Nouveau and Fauvism, faded away with them. Japanese graphic art, now free of such temporary connotations, is asserting its real value and natural position in its own right. The position it holds is not only related to other phenomena of Japanese cultural tradition, but is a genuine position in the worldwide context of creative art.

We can believe that Japanese graphic art will at last throw off the discriminating attitudes which have pursued it so far. Many of the prints were always ignored for one reason or another. Sometimes the themes were the victims, or certain artists, but more often than not whole schools, styles and phases of development. While certain artists were very highly thought of and considered on the same level as Rembrandt, others were greatly underestimated, their work being regarded as 'vulgar', or 'plebeian culture', or 'decadent', and so on.

The European translation of the word '*ukiyo-e*' as 'pictures of the floating world' and the touch of romanticism of such translations did little to increase the understanding of Japanese graphic art. Today we realize the development and glory of Japanese graphic art was not due only to the 'Ukiyo-e schools', and that — starting from the middle of the 18th century — the stylistic procedure, the subject matter and underlying ideas referred to realities far removed from the term 'floating world'. After all, the enormous quantity of pictures of actors and beauties which form the kernel of *ukiyo-e* prints, though advocating the pleasure-seeking life-style of the 'passing' demi-monde, hit a firmer and a more lasting target. The pictures of actors, which remind us rather of the cult of modern movie stars, are in fact unique creative transpositions of theatrical art into pictorial art, and their value is such that even cameramen of our time can learn much from them. Similarly, pictures of beauties said to resemble our pin-up girls, bear such titles as 'Geisha X from the Green House Y', or 'Courtesan X from the Brothel Y', or even 'Harlot X from the Whore-house Y', and give their address and price; we must not forget however that in these pictures Japanese artists created a distinguishable creative counterpart to love poetry, and they are on the same level of dignity as the medieval erotic sculptures of the Indian shrines in Khajuraho, or the Rajput miniatures illustrating the Krishna legends. If we cannot morally reconcile ourselves to the existence of prostitution, or homosexuality, or pornography, if we cannot shake off the feeling that the *ukiyo-e* prints are lascivious, we must condemn them to the same inferno of art where those Indian sculptors — and even Ovid — dwell. They will make agreeable company.

The credit for the evaluation of Japanese graphic art should be given to the scholars who through penetrating research into the historical and cultural background, could look at each print with an unbiased eye. We are equally indebted to the authors who not only provided correct information, but brought to our notice a wider range of the artists, schools and evolutionary phases of graphic art, so opening new approaches and attitudes. Thus, popular graphic art can no longer be interpreted as the reflection of the plebeian interests of the affluent merchant class, but rather as an extension of the stratification of national culture, which was influenced by the intellectual elite of various social orders. From this broader point of view we must evaluate the graphic art of Japan as an art deeply rooted in the traditional culture of the Far East.

Following these recent viewpoints we should try to make use of all available knowledge to enable us to locate and interpret each print as fully as possible. This has yet to be achieved even in the most explored fields of art history, and probably will never be achieved, if only for the reason that the picture is art and the observer a mere human being. Yet we must keep up the attempt of interpreting a concise scheme of the historical whole — a scheme based upon the sequence of major artistic events and stimuli which shaped and directed Japanese graphic art.

The author, in trying to do this here, is of course fully aware that his concise treatment of the subject will always be open to amendments and supplements. This option is made necessary by the shortcomings of previous investigations and by the author's insufficient knowledge; on no account should room be given to amendments occasioned by prejudice. The same also applies to the illustrations of this book, which are based upon the collections of Japanese graphic art in Prague. The opportunity for corrections is limited by the size of the collection of prints, by the size of the book, and by the shortcomings in the technique of reproduction. Moreover, the author can hardly claim to be unbiased when he is faced with the task of selecting the best example from dozens of possible prints. In the world of art one is always biased when enraptured by some of its works. And the more enthusiastic one becomes, the more difficult it is to make the choice.

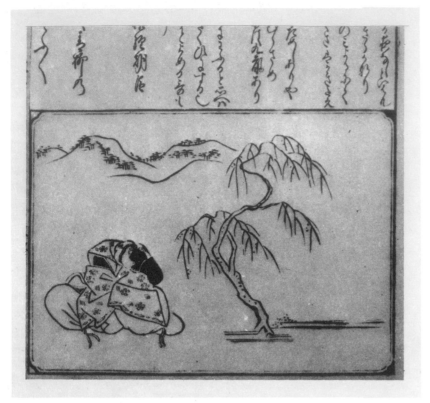

Moronobu: 'A Poet under a Willow Tree'

The 35th sheet from 'The Anthology of My Own Choice' (Jisen Kashū). Three volumes bound in one, 43 sheets. Signed — 'Eshi Hishikawa Moronobu hitsu'; published by Suwaraya Mohei in Edo, 1678.

Hishikawa MORONOBU was born in the province of Awa around the year 1618, and came to Edo in the early 1660s. This textile designer became one of the most prolific painters of his age. He is credited with about one hundred titles of illustrated books that were published during the thirty years between his arrival in Edo and his death in 1694. In the diversity of his subject-matter, illustrations of classical poetry form a substantial part. The anthology *Jisen Kashū* (more often entitled *Waka Chūsen shū*) was selected and annotated by the poet Sōgi (1421—1502). The author of the illustrated poem is Fujiwara Masatsune (1170—1221):

Shirakumo no	'White cloud
Taema ni nabiku	Floats over the green waves
Aoyagi no	Of a ruffled willow tree
Katsuragi yama ni	On my Katsuragi mountain
Harukaze zo fuku	Spring breeze must be blowing'

Art and power

Japan is one of the few countries in the world where the relationship between creative art and the development of productive and social structures has nearly always been self-evident and unequivocal. With a little effort, we should be able to learn how to read its social history from the cultural relics of Japan with the same fluency and exactness as from the most reliable chronicles.

One of the main reasons for this close bond between art and historical development lies in the consistent professionalism of artistic production, which, from ancient times, has been organized on the basis of hereditary family guilds. As early as the first centuries A. D., when the Japanese society was still divided into independent clan communities, hereditary guilds of artisans, called Bĕ, enjoyed a position of exceptional social standing outside the framework of the clan system. The first written evidence about the existence of the painters' guild dates from the reign of the Emperor Yūryaku (ruled 457—479), who invited many artisan families from Korea and China into Japan. These families, which later developed leanings toward the fine arts, did not always enter Japan with the brush or the chisel in their crest. The Tori family, for instance, from which were recruited the famous sculptors of the 6th and 7th centuries, came to Japan in 522 as a saddlers' guild. Also, the so-called hereditary professions were not confined entirely to blood relations. One could be initiated into the family craft through marriage or adoption, the main requirement being the acquisition of the professional skill, the discipline and the morals of the family.

One of the main moral principles of the craftsman's profession was absolute service to the power of his patron. During the course of history, power of course passed from hand to hand, and from one class to another, and the patrons themselves changed. As a consequence of their dependency on their patronage, the new artist families sought new ways of expressing the ideological, ethical and aesthetic attitudes of their new patrons.

The rise of centralized state power administered from the permanent Imperial residence in Nara gave name to the historical period of 710—794. It was connected with the elevation of Buddhism to the position of official state religion. The theocentric learning of the Kegon Sect, who worshipped Roshana Buddha as the centre of the Universe, provided a suitable ideological pattern for the bureaucratic system, with the Emperor standing on the very top of the pyramid of social organization. Art was also turned into an instrument of this centralized state power. The effectiveness of this organization can be judged by the fact that as early as 738 a gigantic bronze statue of Buddha was cast for the Tōdaiji Temple in Nara. Hundreds of artists and craftsmen were evidently used in the construction and decoration of this monumental temple. By then the printers' craft had also reached a considerable stage of organization, for around the year 770 over a million wood-cut copies of Buddhist spells were printed and distributed all over the country.

Buddhist monks at Nara, however, turned out to be over-zealous in their adherence to the concept of

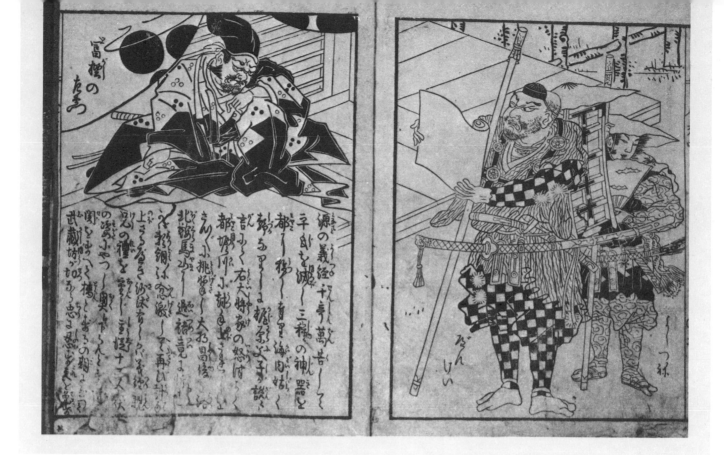

Moronobu: 'A Narrow Escape'

The fifth and the sixth sheet of the second volume of 'Military Reading About the Sea of Cleverness and Bravery' (Bunbu Chiyū no Umi). 9 sheets, sumi-e, 26×18 cm, c. 1790.

Minamoto Yoshitsune, the hero of the wars between Taira and Minamoto (see page 8), accompanied by his personal guard, the brave monk Benkei, tries to escape the vengeful rage of his brother, the shōgun Minamoto Yoritomo. Disguised, they flee to the north. The fugitives are stopped by a suspicious guard, Togashi no Saemon, but the clever Benkei outwits him by pretending they are wandering priests who roam the country to raise money for building a temple. His behaviour is so persuasive that the guard lets them pass. The story of Yoshitsune's narrow escape became a popular theme of *Nō* and *Kabuki* theatre *(Kanjinchō)*. It was probably through this influence that the illustration matured to the point of capturing the psychological tension of a specific situation. The stylization of the faces and the gestures depict vividly the feeling and tension between the two principal characters. At the same time, by using textile designs and background elements, a sophisticated, abstract composition is achieved.

centralized power. When the Imperial court moved from Nara in 784, it was fleeing from the increasing power of religious institutions. The court eventually settled in an auspicious locality, where the new capital of Heian-kyō was built in the fashionable Chinese style. The name of the long Heian period (784—1185), lasting the following four hundred years, was derived from this spectacular metropolis (today's Kyoto). The concept of a nation united into 'one large clan' gradually died in the lavish atmosphere of this city. The fatal blow was possibly struck by the very founders of this concept — the men at the head of state administration, who had finally submitted to the almost physical law of class dichotomy, which divides larger social units into two groups — the organizers and the organized. The concentration of all power and wealth in the hands of a narrow social stratum led to the forming of an exclusive aristocratic class, which radically uprooted the unity of a 'large clan'. The theocentric doctrine of the Kegon sect had to give way to more exclusive, occult concepts of the Tendai and Shingon Buddhism. These sects had imported from China a doctrine which was strictly cosmotheistic and intricate religious rituals, which were disseminated through the frenzied activities of its devotees from the many mountain temples in the vicinity of Heian-kyō. They worshipped a new deity, the Great Sun Buddha Dainichi (Vairocana), who did not stand in the centre of the Universe like Roshana Buddha, but over it and beyond it.

This aristocratic type of Buddhism forshadowed the ideology of that particular time within the Heian period which is known as the Fujiwara rule (897—1086). Members of the Fujiwara family were the supreme executors of the Imperial power. Together with a few equally noble families, they were in command of all the power and wealth of the nation; they were in a position to exercise a dominating influence upon the cultural outlook of the Heian period, which can be roughly summarized in terms of lavish luxury, elegant splendour, sentimental superstition, profuse poetry and the first secular literature of amorous romances. Buddhism, for its part, contributed to the Heian culture with romantic, opulent visions of the Pure Land of the Eternal Bliss

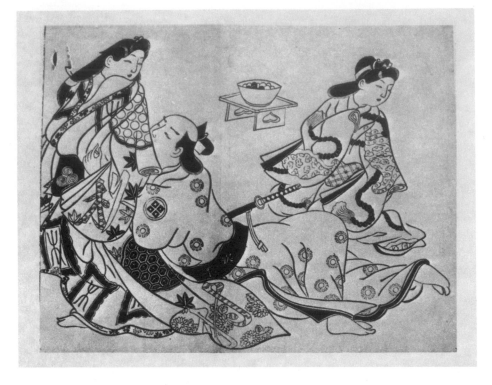

Jihei: 'A Love Encounter'

*A sheet from an erotic album, sumi-e,
28.5 × 38.5 cm; Signed 'Jihei' on the
man's sash; c. 1690.*

The mysterious Sugimura JIHEI, whose
signature — often inconspicuous — appeared on his pictures between the years
1681 and 1697, was probably a more
educated and a more sophisticated author
than his contemporary Moronobu. For
almost two centuries, Jihei was overshadowed by the fame of Moronobu, but today
it can be safely assumed that it was he who
completed the development of the woodcut of the 17th century; he who transposed
the iconography of the brothel into the code
of graphic art; he who endowed the pictures
of Edo beauties with the status of icons.
The prints attributed to him bear the stamp
of an unerring mastery of the compositional
rhythm of black masses and lines, resourceful configurations, and a rich overall structure achieved through extermely thrifty
means.

(Jōdo), a luxurious paradise which could be reached through simple emotional belief and perpetual invocations of the name of the merciful Amida Buddha (Amitābha).

The Fujiwaras who 'made' the Emperors were, of course, capable of 'making' the most noted artists of that age. An example of this was the sculptor Jōchō, who created the most aristocratic sculptures for the Hōōdō or Phoenix Hall of Byōdō-in temple at Uji, near Kyoto, and who founded the most aristocratic family of sculptors. Even at the turn of the 12th century, the creative work of his descendants Kōkei and Unkei greatly influenced the trend of Japanese art. The Fujiwaras may have also influenced the development of graphic art, where the repetitive reproductions of Amidistic pictures could be regarded as a somewhat creative counterpart of the practice of repeating the name of Amida Buddha.

The splendour and glory of the aristocratic courts of the Heian era produced not only magnificent art, poetic anthologies, and popular amorous romances, but also envy, spite, rivalry and wars. When in the mid-12th century the mighty Taira clan of warriors endeavoured to gain the position of the supreme administrator of the Imperial power, an era of fierce fighting began. In the end in 1185 the Taira clan was defeated by the warrior clan of Minamoto (the Gempei war, 1180—85). The Emperor bestowed upon this family the hereditary title of military dictator, the shōgun, and it ruled over Japan for the following two centuries together with the closely related family of Hōjō. As the first shōgun, Yoritomo, chose the city of Kamakura (near today's Tokyo for his seat, the subsequent period is known by this name (1185—1392).

The Kamakura period saw a radical turn in the course of Japanese history, which is said to have occurred because power transferred from the aristocracy to the military class. Such interpretation seems somewhat superficial and insufficient, especially when we try to understand the rich culture of the Kamakura period. In the sphere of fine arts, for instance, remarkable results were achieved in sculpture, narrative picture-scrolls and portrait painting. The masterly sculptures of that era were the work of four generations of artists from the Jōchō family. The abundant illustrations of the narrative scrolls on themes both secular and religious, showed the perfection of the polychrome *yamato-e* style. Fascinating portraits were painted by artists from a single branch of the Fujiwara family, which specialized in the art of portraiture from the 12th to the 14th century.

The first of this line, Fujiwara Takanobu, who painted the famous portrait of shōgun Yoritomo, was a courtier and a poet. He is supposed to have founded a family organization based on the traditional system of artisan guilds. The families of painters who worked on Buddhist temples were probably organized in a similar way. But the actual relationship between the artists called 'Buddhist masters' *(busshi)*, the artists working in monastery schools *(e-dokoro)*, like the school of the Kasuga Shrine in Nara, and the artists of court rank, such as Tosa and Kami, has remained obscure. The paintings of the Kamakura period covered an immensely large variety of themes ranging from Buddhist icons and pictorial biographies of saints to secular scenes depicting life at court, illustrations of battles, and landscapes, portraits, and also genre pictures of the lives of common people. The styles and techniques of paintings were as varied; besides the tradition of polychrome Buddhist painting, and

the expressively coloured *yamato-e* style, there were at least two styles of ink-painting, and elementary wood-block printing. The ideological foundation was as varied, with a revival of the centralistic view of the Nara period, which was intermingled with the tradition of aristocratic Heian culture, where the nationalistic conservative tendencies and the new waves of thought from China were applied.

The principal carrier of the new ideology was the 'meditative' Zen sect of Buddhism, which taught how to achieve religious goals through introspection, perfected to the extreme by strict self-discipline and diligent training. Individual Japanese monks were aware of this doctrine from the 7th century, but only the beginning of the 13th century saw the building of large temples throughout the country by the followers of Zen Buddhism. Officially supported by the shōgunate, it became the most influential religious sect. The most famous follower of Zen Buddhism from the aristocratic circles was the Regent Takiyori (1227—1263) of the ruling Hōjō clan, and he had received his training directly from Chinese monks. The Kamakura shōguns did not patronize only Zen religion, but also Zen art. They laid the foundations for the collections of Chinese ink-painting in Japan, which later became the main source of information and inspiration for Zen ink-painting.

This type of artwork reached its peak during the Muromachi period (1392—1568), named after the new seat of the shōguns of the Ashikaga family, who had moved into the Muromachi district of Kyoto. The creation of Zen ink-painting was mostly confined to Buddhist monks, yet it is worth noting that even such lay artists like Josetsu, Shūbun, Sesshū or Sōtan, were linked together by the organization of monastery schools, with the result that their development did not essentially differ from that of the professional artisans' families. After all, this new style of painting which originated from the Chinese ideal of a solitary amateur, was soon accommodated in the Japanese system of professional families in the service of the military rulers of the country. The first step in this process was taken by a principal aesthete of the shōgun court, Noami (1397—1494), whose authority was passed down the family line, with names ending in -ami (Geiami, Soami, etc.), as means of identification. The system became firmly established with the Kanō family which carried on the tradition started by Kanō Masanobu (c. 1434—1530) for half a millennium, and dictated artistic fashion without ever decreasing their absolute authority. The exclusivity of this dynasty was almost as rigorous as that of the Pharaohs in ancient Egypt, and in order to retain this exclusivity, members of the family intermarried. They also married into families descended from the Tosa lineage of painters, which was almost as long and illustrious as that of the Kanō.

The transitional Momoyama period (1568—1615), was marked by violent social changes and a radical shifting of power. Under the weak rule of the pleasure-loving Ashikaga shōguns, the country disintegrated into many autonomous units, and it was only through the enormous effort of three great military leaders, Nobunaga, Hideyoshi and Iyeyasu, that it re-established its former unity. However, the social changes were so profound that hardly any of the notable families which were powerful at the end of the 15th century played an important role a hundred years later. Yet the artistic aristocracy of the Kanō family survived all these changes without serious damage. Kanō Eitoku (1543—1590) decorated the castles of both Nobunaga and Hideyoshi. His son, Mitsunobu (1568—1608) was employed first by Hideyoshi, and then by Iyeyasu, who did not hesitate to murder the whole family of the previous patron.

At this point, we have arrived at the era which is most prominent in this study of Japanese graphic art. In 1603, Tokugawa Iyeyasu, who was given the title of shōgun, officially re-established unified government of Japan. By capturing Osaka castle in 1615, the last stronghold of his enemy, he secured the rule of this family for the following two hundred and fifty years. This period (1615—1867) bears the name of his family, or, respectively, the name of Edo (today's Tokyo), which was chosen by Iyeyasu as the seat of his military government *(bakufu)*.

The solid state organization, whose goal it was to prevent any possibility of disintegration, revolt, or political changes, eventually turned into a kind of police regime rather than a military dictatorship, though it was based upon the privileges of the aristocratic and military hierarchy. The Tokugawa government enacted a law to secure the superior position of this class (the other three classes were formed by farmers, artisans and merchants *(shi-nō-kō-shō)*. Other edicts regulated the subordinance of the nobility, which was divided into the group of hereditary vassals loyal to the Tokugawas *(fudai)* and the group of the subdued 'outside lords' *(tōzama)*. The conduct of the provincial lords, their samurai warriors, and their retainers were under permanent control of the state censors *(metsuke)*. The Imperial court in Kyoto was supervised by a military governor *(shōshidai)*. The income of the priviliged class was distributed in the form of annual rations of rice. The organization of municipal and agricultural units was also open to overall police supervision — peasants were divided into groups of five families *(gonin kimi)*, which were mutually responsible for the correct execution of duties: the town dwellers — craftsmen and merchants alike — were controlled by the system of guilds and licensed enterprises *(kabu)*. To ensure the enemies of the shōgunate were unable to find support for their activities in foreign countries, travel abroad was forbidden. Foreign trade was limited with only Chinese and Dutch ships being allowed to land in the port of Nagasaki. The alien religious system, Christianity, which had been introduced into Japan in the 16th century, was banned.

The fate of Tokugawa Japan, however, was not only determined by such severe political regime, for it was subject also to inner conflicts which are typical of the transitional stage between feudalism and early capitalism. The downfall of the Tokugawas was not caused by the disintegration of power — which had brought

Masanobu: 'Courtesan Kaoru'

*The last sheet from the 'Picture-book of Courtesans' (Keisei Ehon);
sumi-e, 27.5×19 cm, c. 1701.*

The solving of the actual authorship of this album is connected with
the already complex problem of identifying most artists at the turn of
the 17th century. The first edition in 1700 was signed by Torii Kiyo-
nobu. The next four editions were published in the following three
years under the name of Okumura Masanobu. There are only slight
changes in design — for instance in the first edition the picture of
Kaoru does not have the cat emblem, and the signature is in the
lower right hand corner of the sheet. A possible explanation of the
close resemblance of the two could be that Masanobu had already
painted the pictures for the first edition during his apprenticeship
years in the Torii studio. If we accept the theory that there was only
one Okumura Masanobu, and not two, he must have painted the
figures of courtesans in his early teens, because he died in 1764 at the
age of seventy-nine.

about the downfall of the previous regimes — neither was it endangered by the inner revolts of provincial lords.
The historical events which accounted for the eventual decline of the Tokugawas in 1868, did not turn on the
victory of a rival aristocratic family, but on a new social class, whose triumph was hastened by the intervention
of foreign powers. For it was the economical development which was the decisive factor in this change.

The Tokugawa administrative system was based upon the feudal principles of land ownership and agri-
cultural production; yet industrial production, mining of minerals, development of crafts, trade and transport
had gradually grown in importance as major economic factors. The use of money instead of rice was gradually
becoming established. The Tokugawa system, which was oriented more towards the control of weapons and
people than towards the control of economic factors, proved incapable of stopping this change, or of adapting
to it. From the beginning of the 18th century, the regime was battling with a permanent financial crisis; the
priviliged aristocratic and military class, which was orientated towards the rice economy, was becoming impover-
ished and was forced to give way to the financially superior rich bourgeoisie, who controlled the money market.
When the nobility, after the collapse of the shōgunate, had to hand over their property to the Emperor at the
head of the new system, there was nothing to give but their debts.

The rising power of the towns can be traced back to the beginning of the 16th century, when, to give one
example, the European missionaries referred to the port of Sakai as to the Japanese Venice. During the Hideyoshi
rule, Osaka became of primary importance, as its inhabitants proved to be genuinely talented in trade organi-
zation. It did not take long for Osaka to be firmly established as the unrivalled economic metropolis of Japan.
The city's gigantic rice-lofts had the capacity of storing almost the entire crop production of both the Tokugawa
administrators and provincial 'daimyōs'; their large wholesale and transport associations controlled the entire
production and finance exchange of the country. Kyoto remained the seat of the Emperor's court, and the
centre of traditional culture. It probably took advantage of the prosperity of nearby Osaka. The distant city of
Edo, the seat of the shōgunate, received however the largest portion of the national income; the money poured
into the hands of the priviliged classes and was quickly spent on their own pleasures. The growth of its population
was also remarkable. In less than fifty years of the 17th century, the village in the marshland turned into a large
city with half a million people. By the 18th century, its population approximated one million people, and during
the beginning of the 19th century, Edo grew into a giant municipal conglomerate with about two million in-

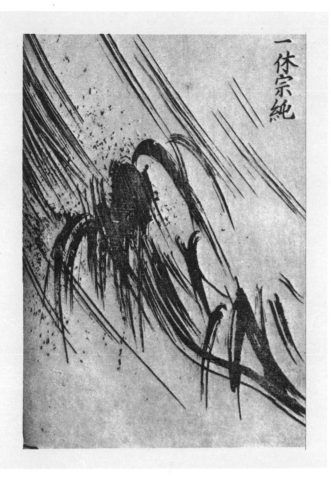

一休宗純

Shunboku: 'Painting of the Storm by Sōjun Ikkyū'

The tenth sheet from the third volume of 'The Mirror of the Exemplary Paintings' (Ehon Tekagami); six volumes bound in one, sumi-e, 262 × 18.1 cm. Signed 'Hokkei Shunboku mo'. Engraved by Murakami Gen' emon, published by Terada Yoemon, Osaka, 1720.

In Shunboku's graphical interpretation of the expressive ink-painting by the monk Ikkyū (1394—1481), the chiaroscuro effect of the original is almost completely suppressed, but the ecstatic rhythm of brush-strokes is well-preserved.

habitants. Yet it never threatened the superiority of Osaka in terms of large-scale trade, and remained the city of the middle and petty bourgeoisie. The majority of the inhabitants was formed by tens of thousands of aristo-cratic families and their courts, who either lived in the city, serving in various administrative posts, or who were bound to the city by the system of temporary residential duty *(sankin-kōtai)*, which was devised by the shōgunate as one of its supervisory provisions. More and more people accumulated around this aristocratic core of the population, and made their living by serving the privileged; there were those sub-servient to these servants and whole ranks of artisans, retailers, actors, acrobats, wrestlers, waitresses, courtesans and hairdressers.

The tendency of the Tokugawa regime to make Edo into a town where the income of the potentially danger-ous aristocratic circles was lavishly consumed, must have been the cause of the large entertainment districts full of brothels, theatres, amusement boats, tea-houses, shooting galleries, etc.

The whole new branch of Japanese painting called *ukiyo-e*, and a substantial part of graphic art of the Tokugawa period drew their inspiration from the cultural life in Edo, and were patronized by the middle classes. During this time, the Kanō school of painters was mostly still in the service of the Tokugawa court, and strove to interpret creatively its ideology of orderly, elegant and respectable society, ruled by a 'just government'; an ideology derived from Chinese Neo-confucianism. The Tosa school of painters was mainly employed by the Emperor's court in Kyoto with its atmosphere of nostalgic memories of the past glories of the court aristocracy. The new group of artists known by the name of the Rimpa school (Koetsu, Sōtatsu, Kōrin, Hoitsu, etc.), was carried by the tide of the new intellectual elite; both the talented artists of noble descent from Kyoto, and the sophisticated members of the well-bred traders from Osaka met there as equals. Other provincial lords and wealthy citizens patronized a new movement of naturalistic painting, sometimes defined by the term 'Return to Nature'. It was no coincidence that some artists of this school came from peasant stock (e.g. Maruyama, Jakuchū), yet they were also receptive to the influence of Chinese academic painting, and European painting. The contemporary Chinese ways of thought and art — some of them too subtle and too dangerous to be acceptable to the Tokugawa regime — inspired the Nan-ga school of ink-painting. European science and art, which was also considered dangerous, penetrated into various cultural spheres with varying success.

The traditional links between art and the political, economic, or military power are, therefore, evident and strong. But at times it seems that the bonds between art and intellectual and cultural life are stronger. Culture itself is perhaps capable of creating centres of power with the same pull as the power of government, or the power

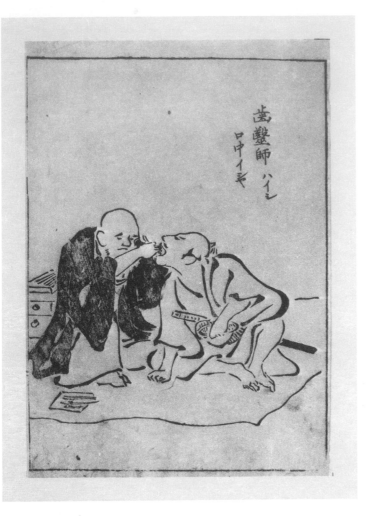

Kokan: 'The Dentist'

The 21st sheet from 'The Album of Figure Sketches' (Jinbutsu Sōga), published in Osaka, 1724.

The monk Myōyo, also known by his artisic pseudonym KOKAN (1652—1717), was a pupil of the court painter Kanō Einō, but occasionally he turned to book illustration. His humorous sketches (published posthumously) express his understanding for both graphic art and ink-painting.

Sukenobu: 'The Brothel Manageress and the Maid'

Detail from the twelfth and the thirteenth sheet of the second volume of the same album as in Plate no. 6.

The album of 'The Studies of One Hundred Women' is justly esteemed as one of Sukenobu's masterpieces. It is a magnificent apotheosis of a single, soft-velvet beauty in innumerable disguises.

of money. The only power to which the art of the Tokugawa period did not wish to be under obligation to was the police. On the contrary, there is a long record of serious clashes between the police and art, which often ended in severe sentence of the artists. It is also worth noting that the art of this period never served those with no power. It totally ignored the gigantic class of peasants, though in the official social hierarchy of the shogunate it was placed as an important second. In all probability art did not serve the poor of the towns either, though statistics prove that its impact on the major cities was so big that it almost merits the title of 'the art for the masses'.

Since the Meiji restoration of 1868, Japan has undergone many profound and extensive social changes; it has had to cope with hasty industrialization, international influences, with scars inflicted by both world wars, and, later, with postwar prosperity accelerated by scientific and technical revolutions. During this long and complicated period, Japanese art — still subject to the powers above it — often met with desperate ends, especially when it was used for commercial purposes, or for military propaganda. Yet it was evident that the service of art to culture, which was already discernible in the Tokugawa period, was gradually increasing. And what is most pleasing of all, is that Japanese art is now progressively finding the resources and the will to serve even the underprivileged and the poor, and to serve peace.

Diversity and homogeneity

According to general opinion, the term *Japanese graphic art* covers a limited type of prints by popular artists — such as Hokusai, Hiroshige, or Utamaro. It is therefore necessary to repeat that, in fact, Japanese graphic art is immensely varied — in its technical scope and range of subject-matter, in its emphasis on aesthetic qualities, even in its ideological and moral attitudes. At the same time, all the different classes and types of prints are interrelated to such a degree that we can take them for a unified whole. This diversity should be seen against an ancient, solid background which is formed by the Far Eastern traditions of writing, painting and printing.

As to the technique of printing itself — Japan — together with China, Korea, and other countries — has been contributing to its development for over a thousand years. Already in the years 762—770, no less than one million

miniature scrolls of *dhāranī* spells written in Chinese were printed in Japan at the command of the Empress Shōtoku, and some of them still exist. The development of printing in its earliest phases was used primarily for religious purposes, and so was, more or less, confined to the reproduction of the written word. Nevertheless, illustrations for the printed texts and separate votive pictures were no rarity in the Far East. As only a negligeable fraction of the once enormous production has been preserved, the study of the earlier periods of the Eastern woodcut is still very problematical. Only the chance discovery of some of the larger sets of prints in Tun-huang, or Khara-khoto for instance, provide enough information to make it possible to reconstruct three major trends which determined print production from about the 7th century to the 17th century: the first trend was to comply with the canonized norms of the time, the sect, or the monastery; the second trend was to follow the current stylistic development of painting; the third was to accommodate the method to the specific demands of the technique and material employed.

The last tendency towards graphic expression is evident especially in the pictures of saints distributed by monasteries as votive pictures. It has been suggested that the woodblocks were carved by professional monastery sculptors, who did not bother to draw a preliminary sketch. Their nonchalant attitude to the contemporary norm of painting has meant a great deal of research into the correct dating of these pictures. However, thanks to the few, rare, dated prints, we can be certain that various types of pictures were already being printed in Japan in the 13th and 14th centuries.

The printed illustration — which is a specific Japanese contribution to the history of Eastern graphic art — began to develop at approximately the same time. The early prints were devoted to depicting the legends of various saints and founders of Buddhist sects, like Kūkai, Ryōnin, or Nichiren. The hand-illustrated scroll manuscripts of such legends come from the 12th century, the first wood-cut versions date from the 13th and 14th centuries, and the book editions appear after the year 1600. The execution of these religious pictures was, as a rule, confined to the technique of black and white prints, though hand-colouring, or colouring through stencils, as well as gilding, was occassionally added.

Printing had never been a monopoly of the monasteries — court workshops had also been engaged in this activity. To a certain extent they participated in the production of the holy scriptures, but their main merit was in the production of prints with secular themes, mostly of a decorative character. Attention is usually centred upon the figurative designs on the fan-shaped paper which was used as a background for calligraphy of the

Lotus Sutra *(Hokke-kyō)* in the 12th century. The ornamental prints of paper and leather preserved in the Imperial repositories *(Shōsoin)* also deserve our attention, as they are the earliest examples of the traditional bond between decorative and graphic art. In addition, a wider scale of printing techniques, such as blind embossing, or glittering mica decoration, is used in these prints for the first time.

Private workshops did not influence the history of Far Eastern graphic art until the 17th century, and even then the sphere of their influence was limited mainly to two cultural centres — Chinese Nanking and Japanese Kyoto. The printing enterprise in Kyoto was sponsored by the learned Suminokura Sōan who, in 1608, published the first book on secular theme, *'Ise Monogatari'*, an anthology of poetic tales from the 10th century; it was illustrated with forty-nine pictures after the drawings of Honnami Kōetsu. Illustrated publication of the early 17th century were named *'Saga-bon'* after Sōan's dwelling in Saga. These books set a high standard in Japanese graphic art, especially as their primary purpose was cultural rather than commercial. Unfortunately, the same does not apply to the multiple publishing activity of the later 17th century, though it is difficult to pinpoint the period when commercial aspects began to triumph over cultural ones. The majority of the early products was concerned with traditional cultural themes and interests, while prints designed for the popular demand of *ukiyo-e* did not emerge till towards the end of the 17th century. Again it is worth noting how imperceptible this emergence was, and how the characteristic themes and styles of the later *ukiyo-e* diverged gradually from the traditional social and cultural conventions.

The thematic range of Japanese prints was already so vast in the 17th century that a detailed account would be not just astounding, but also very boring. Such a prodigious variety of production suggests that the driving force in the background was not just the didactic intention to spread culture, but sheer passion for transmitting all knowledge and all imaginable activities into a pictorial form. There are depictions of all wars and portraits of all leading warriors, famous poetic anthologies, as well as pictures of eminent poets, achievements of Chinese science, and popular beautiful localities, characters and poses of ceremonial dances, all types of weapons, grasses, shells, fish, crafts, or instructions for wearing a suit of armour, and for making love. Besides the lengthy tales taking up several volumes, called *monogatari* and which are richly illustrated, there are novelettes written for the edification and pleasure of women, containing no more than three or five pictures. Apart from monochrome pictures, there are some hand-coloured 'vermilion-and-green' publications *(tan-roku-bon)*, and the occasional prints where an extra colour block was used in addition to the black key block. Though most of the illustrations are anonymous, we encounter the first pictures to which the names of prominent artists — such as Hinaya Ryūhō or Yoshida Hanbei of Kyoto — are appended. Already at this stage the reproductions of traditional ink-painting took up their position within the graphic art, and the basic themes of *ukiyo-e* were also becoming firmly established.

The genre pictures found their home in Edo which, during the second half of the 17th century, had developed into the second largest centre of publishing and painting activities. Soon it was dominated by the artistic personality of Hishikawa Moronobu, who came to Edo from the province of Awa as a textile designer. The authorship of more than one hundred illustrated books is ascribed to him, and though some of the titles are unsigned, (his earliest signed and dated book is of a rather late date, 1672), this remarkable output rates him among the most prolific authors of *ukiyo-e*. One of his indisputable achievements is that he drew the human figures in the foreground of his composition in such a manner, they did not merge with the environment, but tended to dominate the picture. He is also to be credited with the eventual predominance of the cultivated curved lines over the rectilinear rhythm of the traditional *yamato-e* and its early illustrations. He also succeeded in freeing the pictures from their dependence on text with series of picture albums called *e-zukushi*. Finally, Moronobu definitely stirred the interest of artists in themes of contemporary life and people. All the preceeding trends of graphic art and painting were absorbed in Hishikawa Moronobu's unique and definite style, so that the poet Ransetsu justly commented that 'the taste of the Eastern provinces follows the Hishikawa style'.

However, around the year 1770, two factors in which Moronobu played but a small part combined to establish and stabilize *ukiyo-e*. The first was the rendering of daily scenes from Yoshiwara (the licensed quarter of the courtesans) into a new graphic convention, and the incarnation of woman into an image. The second was the important union of graphic art and the *kabuki* theatre. The leaders in the field of these new developments were Sugimura Jihei, a cultivated artist who was unjustly ignored in later history; the numerous painters of the Kaigetsudō school; and the large Torii school, which moved to Edo, bringing with it its hereditary profession of painting theatrical posters. Torii Kiyonobu, the founder of the Tori school, developed the congruent graphic expression of the wild, exaggerated gestures of the fashionable heroic plays in a bombastic style *(aragoto)* and substantialy helped the pictures of the Kabuki theatre to dominate Japanese woodblock printing during the first half of the 18th century. There were two other outstanding schools — the first founded by Okumura Masanobu, the other by Nishimura Shigenaga. As evidence of the youthful vigour and vitality of *ukiyo-e*, it is worth noting that both these artists began producing prints at the age of 15 or 16 — if the generally accepted dates of their birth are correct. Masanobu, in particular, showed a wide versatility, especially in the range of his subject-matter and the structural unity of his compositions. His innovations led to the introduction of lacquer prints *(urushi-e)*, in the 1720s, and to the introduction of prints on long, narrow paper *(hashira-e)*. He endeavoured to apply the rules of European linear perspective to interior scenes *(uki-e)* and two-colour prints *(benizuri-e)*

Sukenobu: 'Winter Reverie'

The first picture in the third volume of 'The Picture-book of Chrysanthemum' (Ehon Chiomigusa). Signed — 'Nishikawa Sukenobu'. Engraved by Fujimura Zen'emon and Murakami Gen'emon. Published by Morita Shōtarō, Osaka. 14 sheets, 27.5×19 cm, 1741 (the first edition 1740).

The calligraphy of the poetry mingles with the poetic mood of the pictures to form a perfect graphic unit. The situation and the mood of Sukenobu's girl is expressed, both by the picture and by the poem:

Hakanaku mo	'*Futility!*
Nochi no yo kakete	*Until the world to come*
Chigirikeri	*He promised*
Imada ni kawaru	*To be mine. Meanwhile —*
Hito no kokoro wo	*His heart is changing constantly*'

in the 1740s. The wealthy Shigenaga focused his activities on book illustrations. He must have been an excellent teacher as such famous *ukiyo-e* painters as Toyonobu, Harunobu, and Shigemasa were among his disciples.

During the first half of the 18th century, book illustration had not lost its impetus in Kyoto, mainly due to the prolific activity of the book-seller and publisher Hachimonji, nor in Edo, where countless publishers issued the popular 'red, blue, and black books' *(akahon, aohon, kurahon)*. Besides such specialized illustrators as Kondō Kiyoharu and Tomikawa Fusanobu, all the prominent artists of the afore-mentioned *ukiyo-e* schools participated in the production of illustrated books, the fervour and vitality of which can be compared to American comic-strips in their early days. Nearly all of them tried their hand also at designing a number of popular subjects which appeared on broadsheet prints of the day. Since the immense popularity of military tales *(gunki monogatari)*, one of the favourite themes of *ukiyo-e* from its very beginning was the depiction of formidable warriors and battle-field scenes *(musha-e)*. In the 1720s, there was a brief excursion into the realm of landscape woodcuts *(miyage-e)*, which resulted in a strangely archaic form of landscapes somewhat similar both in principal and execution to the style of landscape painting which became obsolete in China as early as in the 10th century. Neither did the attempts of the early *ukiyo-e* in Edo on the traditional theme of flowers, birds and animals *(kachō-e)* find fertile soil, and had to wait for several decades to blossom. All these early ventures on classical themes were overshadowed by the enormous production of theatrical prints, which registered each little activity within the precincts of the three major *Kabuki* theatres in Edo. This outburst of theatrical themes logically led to a certain degree of mannerism; the actors were always depicted as if frozen in several conventional poses, regardless of the actual range of their expressive gestures; and the designs seem to have been cut with closed eyes, as the differences in conception and brush-work of the individual artists were not really obvious.

This was the period when the gap between the concepts of *ukiyo-e* and the traditional ink-painting of the

19

Itchō: 'An Ox-Cart by the Yodo River' (Yodo no ushi-kuruma)

The twenty-sixth and the twenty-seventh sheet from the 'Album of Hanabusa's Drawings' (Eiga zushiki). Published by Yamazaki Kinbei in Edo. Sumi-e, 28×19 cm; c. 1773.

Hanabusa ITCHŌ (1652—1724) received his training in the sophisticated Kanō and Tosa school of painting. Though he never drew belles and actors, his witty genre paintings had already exercised a considerable influence upon the painters of *ukiyo-e* by the end of the 17th century. A collection of wood-cut reproductions of his drawings was prepared for printing by his pupil Ippō in 1758. Suzuki Rinshō republished the same collection with minor modifications in six volumes under the title of 'Sketches in the Superior Brush' *(Eihitsu Ryakuga)* in the year 1773. The album from this collection is identical with the sixth volume of Rinshō's edition, and was printed from the same blocks.

Far East was at its greatest. This is evident when we compare the hand-coloured, or two-colour actor prints from Edo with the albums of paintings then published in Osaka and Kyoto. Inspired by a similar Chinese practice, the Kamigata painters, especially those who had been trained in the traditional Kanō school of painting, produced albums of woodcut reproductions of the masterpieces of Chinese and Japanese ink-painting. Tachibana Morikuni published its encyclopedia of Chinese painting 'Morokoshi Kinmō Zui' ('The Illustrated Encyclopedia on China') in the year 1719. Ōoka Shumboku published five volumes of the Chinese and Japanese ink-painting 'Ehon Tekagami' ('Picturebook of Exemplary Paintings') in 1720; many other similar compilations appeared later. As the least charitable interpretation, these works may be regarded as insipid copies, and imitations of ink-painting by an inadequate medium. The most generous view is that these works were stimulated by the ancient, respectable practice of re-interpreting the revered paintings of old masters. All in all, they opened new vistas for Japanese graphic art, and enriched its technical scope. Colour prints appeared in 1746 in Shumboku's 'Minchō Seidō Gaen' ('The Growing Garden of Painting at the Ming Court'), and two years later also in the Japanese edition of the famous 'Chieh Tzu Yüan Hua Chuan' (Japanese 'Kaishien Gaden', or 'Mustard Seed Garden Manual of Painting'). New engraving techniques were used in 1749 in Morikuni's reproductions of the cursive brush-work style entitled 'Umpitsu Soga' ('The Movement of the Brush in Coarse Painting'). They introduced the type of caricature known as *toba-e* into graphic art, and last but not least, they heralded the renewal of creative activity in the now rather effete school of Kanō (the drawings of monk Kōkan were published in 1724 and the drawings of Itchō were prepared for printing by his pupils in the middle of the 18th century), and in painting in general.

Nishikawa Sukenobu, and his predecessor Omori Yoshikio, who around the year 1700 was already painting the geisha girls from the Kyoto district of brothels (the 'Shimabara'), may be regarded as intermediates between the albums of classical paintings printed in Kyoto and the genre prints published in Edo. About 1710, Sukenobu began to compile albums, where the pictures of women were often accompanied by the poem, *tanka*, calligraphic-ally written, or by other traditional verses, which was to the taste of the cultured classes in Osaka, Kyoto and in Edo. From his hundred titles, the most popular ones were: 'Hyakunin Jorō Shinasadame' ('The Studies of One

Hundred Women', 1728), '*Ehon Tokiwagusa*' ('Picture-book of the Evergreen Grasses', 1730), '*Ehon Chiomigusa*' ('Picture-book of the Chrysanthemum', 1740), and the ten volumes '*Ehon Yamato Hiji*' ('Picture-book of Japanese Things', 1735—1742). His work is a lyrical apotheosis of women of all ranks and professions; but he quite naturally favoured the oldest known profession. His style is tied more to the old tradition of painting, rather than to the contemporary *ukiyo-e* schools of Edo. Edo painters like Masanobu and Harunobu, to name the most famous ones, derived from his books not only figures, but often complete compositions. It was probably due to his influence that they turned towards a more poetic style during the middle of the 18th century. One could therefore say that Sukenobu as an *ukiyo-e* painter with the closest connection to classical painting and culture prepared the ground for the rapid succession of events which so strikingly accelerated the development of Japanese graphic art in the 1760s and 1770s.

When talking of this rapid development, we are not only referring to the much discussed introduction of polychrome 'brocade' prints *(nishiki-e)* in 1765, but also to such events as the publication of Harunobu's '*Ehon Kokinran*' ('Picture-book of Ancient Gold Brocade') in 1762, which was influenced by the illustrative style of the famous Chinese portraitist of women, Ch'iu Ying, as well as the publication of Harunobu's series of '*Zashiki Hakkei*' ('Eight Views of Interiors', 1776), or his picture dictionary of contemporary beauties, '*Yoshiwara Bijin Awase*' ('Collection of Yoshiwara Beauties'), which was published in 1770. It is no coincidence that the two other most interesting books of the period — the book that opened new possibilities for actor prints, '*Ehon Butai Ōgi*' ('A Fan-shaped Picture-book of Actors'), designed by Bunchō and Shunshō, and the book depicting various artisans at work, '*Saiga Shokunin Burui*' ('Classified Artisans in Coloured Pictures') by Tachibana Minkō — were issued in the same year as the great Harunobu's compendium '*Yoshiwara Bijin Awase*'. Other works of importance in Japanese graphic art were Ryūsui's colour studies of sea fauna, published under the title '*Umi no Sachi*' ('Treasure of the Sea', 1762), and the books of drawings by Sō Shiseki and Tatebe Ryōtai, the two painters who form the vanguard of the renaissance movement in Japanese ink-painting. The first artist published his '*Sō Shiseki Gafu*' ('A Book of Paintings by Sō Shiseki') in 1765, and '*Yokōn Gasō*' ('Collection of Ancient and Modern Paintings') in 1771. '*Kanyōsai Gafu*' ('A Book of Paintings by Kanyōsai'), and '*Kenshi Gaen*' ('Mr Ken's Picture Collection'), which were the works of the second artist, came out in 1762 and 1775 respectively. The convergence of the traditional schools of painting and *ukiyo-e* is manifested in the colour drawings by Toriyama Sekien ('*Sekien Gafu*', 1774), and in the editions of Itchō's drawings published by his pupil Suzuki Rinshō, in 1773. The renewed activity in the thematic field of flowers, birds and animals, practised by Koryūsai, for example, and in the field of landscape printing, as shown by Shunshō, is further evidence of this convergence. The perspective pictures *(uki-e)*, and the copies of Dutch copper-plates in which Toyoharu allows European influences to impinge upon the graphic art of Japan, are other noted achievements. So are the works which return to the traditional style of Tosa painting, such as Shunshō's series on the theme of '*Ise Monogatari*' ('The Tales of Ise', 1771), and his '*Nishiki Hyakunin Isshu*' ('One Hundred Poems in Brocade', 1779).

The development in the pictures of beauties *(bijin-e)*, which dominated *ukiyo-e* in the second half of the 18th century, was hastened not only by Harunobu's new conception, but also by his surpassing it. After 1775, illustrators of a new type of popular literature, '*Kibyoshi*', (so called 'Yellow Booklets'), were also responsible for the advancement of *bijin-e*. The publisher Tsutaya recruited Shunshō and Shigemasa to illustrate the picture album '*Seirō Bijin Awase Sugata Kagami*', ('Mirror of Beautiful Women from the Green Houses', 1776), which prompted the competitive publisher Nishimura to immediately employ the renowned Harunobu's pupil Koryūsai to design the series '*Hinagata Wakana no Hatsu Moyō*', ('The First Fashion Designs for the Spring Sprouts', i.e. young beauties), which was later completed by Kiyonaga.

These events were of great importance not only for the further development of the *bijin-e* theme, but also for Japanese graphic art as a whole, because they opened the way to larger compositions and more complex and harmonious colour schemes. Furthermore, they introduced a completely new feature into the graphic art of the Far East — large figure compositions resembling those of the Italian Renaissance. In these pictures graphic art surpasses its own innate limits, and enters the sphere of murals. The results of this development are evident in the excellent and diverse production of the subsequent twenty years — the 1780s and 1790s. We have in mind the series of Kiyonaga diptychs and triptychs, exemplified by the famous '*Minami Jūniko*' ('Twelve Months Among the Beauties of the South', 1784), Kitao Masanobu's album of *ōban* diptychs, depicting the Yoshiwara courtesans, their poems, and their calligraphy, called '*Yoshiwara Keisai Shin Bijin Awase Jihitsu Kagami*', ('A New Collection of Beautiful Yoshiwara Courtesans and Mirror of their Handwriting', 1784); Shunman's hexaptych '*Mu Tamagawa*' ('The Six Crystal Rivers', 1785—90); Eishi's pentaptych of the ships under the Ryōgoku Bridge (1785), as well as all the similar compositions by Shunshō, Utamaro, Toyokuni, and their lesser contemporaries. The mere existence of hexaptych in Japanese graphic art suggests that graphic art goes beyond its original scope — from the sphere of intimacy, where the picture was small and focused on one or two figures only, to a sphere of entirely different communication. The hexaptych has to be spread on the ground, or attached to the wall, so the structural, chromatic and narrative interplay between the individual details of the whole series could be fully appreciated.

It is not difficult to realize that such changes were helped by the eclecticism of *ukiyo-e* artists, who felt free

to appropriate any feature from any source. Figures are depicted both from the traditional *yamato-e* bird's eye view, and the European frontal view; the interiors open up from the top, or in the European linear perspective; and the conception of landscapes is based on the experience of Eastern ink-painting, or Western oil-painting. Such an attitude may seem to be both arrogant and naive, but it makes us realize that great art and great culture must use their ability to take in external experience from other sources. But art, which stays overbearingly puristic in its originality, rarely reaches greatness.

The freedom of the system of Japanese graphic art at the turn of the 18th century led to such a variety and multiplicity of production, that to enumerate in detail would result in an almost endless list of names. The genre of *ukiyo-e* itself is overcrowded with names of exceptional painters like Shunkō, Shunei, Sharaku, Toyokuni, Utamaro, Shunchō, Toyohiro, Eishō, Eishi, Chōki, and Hokusai. Their compositions range from large portraits *(ōkubi-e)* to the above mentioned hexaptychs. Their colour schemes cover both the extremes of ethereal gradation of light grey and violet, and the earthy areas of opaque brown, black, and heavy metallic layers. The technique scale embraces robust black and white pictures as well as multi-coloured prints with graded chiaroscuro areas, *(bokashi)*. The themes, subjects and styles are equally rich — let us mention here at least the diversity between the delicate occasional prints *(surimono)* and the huge beauty-portraits in the field of broadsheets; or the disparity between Utamaro's albums of flowers, birds and insects or Hokusai's genre albums and Masayoshi's albums of concise and rough sketches *(ryakugashiki)*.

Outside the *ukiyo-e* genre, artist like Shiba Kōkan emulated the European copperplate technique at this time. Meanwhile the painting-schools in Kyoto and Osaka, known under the names of Nan-ga, Maruyama, Shijo and Kishi, strove to enliven the ink-painting tradition through the means of graphic art. Chō Gesshō, Tōkai, Goshun, Ki Batei, Soken, Buson and Bumpō are among the artists of this genre who published the majority of their works before the turn of the 18th century, while the works of Chikudō, Taigadō, Koshū, Bosai, Bunchō, etc. belong to the first decades of the 19th century. The former task of transposition of ink-painting into graphic art, and the exploration of the artistic experience achieved in emulating the Chinese ink-painting of the Ming and the Ching periods had been completed and surpassed. The albums of the above-mentioned artists represent a distinctive graphical type, and they are sometimes labelled as 'classical schools'. It is pointless to hide the fact that their maturity was stimulated by the invaluable experience with *ukiyo-e* graphic art. Even the paintings of the most distinguished exponents of the Nan-ga school, like Ike no Taiga, or Buson, differ from the prototypes drawn by Chinese literati mainly in their charming freshness which was cultivated in the field of *ukiyo-e*.

The gigantic production of *ukiyo-e* prints during the first half of the 19th century, which is dependant on names like Kunisada, Kuniyoshi, Hokusai and Hiroshige, is quite familiar to the Western reader. But it may be of some importance to mention that the critical reservation which some Japanese critics maintain towards Hokusai and Hiroshige does not spring from the fact that these two artists belong to the 'low' tradition of *ukiyo-e*, but rather from the fact that Hokusai's art seems to be too Chinese, and Hiroshige's too European. As for the objections of Western critics to Kunisada and Kuniyoshi, we may suspect that the alleged reason for their condemnation — that is, the lack of artistic qualities in the majority of their prints, which was a result of over-production and commercial pressures — is only half the truth. For in the history of *ukiyo-e*, there are very few artists who were not forced into overproduction by the commercialization of graphic art. The other half of the truth is probably that the works of these artists resemble Western Art Nouveau — which had been, incidentally, inspired by many late *ukiyo-e* prints, and which had also been banned for several decades. Now, when the attitude to Art Nouveau is growing more favourable, a similar change is taking place with regard to Kunisada, Kuniyoshi, and their followers; Japanese art-dealers may soon realize their dreams of forty years ago by receiving as much money for Kunisada as for Utamaro.

The *ukiyo-e* produced in Edo during the first half of the 19th century should by no means be taken as uniform. Although, in fact, it is formed by the four mentioned giants, three of whom, moreover, come from the same school of Utagawa, the total output is of surprising variety. This is particularly evident when we take into account the privately printed *surimono*, and the diverse production of book illustrations. In the first quarter of the century, the book market was saturated by Hokusai who, besides illustrating innumerable booklets and big titles like '*Suikoden*' and '*Hakkenden*', was also successful in publishing drawings and sketches *(manga, gafu, soga)*, which used to be the privilege of the classical schools of painting. In the subsequent period, Kunisada exercised a dominant influence on *ukiyo-e* through his illustrations of the famous novel '*Nisemurasaki*', which continued to be published in a neverending chain of slim volumes *(kusazōshi)* over a span of fourteen years. Around the middle of the century, the book market was enlivened by Hiroshige's landscapes, guide-books and sketches, and by Kuniyoshi's illustrations of war-tales. But even if we concentrate our attention on broadsheets only, we cannot overlook the fact that some landscape series differ from the theatrical series *(shibai-e)*, not just in their themes, but in toto; we cannot ignore the fact that Kuniyoshi's ghostly 'horrors' have little in common with Hiroshige's still-life pictures of flowers, birds and fishes.

The expressive variety of *ukiyo-e* of the 19th century, when compared, for instance, with the first half of the 18th century, is still more striking when we also consider the artists of minor repute, and the pupils of the 'big four', namely those who brought *nishiki-e* to Osaka. In Osaka, several artists such as Nagahide, Renzan, and

22

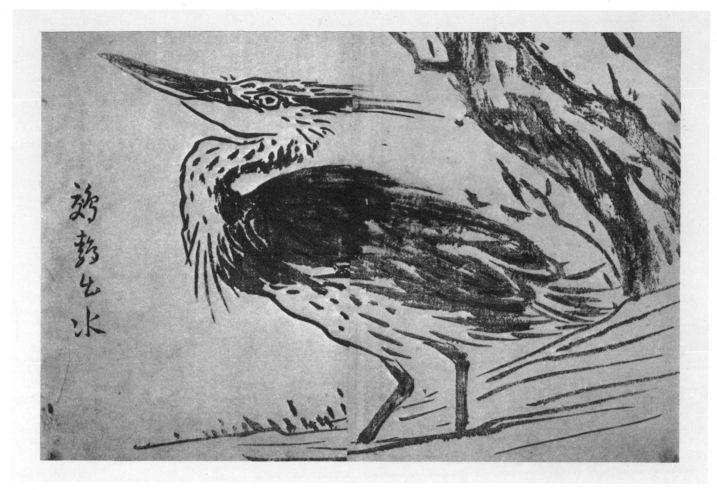

Kanyōsai: 'Night Heron Stepping Out of Water'

The eighth and the ninth sheet from the second volume of the 'Japanese and Chinese Miscellany of Pictures by Mōkyō'
(Mōkyō Wakan Zatsuga) in five volumes, 1772.

Kanyōsai (alias Tatebe Ryōtai, known also by his art name Mōkyō, 1719—1774), was a Buddhist monk, poet scholar, and teacher, who studied Chinese ink-painting. In the history of graphic art, his albums show for the first time that the aesthetic qualities of the brush-stroke can be transformed into graphic terms.

Roshū had already published stencilled *(kappazuri)* actor prints around 1800; brocade prints, however, did not take root there until the pupils of Hokusai, Shigenobu, and Toyokuni, such as Hokujū, Hokushū, Shigeharu, Kunihiro, Hokuei, etc., spread their influence. The particular local conception stressing the graphic rhythms and the traditional ideals of the Tosa school of painting became patently discernible in the works of the next generation of painters who claimed to be pupils of Kunisada and Kuniyoshi — Sadamasa, Sadanobu, Yoshiyuki, Hironobu, Hirosada, Enjaku, etc.

Also in this period, Osaka and Kyoto artists of classical orientation remained faithful to the graphical expression, which is rooted in the traditional process of ink-painting. The Kamigata graphic tradition continued in a succession of remarkable albums of drawings by such important painters as Kihō, Nantei, Kōchō and Matora, and the no less remarkable works of numerous amateurs, who illustrated both broadsheet and book editions of *haiku* and *kyōka* poetry. In the middle of the 19th century, two artists who represent the meeting of the classical and genre school of graphic art, Hanzan and Kyōsai, published their noted works.

The prints of the pupils of Edo masters in Osaka, and the editions of Kyoto masters in Edo, symbolized the mutual convergence of the cultural standards of the two centres, at the twilight of the Tokugawa period in the 19th century. We have considered the gradual convergence of artistic attitudes of the *ukiyo-e* schools, and the Sino-Japanese traditional school, and the influence of European art. Some picture albums, published in the first half of the 19th century, such as 'Shinji Andon' ('The Festival Lanterns', 1829—47), bring together the works of both distinctive schools. Sometimes, when we examine an album, it is difficult to distinguish whether the pictures were drawn by an artist from *ukiyo-e* school, or by an artist from one of the reformed traditional schools. Such is the case with Hokusai's pupils, like Gakutei, or with Bunchō's pupil Watanabe Kazan, a leading authority of the Nan-ga school; Kazan's tragic death in 1841 is not without social interest — he killed himself when in exile because of studying European science and art (called 'Dutch learning', *rangaku*).

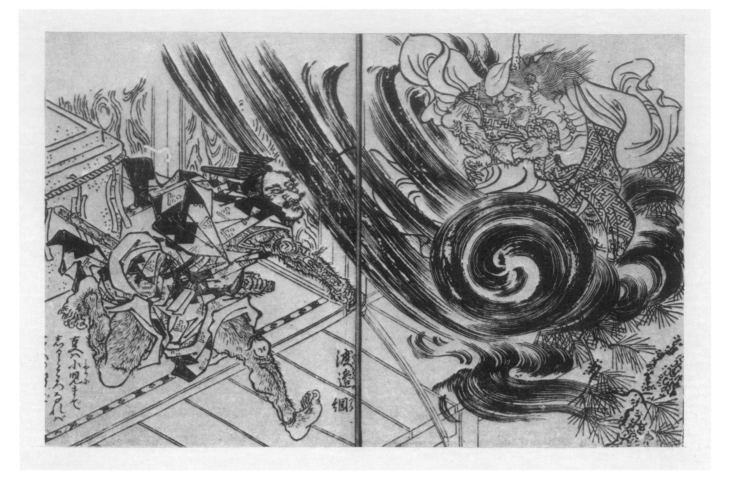

Shigemasa: 'Watanabe no Tsuna Fighting with the Demon Rashōmon'

Sheet from the second volume of the 'Picture-book of Lessons about Famous Warriors' (Ehon Bumei Kun). Two volumes bound in one, 18 sheets. Signed — 'Kitao Kōsuisai', engraved by Densen Shōto, published by Yamatoda Yasubei. 22.5×15 cm, 1790.

A concise moral instruction is appended to each picture. Watanabe no Tsuna (953—1024) was a warrior of the Saga-Minamoto clan whose greatest deed was the conquering of the demon Rashōmon.

It is one of fate's sad ironies that the two different cultural and artistic attitudes converged only to fade away together. But what had actually withered away by the date of Hiroshige's death (1858) — which so strangely coincides with the date of the treaty between Japan and five Western powers — by the date of Kuniyoshi's death (1861), the death of Kunisada (1864), and the fall of the Tokugawa regime (1868)? Was this the end of the Edo culture and *ukiyo-e*? Was this the end of traditional Japanese culture and ink-painting? From the viewpoint of history of Japanese graphic art, it was but one of its evolutionary phases, and definitely not its extinction. Therefore, it may be right to assume that traditional Japanese culture and Edo culture had not totally vanished. Certain values achieved during creative struggles under specific historical and social conditions, certain aesthetic values and artistic techniques exploited by generations of artists remained untouched and untouchable and at the disposal of future generations.

Graphic artists of the Meiji period (1868—1912), such as Hiroshige III, Yoshitoshi and Kiyochika in the 70s and 80s; Toshikata, or Gekkō, at the turn of the 19th century, had to face tasks entirely different to those of their predecessors: they had to depict the gradual process of the 'civilization' of Edo, the battle of Seinan, the big fire of Edo, the Sino-Japanese war, and other head-line events, in the so-called '*ukiyo-e* news'; they had to illustrate newspapers and scientific works; they had to cope with the existence and rivalry of photography (the first photographic edition of the famous landscape series, 'Fifty-three Stages of the Tōkaidō', was published as early as 1876); they had to absorb the impact of Western painting, and search for suitable ways to maintain their domestic tradition. As admirers of the old *ukiyo-e*, or the sophisticated ink-painting, or as connoisseurs of 20th century art, we may have numerous objections against Meiji graphic art. But we can hardly disregard the evidence seen in the Meiji prints — that they profitted from the earlier experiences of Japanese graphic art, and also from the experiences amassed by their forerunners during their early confrontations with Western art.

Kobayashi Kiyochika (1847—1915) continued with the attempts of his master Kuniyoshi, and succeeded in

24

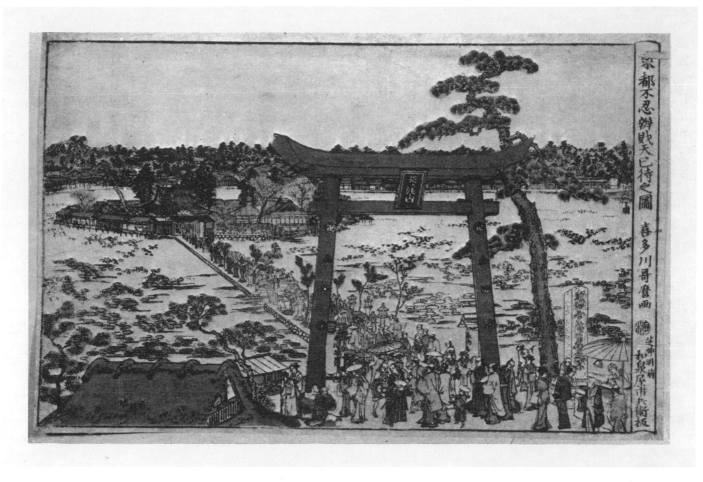

Utamaro: 'The Metropolitan Temple of the Goddess Benzaiten' (Tōto Fujin Benzaiten Kōji no Zu)

Signed — 'Kitagawa Utamaro ga', published by Izumiya Ichibei, censor's seal 'kiwame'. Ōban yoko-e, nishiki-e, c. 1790.

Interior pictures ruled by European perspective *(uki-e)* were first published by Okumura Masanobu already prior to the middle of the 18th century. In the 1770s, Utagawa Toyoharu (1735—1814) applied the perspective principles to exterior views in both townscapes and landscapes. It is not surprising that several *uki-e* of the late 1780s were signed by Toyoharu's ambitious and versatile pupil Toyokuni, but it came as a surprise when the young Utamaro also joined in. He was not attracted only by the perspective rendering of pilgrims' procession to the shrine of the Shintoist goddess of wealth, music, and eloquence, but also by the landscape of the Kinryūsan hill in Asakusa where the shrine is situated, and — above all — by the problems connected with landscape painting in general.

applying the European chiaroscuro technique in a systematic manner. But ever prior to his death, Japanese graphic artists were tredding the path of new, more progressive ways of exploring the technical and expressive possibilities offered by Western art. One of such decisive actions was to abolish the traditional co-operation between artist, engraver and printer, and to reunite these three functions in one person.

The first artist to take this step forward was Yamamoto Kanae (1882—1946) who conceived a new type of Japanese graphic art which is called *hanga*, i.e. 'printed picture'. Another important step forward was taken by the artists who, around the 1920s, turned their attention towards modern, contemporary European art. This initiative was shown by Onchi Kōshirō (1891—1955), and plenty of other artists like Saitō Kiyoshi (b. 1907), Shinagawa Takumi (b. 1907), etc.

Happily enough, modern art is, as a rule, highly tolerant of bygone centuries and the art of other countries. On being asked which of the older Japanese graphic artists was his favourite one, Munakata Shikō (b. 1903), an outstanding contemporary artist, who is both very Japanese and very universal, very modern and very archaic, replied: 'They were all great, there is something to admire in each of them.'

Calligraphy and graphic art

25 We may assume that specific features of the graphic art of the Far East grew out of the specific qualities of

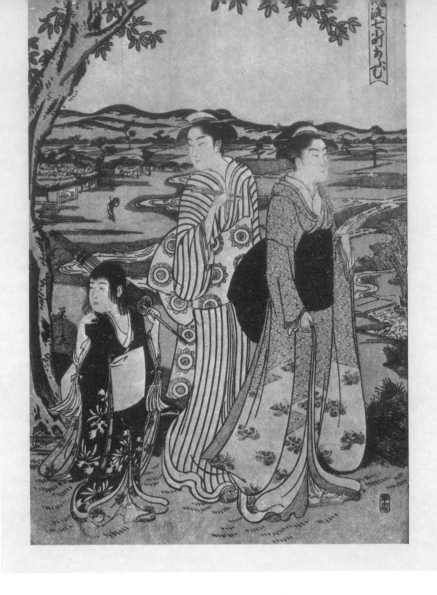

graphemes of the Chinese character scripts. Printed texts were the predecessors of printed pictures, and set them certain graphic norms.

By 'graphic norms' we mean at this point such qualities which befit the printing, but are not necessarily derived from it, and which may also permeate other artistic techniques. They can be, for instance, the contrast of dark and light, or colour areas; the rhythm of lines, or the distribution of empty spaces; the emblematic character of forms and colours; the linkage and repetition of certain elements; and the outline of characteristic forms.

In view of these qualities, the written characters of the Far East are a paragon of graphic art. Each of the eight basic brush-strokes the Chinese grapheme may consist of, is constructed as a unique graphic symbol, however simple it may be. An ink spot on a piece of paper, even in its most elementary form, is regarded by the Eastern artist as a meaningful sign with a wide scale of acsthetic, ethical, and universal implications. A famous Chinese painter of the 17th century, Shih-t'ao, devoted the whole first chapter of his aesthetic treatise '*Hua Yü Lu*' to 'One Brush-stroke' as an elementary unit of artistic language, which is capable of transforming the visions of the spirit into the realm of forms. According to his words, the brush-stroke 'penetrates the heart of things', and 'only the man is capable of controlling it!' To write one of the thousands of characters, 'one brush-stroke' and 'one brush-stroke', and perhaps tens of 'one brush-strokes' are necessary, yet their composition is not mechanical. It is ruled by dialectic dynamism, so that the individual strokes are interrelated to form a harmonious, complex, and complete sign. As the system of writing consists almost always of a larger number of characters, each of them must be capable of functioning as an individual grapheme, and of entering into relations with the preceding and ensuing characters.

It can be objected that the sophisticated standards and interpretations of the classically oriented calligraphers and literati painters *(bunjin)* have little in common with the 'commonplace' ideals of Edo illustrators, painters of theatrical posters, and with *ukiyo-e* as a whole. Nonetheless, the Japanese graphic artist had always worked within the boundaries of expression delineated by the grapheme of Chinese characters, and he could not but succumb to its rule. First of all, he had to be literate before he could handle the brush. Secondly, he had to construct and relate the brush-strokes as if writing the characters; probably it did not even occur to him it could be done in any other way. Thirdly, he never tried to hide the fact that his painting was composed of ink

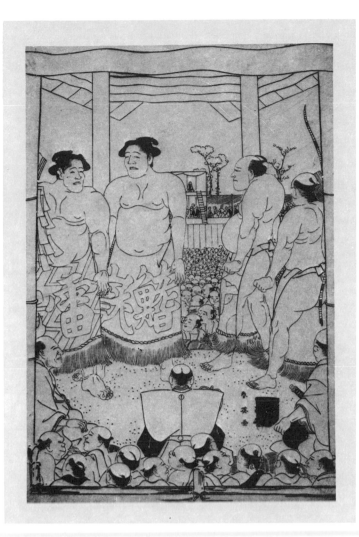

Shun'ei: 'Sumō Wrestlers Taking a Bow'

Signed — 'Shun'ei ga', and incomplete seal of the publisher. A rough print from the key-block. The definite version is unknown. Ōban, 1790—1796.

Katsukawa SHUN'EI (1762—1819) was, like Shunkō, a promising pupil of Shunshō. He was a musician and a singer of the *jōruri* chorus by profession, which may have been the reason why in painting he concentrated on the actor's personality rather than on his role. He also treated the *sumō* wrestlers with a similar emphasis.

lines and brush-strokes — the opposite of European graphic artists. It is remarkable that this attitude is consistent throughout the development of Japanese graphic art, with the exception of such artists as Kobayashi and Yoshitoshi, whose responsibility towards the purity of the brush-stroke had temporarily slackened during the Meiji period.

This responsibility is the most prominent in the painters of the Nan-ga school, such as Taigadō, and accordingly is obvious in their work. But when we scrutinize the *ukiyo-e* prints in detail, we cannot fail to notice that each of the well-known artists has his distinctive brush style which is consistent even in the endless, stereotyped repetitions of the fashionable cliché. For this reason he also signs unoriginal compositions and poor designs — as if he was aware that 'only he, an artist, is capable of controlling the brush-stroke'. The engraver, the printer and the publisher might have distorted the graphemes in cheap editions of his prints, but never to the extent that his lines and their rhythm would not have been recognized as the work of the particular artist.

Wood, colour and paper

A line engraved into a wooden-block with a metal knife is, because of the character of the material and the technique used, essentially related to one of the brush-strokes which form the graphemes of the Chinese script. But it would be an exaggeration to assume that for this reason wooden blocks were used in the Far Eastern printing in preference to other material, although other materials had also been experimented with.

The experimentation with wood-blocks is very ancient in the Far East — apparently of a much greater age than the earliest extant prints. A well-known Japanese graphic artist Hiratsuga (b. 1895), who collects ancient ceramic tiles with relief decoration, claims that they must have been stamped from wooden blocks. He maintains that it appears as if the printing — or at least the blind embossing — had originated several centuries B.C.

The most popular wood in Japan is that of the wild cherry tree, and it is customarily cut lengthways, along the annual rings. The engraver *(hangishi)*, evens and polishes the surface, and pastes, face down, the design painted on a transparent paper *(minogami)*. Then he carves the contours of the picture with a sharp knife *(kogatana)*, and removes the remaining wood with the use of chisels and mallets, and brushes the block clean. This procedure, in a way, resembles that of the sculptor, and Hiratsuga believes that medieval Buddhist wood-blocks

27

were carved by the same sculptors who made the huge temple statues. This view is supported not only by the fresh naivety of the early prints, but also by the characteristic use of the basic material. In the Tokugawa period, wood-block carving was a highly specialized craft, which demanded an apprenticeship of up to ten years. The less skilled pupils *(dōbori)*, engraved the body and the dress while the masters *(kashirabori)* had the privilege of engraving the face and the hair. The artisans were made to follow the original painting to the last detail, so that the qualities of the wood-cut technique could never be fully developed. On the other hand, the painters never did their own engraving, even if this was their original vocation — as was the case with Hokusai. Nonetheless, the painter and the carver were a team, and they often recognized and stimulated each other's talents, as can be judged from the cooperation between Morikuni and his engraver Zen'emon, or between Hokushu and his engraver Kasuke, in Osaka. Occasionally the names of the engravers appear on the prints side by side with the artist's signature, but more often we find them in the colophons of printed books. The only complete historical lists of engravers cover the end of the Tokugawa period.

The grain of wood and the structure of the annual rings was already being used to effect in some prints of the 18th century, but not until the days of the modern *hanga* prints was the quality of wood consciously utilized to enhance the resulting effect. This assertive attitude is obvious especially in prints by Munakata Shikō, who strives to emphasize the natural quality of the material. He attacks the wood-blocks as if in a trance of ecstasy, and he carves with an amazing speed — as if the wood and the knife were guiding his hand, and the cadence of splinters was composing the structure of his picture.

Kuniyoshi: 'Benkei Calming the Spirits of the Elements'

The nineteenth and the twentieth sheet of the 'Album of Ichiyūsai's Drawings' (Ichiyūsai Gafu). Twenty-five sheets of colour wood-cuts, 22×15 cm. Published by Suwaraya Shinbei in Edo and Kawachiya Mohei in Osaka, 1846. The preface dated 1829.

The incarnation of the elements portrayed pictorially was the traditional forte of Japanese art. It had found many exponents among the graphic artists of the 19th century, and it attracted quite a few admirers among the first European connoisseurs of Japanese graphics (see Plate 112). In his early work, Utagawa Kuniyoshi (see Plate 99) combined the theme of the elements with his favourite theme of warriors and heroes. This picture probably illustrates an episode from *Heike Monogatari* in which Yoshitsune, his ward Benkei, and other brave men from the Minamoto army dare to sail a stormy sea from Watanabe shore to Shikoku island in pursuit of the Heike army camping at Yashima (see Plate 44).

Masayoshi: 'Ford on the Ōigawa River'

The twenty-first and the twenty-second sheets from the 'Album of Landscape Sketches' (Sansui Ryakuga-shiki). Engraved by Noshirō Ryūko, published by Suwaraya Ichibei, signed — 'Keisai hitsu'. 26 × 53 cm, 1800.

In this landscape album, Masayoshi had not freed his brush to the same extent as in the figurative album (see Plate 81). Though the drawing line has the typical short-hand features and the actual reality conforms to the compositional demands, the picture in no way aspires to the ancient ideal of 'the landscape of the mind'. Rather, it is a 'topographic landscape', a description of a real countryside the early prototype of which can be identified, for instance, in the painting of 'The Bridge to Heaven' *(Ama no Hashidate)* by Sesshū. Not even Hokusai and Hiroshige deviated away from this way of presenting nature.

This brings us to the group of specific qualities of graphic art, which are directly dependent on techniques and materials. The process of cutting or carving into a solid material, and the process of printing the colours upon an absorbent paper surface create a distinctive aesthetic quality, which is quite independent of the likeness of the original painting. In the appreciation of a print, we must insist that this quality should be evident, and not diminished by simulating another material or technique. The superior quality of hand-made Japanese paper had always been a supporting agent in this process. Onchi Kōshirō, one of the forerunners of modern graphic art, said on its behalf: 'I give half the credit for the world-wide fame of *ukiyo-e* colour prints to the wonderful *hōsho* and *masagami* papers on which they were made'. The other half of the credit should be given to the excellent pigments which, in the Tokugawa period, were prepared and perfected with the same zeal and care as in Renaissance Italy. The modern graphic artist Shinagawa, a great admirer of Picasso and Miró, was fascinated when he observed the colours of an old *nishiki-e* print he happened to come across. They seeped deep into the paper, becoming, in fact, a part of it; when examined against the light, they gave the illusion comparable only to the beauty of stained glass windows of medieval cathedrals.

The application of the qualities inherent in the printing technique was the task undertaken by the printer and his highly sensitive implement, the bamboo pressing pad called *baren*. The printer prepared the hand-made paper by soaking it thoroughly for several days. Next he mixed the pigment with an appropriate paste, and applied it to the surface of the wood-block in an exact quantity and consistency. Then he placed the paper upon the block, and with the carefully measured pressure of the discus-shaped pressing pad *(baren)* the paper was impregnated with the pigment from the wood-block. This technique cannot be called intricate, but it was not simple either; to produce a first-class *baren*, for instance, years of training were necessary. The infinite possibilities of regulating the pressure and the direction of the *baren* by the printer make us realize that the resulting imprint is bound to reveal a creative control of a higher degree than a print obtained from a western printing press.

Until the 1740s, a monochrome print from a single block *(sumizuri-e)* was very common, and only occasionally was it decorated by hand colouring. As the colours available in the 17th century were dominated by mineral pigments of vermilion *(tan)* and green *(roku)* — (cinnabar and copper oxide), the coloured pictures were known as *tan-e*, and the books as *tan-roku-bon*. At the beginning of the 18th century, lighter tones of vegetable pigments

were favoured, with crimson *(beni)* as the central colour *(beni-e)*. In the 1720s the colour scheme was enriched with black lacquer and mica or brass dust, and these prints were known as 'lacquer prints' *(urushi-e)*, as they imitated lacquer-ware technique. One imprint lasted from three to five minutes, so the daily output was approximately two hundred copies, and the whole edition of the average one thousand prints was completed within five days (any further prints from the same blocks were of poor quality). The colouring was usually done by women whose work was cheap; even so, such manual work was far less efficient than printing itself. For this reason, the eventual introduction of the polychromatic print around 1744 was more of a result of rational and technical development than an artistic accomplishment. For about twenty years the colour range was restricted from two to five blocks, with crimson *(beni)* as the dominant colour *(benizuri-e)*. The polychromatic print — in the genuine sense of the term — did not appear until 1765, and then it was given the flattering name of 'brocade picture' *(nishiki-e)*.

Mechanization, however, bore its aesthetic fruit. The main stress on the graphic qualities shifted from the dialogue between the black lines and spots, and the white background to the composition and interrelation of colours, and also to the possibility of mixing the colours by printing several layers from separate blocks. Accurate printing was achieved with a single device which was the location mark *kentō* carved at two corners of each block. With the use of imprints from the key-block on transparent paper, a separate block was cut for each colour, and also for blind embossing, and for the intricate reproduction of the hair-style — one for the dark grey background, and one for the raven black hair-locks. Mosquito nets and translucent materials were also printed from two blocks — one for the horizontal, the other for the vertical lines. The glistening lacquer effect was obtained by the polishing of some colour areas *(tsuyazuri)*, while the shining metallic effect was achieved by sprinkling metallic dust or mica on the surface *(kinginzuri, kirazuri)*.

These more intricate processes naturally made greater demands on the printer. The printers of *nishiki-e* were more highly thought of than the printers of black and white prints, and their names sometimes appeared next to the names of the painter and the publisher. The multi-coloured prints provided a new dimension for the painters' artistic versatility, and some of them explored it to the utmost degree. But their vision was still bound by the technical scope of the engraver and the printer, as well as by economic restrictions imposed either by the publisher or by the authorities of the Tokugawa regime, which did not allow printing of expensive prints.

The other restriction, regarding the size of paper, was in a way a pleasant one. It is easy to imagine that to compose a picture on a regular size of paper must have the same benefits as playing football on one's home ground. Imposing a limit of several standard sizes had obvious advantages for both the engraver and the printer; also for the publisher and the distributor, in storage and transport; and finally, for the customer and the collector, who often pasted the prints in home-made albums. In the case of modern prints, the standard norm is dictated by machine production. In the case of old *ukiyo-e*, there was no such restriction, and the norm was probably set by the wood-block maker. On the other hand, we may assume that the standard size is incidental to the inner logic of graphic art, and belongs among its basic characteristic features.

Reproduction and distribution

Another characteristic feature of graphic art lies in its unrestricted possibilities of reproduction — its multiple offspring of identical quality and appearance. This requires a different type of distribution, i.e. the relation between the artist and the consumer — than for instance, the distribution of unique works of art, such as sculpture or painting. In the case of Japanese wood-block prints, which are produced jointly by the artist, the engraver and the printer, an agent acting as co-ordinator seems to be quite indispensable. The complicated process of distribution multiplies the duties of such a co-ordinator to such a degree that he can be classed as a manager. In Japan, quite logically, the publisher took on this task. It is therefore useless to regret the commercialization of Japanese graphic art, because without such commercialization we would have been left only with fragments of the whole production, preserved through the initiative of private societies, clubs, or wealthy patrons.

In Western studies, the publishers of *ukiyo-e* are often ascribed a negative role, for it is stated that besides the high-quality prints, they also supply the lower end of the market with cheap, second-rate publications. Such reasoning is rather illogical, for the only alternative would be to disregard the cultural needs and the economic means of the poor. After all, it is always illogical to apply our ethical norms upon a society where such norms did not exist. A more fundamental objection is that to the publisher, his own profit was, as a rule, the primary goal, and that he neglected the interests of art and artists, as the writer Shikitei Samba had pointed out already in 1804. As a matter of fact, during the Tokugawa period, there was no real objection to such an attitude, and the artists themselves seldom demanded any change of affairs — with the exception, perhaps, of such business-oriented painters as Toyokuni and Kunisada. They held it was beneath their dignity to squabble about fees, and to soil their hands and minds with money. This is another example of the ethical attitude; one must admit that the artists of today would be far less tolerant. Yet the sharpest words that the avaricious publishers ever heard were probably those pronounced by the painter Keisai Eisen in his 'Jottings by a Nameless Old Man': 'They cannot tell good from bad, buns from horse-dung, or bean-paste from dog's excrement . . . They are like stupid

Taigadō: 'Landscape with a Village'

The tenth and the eleventh sheets from the second volume of the 'Picture Album of Landscapes by I Chai and Ike no Taiga' (I Fukyū Ike Taiga Sansui Gafu). Fourteen sheets, 27×18 cm, Kyoto, 1804.

IKE NO TAIGA (1723—1775), a fan-merchant from Kyoto, was a leading artist of the *Nan-ga* ink-painting style. This was a Japanese version of the Chinese 'literati painting' (wen-jen hua), the primary principle of which is the stern discipline of the brush-stroke. Transposition of this type of painting to graphic art — or to any other system of reproduction — is extremely difficult, yet not impossible. Prints like this example gave Japanese graphic art a valuable lesson: the artist's intention must be evident in every mark on the paper. Each one must, without fail, express all of his personality. Nothing must be easy, void, or deaf.

horses . . . Bad luck to them. But we have to co-operate with them, as we are bound by the chain of their silver and gold.' Eventually, Eisen leaves the battlefield with a sigh: 'Ah, the world is going to the dogs. How can we, the lovers of art, get along with such snakes?' And it is not improbable that other artists also quit their profession for the same reason.

But it is equally probable that they realized later they paid a high price for their departure, for their painting must have lost the quality which is now so discussed in all books on *ukiyo-e*, and which was intermediated by the condemned publisher. It was the quality of an intense and lively rapport with the contemporary life in Edo. Such a vital reciprocity between art and its public has hardly any analogy elsewhere in the world. The institution of great publishers *(jihon tonya)*, which was obviously connected with parallel institutions of theatre owners, brothel patrons, textile merchants, etc., and also with the shōgunate administrators, served as necessary links in the chain between the artists and their public, between art and the society of the Tokugawa period. It is therefore the publisher who should be given more merit for enabling us to read the cultural and social history of Edo from the *ukiyo-e* 'pictoral chronicle' today. There is some truth in the saying that the more independent the artist is, the more his work lacks the value of a meaningful relation to his social environment. And it is probably also true that the tighter the bond between the artist and his social environment, the more he is forced to neglect his personal taste and talent, and to cater to the usually less sensitive and cultivated taste of the public.

It is only fair to admit that not all publishers forced their artists to neglect their taste — on the contrary, some of them elevated painters into the realm of a more sophisticated art. Such credit shoud be given, for instance, to Nishimuraya Yohachi and Tsutaya Jūsaburō, two remarkable personalities who strongly influenced the character of graphic art in the second half of the 18th century. It is always debatable whether the most valuable prints of this period were painted by Harunobu or Koryūsai, Kiyonaga or Masanobu, Eishi or Utamaro, Shunshō,

Shunman or Sharaku, but it is indisputable that virtually all the superior prints of this time were published by one of these two publishers. Nishimuraya and Tsutaya eventually did more to stimulate the artistic blossoming of the period than any two of the most significant artists.

It is, of course, a known fact that artists occasionally partook in publishing activities. Such was the case of the painter Okumura Masanobu, the owner of one of the most influential Edo publishing houses in the first half of the 18th century, named Okumuraya. Hirosada, the famous Osaka painter of the middle of the 19th century, may be identified with the owner of the prosperous publishing house, Ten-ki. The responsibility of the publisher for each separate print is unequivocally shown by his seal or trade mark attached to the signature of the painter. This was not just a legal or political responsibility, but also an aesthetic one — or, to put it more widely, the responsibility of the publishing guild for the fate of graphic production. Statistics prove that the number of publishers rose and fell in accordance with the number of productive artists. But this does not prove whether the publishing enterprise depended on graphic artists, or vice versa. The publishers, of course, could hardly manage without the graphic art and its painters. But could the innumerable graphic artist dispense with the publishers? When we take into account how complex, and extensive the activity of Japanese graphic art really was between the 17th and the 20th century, and that it has no counterpart in the world's history of art, we cannot doubt that it must have been occasioned by excellent organization. As we know from the history of the Japanese economy, the country had an excellent organisational tool in the form of efficient guilds and corporations of artisans and merchants. Their operative system was inherited even by the guild of publishers *(jihon tenya)* — and perhaps this is why the 'miracle of graphic production' happened in Japan and nowhere else.

Pictorial cycles

Pictorial cycles, as some graphic artists say, are a possibility in painting, but an absolute necessity in good graphic art. Some of them point to the close relationship between graphic art and illustration, but this reference is rather inexact, for in illustrations of the narrative, relevance to the text and progression are of primary importance, while the cycle is based upon the variations within the framework of a definite thematic whole.

The consistency of the cyclical principle in Japanese graphic art justifies our assumption that the cycles or series represent the thematic axis of graphic art. The early votive pictures were drawn as cycles or as series, and we can easily imagine that invocations of Kwannon, for instance, and other gods were apposite for serial treatment. After the introduction of secular themes in the 17th century, graphic art was again faced with the problem of illustrating the narrative series — as the structure of classical novels and poetic tales was, more or less, episodic. In the 18th and 19th centuries, the same themes were easily republished in abbreviated series of broadsheets, and the sets of fixed subject-matters taken from tales like *Taketori Monogatari, Ise Monogatari, Genji Monogatari, Heike Monogatari,* or poetic anthologies like *Hyakunin Isshū,* reappeared in continuing new editions. The series form was applied to subject-matters of contemporary books as well, whether illustrating the editions of moral instructions for women, or the Yoshiwara guides, or topographical descriptions of the beauty-spots of Japan.

The most popular themes of *ukiyo-e, bijin-e* and *shibai-e,* only reinforced the general trend towards publishing prints in series. The exuberant richness of the two central worlds — the world of Edo beauties, and the world of *kabuki* theatre — provided such an amazing multitude of subjects for prints that they usually fill a substantial part of books dealing with Japanese graphic art, or with *ukiyo-e.* Each print is full of information about all the imaginable activities of the Edo underworld and this only serves to emphasize its aesthetic mission. Yet, when we are confronted with a larger collection of theatrical prints or pictures of beauties *bijin-e,* we find ourselves lost in the wealth of informative detail. We may try to systematize our knowledge by putting the prints in chronological order, stressing some correlations and omitting others, qualifying and disqualifying, but we can hardly ever achieve a satisfactory coherent reconstruction.

This is because these prints were painted and perceived in cycles: a cycle depicting scenes from a play which had just opened in one of the three major *kabuki* theatres; a cycle of portraits of courtesans presiding over the Yoshiwara night-life; or perhaps a cycle illustrating the deeds of renowned warriors from the 11th century; or a cycle of portraits of poets of the Heian period. If a cycle was successful, a new edition was bound to appear almost immediately; if it was not, a different cycle had to be hurriedly published, for the Edo inhabitants were accustomed to the printed series, and knew how to enjoy and appreciate them. Perhaps they could perceive them in the way their forefathers used to perceive litanies. They knew how to appreciate the way the repetitions and variations of the familiar motives were ever present and ever reappearing, lulling them into a soporific ecstasy, which was not dissimilar to that invoked by the Indian raga, or modern jazz improvization, or Warhol's picture of Marilyn Monroe. The cyclical structure seems to be opposed to the hierarchical, symphonical structure which befits the Western pattern of artistic compositions.

We are unable to evoke the experience of the former Japanese collectors who enjoyed the complete cycles for the simple reason that the series are seldom preserved — either they have been lost, or they have been dispersed in different collections, and have never been published as a whole. There are the few exceptions, like the

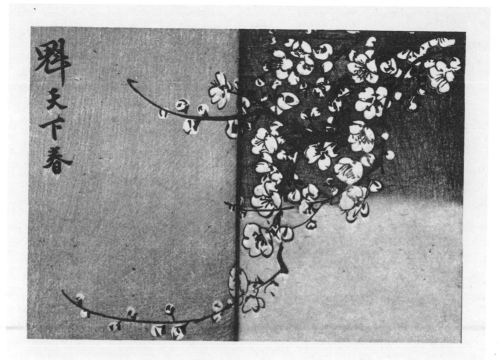

群天下春

Bunchō: 'Plum Trees in Blossom'

Sheet from the 'Picture-book by Shazanrō' (Shazanrō Ehon). Publishing house Hōshudō. Twenty sheets, 25×18 cm, 1811.

Tani BUNCHŌ (1764—1841) was the leading painter of the Edo section of the *Nan-ga* school. Though landscapes were, quite logically, his main themes, in this album he depicts smaller motifs from nature. The ink drawing has the finishing touches of ink-wash, or faint colours.

famous cycles of Hokusai's 'Thirty-six Views of Fujisan', Hiroshige's 'Fifty-three Stages of the Tōkaidō', and some cycles of Harunobu, Kiyonaga, Utamaro, etc., that are reprinted and reproduced in modern editions. The sharply observed works of Sharaku make us realize that a complete series of actor prints created during a spell of inspiration can become such an astounding work of art that its unique impact cannot bear comparison with the most beautiful single print, or even with a whole colection of masterpieces.

It is worth noting that the larger cycles in albums and picture books are sometimes arranged according to the passage of time. The order of the year's four seasons, twelve months, twelve hours of the day and the night, or the regular annual festivals and celebrations, are often used as a backbone on which a series of prints rests. In a similar way, the magic power of numbers is brought to life in series such as 'Six Crystal Rivers' *(Mu Tamagawa)*, 'Seven Aspects of Life of the Poetess Komachi' *(Nana Komachi)*, 'Eight views of the Eastern Capital' *(Tōto Hakkei)*, 'Six Poetic Genii' *(Rokkasen)*, 'Thirty-Six Poetic Genii' *(Sanjū Rokkasen)*, 'Poems by One Hundred Poets' *(Hyakunin Isshū)*, etc. The Western reader is often puzzled by the fact that there is no evident connection between the title of the series and the subjects of the picture, and may conclude that the strange and 'exotic' titles are but a meaningless addition in Japanese graphic art. And he may not be far from the truth. But he may, just as well, be mistaken, because he often fails to understand how this 'structure of structures' operates in the art of the Far East. When the old Chinese poet-painters worked with the motifs of the 'Four Seasons', or the 'Eight Views of the Hsiao and Hsiang Rivers', they did not take them only as suitable themes for poetry and painting, but also as principles of the Universal Law and its changes which had been revealed to them by the ancient sagas. When around the year 1500, the Regent Konoe, during his stay in the province of Ōmi, named the 'Eight Views of the Ōmi Province' *(Ōmi Hakkei)*, he did not want only to constitute a parallel to the cycle of Chinese landscape painting, but he also referred to the same Universal Law. When, in 1776, Harunobu painted his 'Eight Views of Interiors' *(Zashiki Hakkei)*, he referred back not only to Lord Konoe and to the theme of the eight Chinese scenes, but also to the hexagonal mandorla of the Universal Law. And so the meaning of his paintings is enriched by far-reaching connotations: the interpretation of a portrait of a quasi 'courtesan' of his time is interwoven with our eternal desire for beautiful women, and encircled by the Universal Law of the male and female principle.

If we are to assess the value of series and cycles of Japanese graphic art, we must realize that they have endowed this art with a special dimension magnifying its aesthetic impact, which reaches far beyond the possibilities of a single print. And we must also realize that the cyclical principle is inherent in the traditional culture of the Far East, and that Japanese graphic art, and *ukiyo-e* too, continue this tradition.

Brush and knife

33
 Graphic art, in practice, does not exist outside painting, and when we treat is as an individual or even unique

art, we are risking a serious distortion. But even when we cautiously avoid such a pejorative term as 'parasitic', the relationship between graphic art and painting can be aptly described in terms of 'the creeper' and 'the tree'.

In the orchard of Japanese art, various trees of painting were cultivated, each of them supporting its 'creeper' of graphic art with a distinctive branch. Buddhist painting had an ancient history, and its roots were spread all over eastern Asia. This type of painting was the least dependent on the brush technique, and so was highly suitable for wood-cut interpretation. During the long centuries of co-existence with Buddhist painting, wood-cut printing derived many technical and compositional devices from it. For instance, the only compositional parallel with the concept of a single human figure covering the whole area of paper, and seen from the frontal view, which first appeared in prints around the year 1700, is to be found in the paintings of Buddhist images. The principle of a sacred image, is not derived from line and colour, not even from the effective composition which is mentioned above, but rather from the final presentation, and the realization of the painting. There need not be much space for the figure depicted in the painting, but there must be enough space for the observer in front of the picture, so that he may initiate a sincere and undisturbed dialogue with the painting. Although in the case of Japanese graphics this effect, which is both awe-inspiring and intimate — had been diminished by the secular subject-matter, the restricted size of the paper, and the limited approach of the observer, we often feel that the typical impact of Buddhist painting has been brought to life.

The basic experience with outline and colour was derived from the classical Japanese painting style *yamato-e*, which was established in the narrative illustration of the *makimono* scrolls in the 12th century, and later adapted by the Tosa school of painting. The subject-matter repertoire of *yamato-e* was confined to the classical novels, histories and legends, and the execution was accomplished with a limited scale of stylistic and compositional norms. The line explains the form, defines its outlines; the colour which covers the area marked by the contour, elevates the form from the neutral background. This process can be easily emulated by graphic art. And actually many early prints show a striking stylistic affinity with the *yamato-e* painting. With the end of the 17th century, however, the compositional scheme and the stylization of the elementary forms begin to separate from the traditional *yamato-e*. There is also one important distinction between *yamato-e* and woodcut prints which is not evident at first sight. While in *yamato-e* the original outline of forms is redrawn after the colouring, and the details are painted upon the colour layer, in colour wood-cut prints the outlines of the key-block imprint stay intact during the whole process of colouring. The lines of the key-block, therefore, maintain almost as important a position as the lines of ink-painting.

In ink-painting (*suiboku-ga*, or *sumi-e*), which reached its peak in the 15th century through the works of Sesshū, the structural dominant is the brush-stroke. The gentle gradations of the ink shades, and the conscious regulation of the strength of the brush-stroke can only be emulated by graphic art with great difficulty. Yet the Japanese brush-stroke technique was based more on robust strength than on gentle control, and this fact may have inspired the seeming paradox of Hiratsuga's words: 'If the technique of wood-block printing had been more

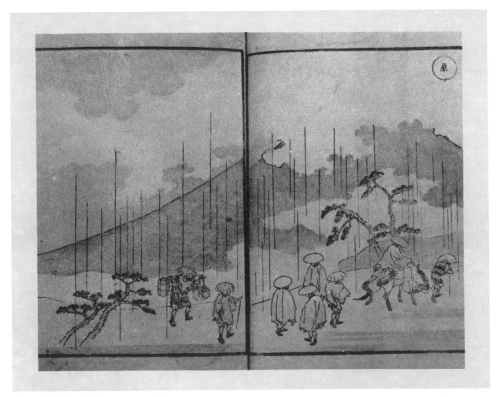

Hokusai: 'Rain at the Station of Hara'

The ninth and the tenth sheet from the first volume of 'The Book of Paintings from the Journey Along the Fifty-three Postal Stations by Hokusai' (Gojūsan Tsugi Hokusai Dōchū Gafu). Published by Eirakuya Tōshirō. Seventeen sheets (from the station Nihonbashi to Nissaka; complete in 34 sheets), 22.5×16 cm, c. 1830.

Though Hokusai is mentioned in the title, some scholars ascribe this album to his pupil Hokkei. The first edition dating from 1830 is kept in The National Library in Paris.

34

developed in the time of Sesshū, he would have deserted painting'. Japanese artists were trying their hand at a graphic interpretation of ink-painting from the 17th century, and a certain technical development was achieved as late as the first half of the 18th century, due perhaps to the hard work of Morikuni. However, if we apply less strict criteria than the orthodox admirers of Chinese brush-style, we cannot fail to see that the line in Japanese graphic art inclined to calligraphic modulation and accentuation from the very beginning. For this reason, the transference of ink-painting brush-stroke into graphic art in the middle of the 18th century was not, in fact, such a great problem.

When discussing the relation of graphics to individual branches of Japanese painting, we should remember that right from the 17th century, graphic art seldom had encountered a pure, orthodox presentation of any type. The official schools of Kanō and Tosa displayed a wide range of stylistic attitudes of mixed origin and composition. With this in mind, we may agree with the statement of the president of the modern Japanese Ukiyo-e Society, Narazaki Muneshige, who says that the first *ukiyo-e* pictures are to be identified with the genre paintings of these schools as early as the beginning of the 17th century. As *ukiyo-e* has represented the strongest branch of graphic art during the last three centuries, we may as well re-interpret the statement, and say that the synthesis of disparate elements of various schools of painting prepared the way for graphic art already at the beginning of the Tokugawa period.

Nevertheless, this synthesis of various elements of painting at such an early stage of development does not solve the question of the interrelation between graphic art and other schools of painting. On the contrary — the situation becomes confused at just this stage. This is because the intersection of the converging attitudes of the traditional schools of painting was, at the same time, the launching platform not only for genre painting and *ukiyo-e*, but also for the so-called 'decorative' Rimpa school. This school is represented by the names of Kōetsu, Sōtatsu, Kōrin, Kenzan, Hoitsu, etc. The Rimpa school brought to painting not only several highly decorative stylistic norms like painting of clouds and water, and technical innovations such as painting onto wet background, or in low relief, but even an emphasis on the design, by which we mean the arrangement of white and colour areas upon a given surface. Elementary forms and clearly outlined monochrome areas are arranged asymmetrically, but in accordance with the ideal of quiet sobriety *(shibumi)*; the same which also underlines the mutual relation of the 'carefully strewn stones in a Zen garden'. The Rimpa school exerted a great influence upon painting and the applied arts, and thus also upon the aesthetic awareness and taste of the Japanese. Though its leading exponents had no access to graphic art, they must have affected the graphic artists, if only by virtue of the fact that their method of composition was strictly graphical. The influence of the Rimpa school is relevant especially in the *surimono* prints, but it would be worth while considering how much Harunobu, Utamaro, or Sharaku owe to it.

The official school of Kanō was also undergoing a remarkable stylistic differentiation. The artists classed as the 'Popular Kanō' — Morikuni, Shunboku — or the 'Independent Kanō' — Itchō, Kōkan — are especially known to the collectors of Japanese graphic art. These men may have influenced graphic art more than is usually admitted — mainly through the humour of their sketches, and through their profoundly graphic presentation.

An even closer link between graphic art and ink-painting can be traced in the works of the painters who were trying to draw new inspiration from the old Chinese paintings, or from the synthesis of Japanese traditional sources and modern stimuli — the painters of the so-called 'Mixed Schools'. And, surprisingly enough, the works of the most orthodox school of ink-paintings, the Nan-ga school, which so strictly adhered to the rule of the brush-stroke, testify to the strong influence of wood-cut reproductions of Chinese paintings. The wood-cut albums of Kanyōsai, Sō Shiseki, Bunchō, Chinnen, etc. belong to the treasure-house of Japanese graphic art, along with works by the artists of the 'Mixed Schools' — Maruyama, Shijō, Kishi, etc.

Japanese painting of the 18th—20th century sought inspiration and instruction from its European counterpart, yet it was graphic art which often took the initiative in understanding the intrinsic features of European painting. On the other hand, graphic art was usually rather clumsy wherever the transposition of the subtle intrinsic qualities was concerned. When, for instance, it was faced with the task of finding an equivalent medium for the sublime poetic expression permeating *haiku* poetry, graphic art proved to be much more cumbersome than light brush sketches *(hai-ga)*. Also the encoded Zen disputations *(kōan)*, which were so well rendered by the concise brush-strokes of Zen painting *(zen-ga)*, had no appropriate counterpart in graphic art. Among the qualities alien to the expressive range of Japanese graphic art belongs the intense, ecstatic spirit emanating from the outstanding ink-paintings of artists like Gyokudō.

Some modern scholars chose to discuss Japanese graphic art in terms of the aesthetic ideals of the Tokugawa period. They found that *ukiyo-e* prints do not comply with the demanding and sophisticated — though simple — ideals of solitude *(sabi)*, weariness *(wabi)*, or simplicity *(karumi)*, but rather with popular ideals like wit *(share)*, cleverness *(sui)*, nonchalance *(iki)*, and smartness *(tsū)*. But such schemes are just schemes. Art will not comply with a scheme, nor will the world comply with a scheme. Yet, surprisingly enough, it will comply with the tip of a brush, or a knife. Munakata Shikō, alluding to Hokusai's words, confesses: 'I wanted to have the world on the tip of my brush . . . When I looked back into Japan, into my country, I saw that my herritage was the engraver's knife.'

Glossary of Japanese terms

Aiban — 'medium-size print' — paper size circa 33 × 22.5 cm

Aizuri-e — 'blue printed picture' — colour print with a predominance of various shades of blue

Aragoto — 'wild thing' — bombastic style of heroic *Kabuki* roles

Aratame — 'examined' — censor's seal used from 1842; from 1859 combined with a date

Baren — press-pad made of bamboo; used in printing instead of mechanical printing press

Beni-e — 'crimson picture' — hand-coloured pictures with crimson *beni* as the dominating colour

Benigirai-e — polychrome prints in greyish shades where the crimson *beni* is entirely omitted

Benizuri-e — 'pictures printed in *beni*'; mid 18th century prints using from 2 to 5 colour blocks

Bijin-e — 'picture of a beautiful person' — genre print portraying girls and courtesans, one of the two main themes in *ukiyo-e*

Bokashi — 'shading off' — gradation achieved by the dilution of a colour straight on the wood-block

Bunjin-ga — 'literate man picture' (Chinese: 'wen-jen hua') — painting by the literati-dilletanti; in Japan synonymous with ink-painting of the so-called 'Nan-ga' school

Chūban — 'medium-size print' — paper size of c. 26 × 18.5 cm

Edo — present-day Tokyo, the administrative capital of the Tokugawa, or Edo period

Daimyō — 'great name' — nobleman, feudal lord

E-zukushi — picture album

Ga — 'pinxit', painted by . . .

Haboku — 'broken ink', dynamic style of brush stroke, typical of the Japanese ink-painting from the 15th century

Hai-ga — concise style of ink-painting using only a few brush-strokes, equivalent to *haiku* poetry

Haiku — an unrhymed poem of three lines of 5-7-5 syllables, respectively, which reached its peak at the end of the 17th century with the poet Matsuo Bashō

Hanga — 'printed picture' — term for the wood-block print of modern graphic art

Hashita-e — design, or the key-block copy on thin paper used for engraving

Hashira-e — 'pillar picture', also *naga-e, naga-ban, hashira-kake* — paper size of c. 67.5 × 12 cm

Heian — historical period named after Heian-kyō, the old capital, the present-day Kyoto (794—1185)

Hitsu — 'brush', also *fude* — 'fecit', 'delineavit', painted by . . .

Hokku — another term for *haiku*

Hori — 'sculpsit' — engraved by . . .

Hosoban — 'narrow print' — paper size of c. 30 × 15.5 cm

Ichimai-e — 'single-sheet picture' — broad sheet

Jihon ton'ya — (resp. *toiya*) — big publishers

Jōruri — melodic recitation of the narrative of a puppet play, or *Kabuki*; sometimes used as a synonym for *bunraku*, the puppet theatre

Jū-hachi ban — 'eighteen numbers' — basic repertoire of the Ichikawa family of *Kabuki* actors, consisting of 18 famous plays

Kabuki — immensely popular theatrical form which became fully developed by the end of the 17th century; all parts are played by actors of the male sex

Kaburo — (resp. *kamuro*), girl attendant to a courtesan of a higher rank

Kacho-e — 'flower and bird picture' — prints with the themes of flowers, birds and animals

Kakemono-e — vertical picture-scroll

Kakihan — cryptogram, sometimes used instead of signature or seal

Kanō — famous family of painters who, from the late 15th century on, worked primarily for the aristocratic circles at the Imperial court

Kappazuri-e — a print coloured with stencils

Karazuri — blind embossing

Keisei — courtesan

Kentō — simple location mark used to secure accurate register of the blocks when printing with different colour blocks

Kishi — school of ink-painting, founded by Gan Ku (1749—1793)

Kirazuri — printing with the use of mica

Kiwam — 'approved' — censor's seal in use from c. 1790 to 1842

Kizuri — 'printing with yellow colour' in the background

Kōan — sayings, often paradoxical or absurd, serving as themes for Zen meditation

Koban — 'small-size print' — paper format of c. 18.5 × 13 cm

Kyōgen — 'crazy words' — farce, traditional theatrical form parallel with *Nō*

Kyōka — 'crazy poem' — humorous or unconventional poem of 31 syllables of a form identical to *tanka*

Makimono-e — horizontal picture-scroll

Maruyama — Kyoto school of painting founded by Maruyama Ōkyō (1733—1795)

Meiji — historical period starting with the restoration of the Emperor's power (1868—1912)

Miyage-e	'souvenir pictures' — early prints with landscapes or townscapes
Mon	crest of a family or an individual, often worn on clothing
Monogatari	long lyrical narration — the novel or novella of Japanese literature
Musha-e	'warrior pictures' — prints where the subject are military heroes and great battles
Nan-ga	'southern painting' — (Chinese: 'Nan-hua'), school of ink-painting derived from the style of four great Chinese landscape painters of the 14th century
Nishiki-e	'brocade pictures' — full-colour wood-block prints produced after 1765
Nō — (Noh)	classic lyrical drama of Japan with the components of dramatic recital, instrumental and choir music and masked dancing, which evolved in the 14th century from religious plays
Ōban	'large print' — paper size of c. 37.5×26.5 cm
Obi	sash of the traditional Japanese costume
Oiran	courtesan of the highest rank
Raga	traditional melodic formula of Hindu music which sets the basic 'mood' for the improvization of the musician
Rangaku	'Dutch learning' — the term of Tokugawa Japan for European studies
Rimpa	conventional expression of the decorative style in painting as represented by Sōtatsu (beginning of the 17th century) and Kōrin (1663 to 1743)
Rōnin	'wandering man' — a samurai who had lost his master
Ryakuga	'condensed picture', sketch
Shibai-e	'stage pictures' — genre prints depicting actors and scenes from the *Kabuki* performances, one of the two main themes of *ukiyo-e*
Shijō	Kyoto school of painting founded by Matsumura Goshun (1752—1811)
Shiki-e	'pictures of the four seasons' — traditional thematic circle inspired by the symbolic rotation of the four seasons of the year
Shōgun	military dictator, the actual ruler of Japan from the end of the 12th century to the year 1868, when the Imperial power was restored
Shōsagoto	dance-play, a type of *Kabuki* play based upon mime dancing
Shunga	'spring picture' — print with erotic theme
Suiboku-ga	'watery ink picture' — ink painting, also *sumi-e*
Sumi-e	'ink picture' — ink painting, also *suiboku-ga*
Sumizuri-e	'ink-printed picture' — black and white print
Sumō	type of wrestling contest depending mainly on physical weight and strength of the athletes
Surimono	'printed thing' — privately published elaborate woodblock prints used for conveying acknowledgement, congratulations, seasonal greetings, etc.; the picture is often adjoined by an occasional poem *(kyōka, haiku)*, and thus serves as 'libri amicorum'
Tan-e	early hand-coloured prints with the predominance of vermilion *tan*
Tanka	'short poem' — also *waka, uta*, the classic form of Japanese poetry; an unrhymed poem of five lines of 5-7-5-7-7 syllables, respectively
Tanzaku	size of paper, c. 37.5×7 cm
Tate-e	'upright picture' — vertical composition on a usual paper-size
Toba-e	caricature, often with animal figures mimicking men
Tokugawa	historical period named after the family of Tokugawa who held the hereditary title of the military dictator (shōgun) from 1614 to 1868, and ruled over Japan from their residential town of Edo
Tosa	dynasty of court painters who, from the 15th century, worked mainly with literary and historical themes using the technique of *yamato-e*
Tsukinami-e	'pictures of the cycle of the twelve months' — traditional thematic circle inspired by the symbolic rotation of the twelve months
Uki-e	perspective prints introduced around the year 1740 under the influence of European copperplates
Ukiyo-e	'pictures of the passing (floating) world' — production of popular schools of the 17th to 19th centuries centred upon the subjects of genre figurative compositions and the technique of wood-cut printing
Ukiyo-e news	prints of the Meiji period depicting and describing current events; also called *nishiki-e shinbun* (brocade-picture newspapers)
Urushi-e	'lacquer pictures' — hand-coloured prints where the colour scheme is enriched by the application of lacquer (ink and glue) and metallic dust layers
Yakusha-e	'actor prints'
Yamato-e	'pictures from the region of Yamato' — which was the historical cradle of Japan; illustrational style stressing the contours of thickly coloured drawing and using specific stylistic elements
Yoko-e	'sideways picture' — horizontal composition on a usual paper format
Yomi-hon	'book for reading' — type of popular literature from the 17th century
Zen-ga	painting of the adherents of the meditative Buddhist sect Zen marked especially by the free and concise use of brush

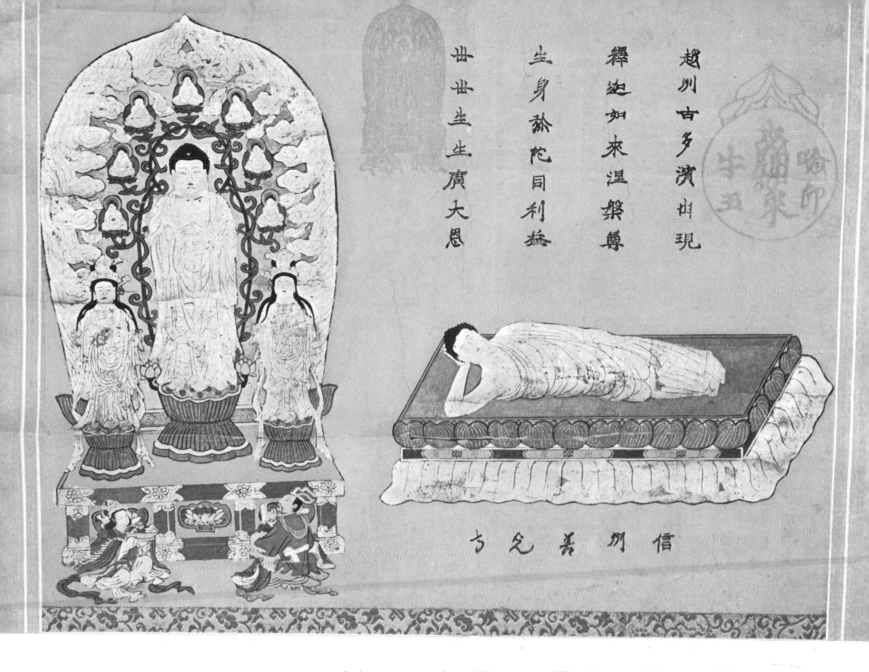

越川古多濱出現

釋迦如來温槃尊

生身於彌陀同利益

世世生生廣大恩

信州善光寺

1. Anonymous authors, 16th century: 'The Sākyamuni Trinity and The Death of Buddha'

Hand-coloured and gilded print from several wood-blocks on paper; from the Zenkōji temple workshop; 36.5×46 cm.

The combination of at least six wooden blocks make this picture. The first was used to print the left-hand part of the picture presenting the Sākyamuni trinity (*Shaka* in Japanese); the seven previous Buddhas (i.e. the theme of the 'Seven steps of Buddha') in the mandorla surrounding the trinity, and a royal pair in the foreground. A black-and-white copy from the same wood-block printed as a single votive picture was released for the 1902 sale of the famous Hayashi collection. It is fairly possible that the wood-block used for the right-hand part of the dying Buddha (i.e. the motif of 'parinirvāna', in Japanese *nehon*) was also used separately as a votive picture. A third wood-block had been cut for the four-line inscription taken from a Buddhist script. Another block served to print the name of Zenkōji temple (founded in 642) in the province of Shinshū (today's Shinano), which is situated towards the lower part of the picture. The two large red seals on the upper part were printed from two other blocks. The left one is an exact miniature of the large Sākyamuni trinity placed in the lower left-hand part of the picture; it was possibly the central icon of the temple. The background of the two main pictures is coloured in gold and nontransparent organic pigments. In accordance with the tradition of Asiatic religious painting technique, the basic lines are redrawn upon the colour layers to give the picture a finishing touch.

The overall stylization of both the icons is derived from the Heian period prototypes. The details are executed in the style of the Muromachi period, yet it is rather difficult to determine wheter this print dates from the 16th century, or from a much later time.

2.—3. Anonymous author; c. 1665: 'On the Stage of a Nō Theatre'

The 2nd and the 11th page from the fourth volume of 'The Illustrations for the Nō Plays' (Nō no Zushiki). Tan-ryoku bon, 21×15 cm

The two full-page illustrations depict scenes from the plays of Naniwa and Hagoromo. The upper parts of the pages with the text are devoted to the designs of costumes *(ishō no zu)* for the individual characters of the respective play. The carefully illustrated, printed, and coloured books of the lyric drama *Nō* and the popular farce *Kyōgen*, published around the middle of the 17th century, are quite correctly considered the predecessors of the theatrical prints which were to dominate the field of Japanese woodcuts fifty years later.

4. Moronobu: 'Horse Races', (Fukakusa matsuri)

Hand-coloured sheet from an album, tan-e, 23×23 cm, c. 1675.

The horse races which were held annually on the 5th day of the 6th month of the lunar calendar in the Fukakusa district of Kyoto by the river Kamo, were known as *Fukaki sa Matsuri*. They were a popular theme of genre painting at the beginning of the 17th century. In the second half of the century, the theme was taken over by graphic artists from the Moronobu circle. The text speaks about the possible origin of the 'Fukakusa Festival' and remembers the unsuccessful Mongolian invasions of 1274 and 1281.

5. The Torii school: 'Tsugawa Kamon, the actor, in the role of Shizuka Gozen, the concubine of Minamoto Yoshitsune'

Signed — 'Torii fude', publishing house Komatsuya. The inscription 'Departure from the Capital' (Miyako Kudari) following the actor's name indicates a guest performance of a Kyoto actor in Edo. Urushi-e, hosoban, c. 1725—27.

The problem concerning Kiyonobu and Kiyomasu, the two names of the Torii family which appear on prints painted in this studio between 1790s and 1850s, has still not been resolved. It is uncertain whether two, three, or four artists were using these names, and what their relationships to each other were. To see just the family name 'Torii' was a rarity. It may have been used around the year 1727 when the leadership of the studio passed from the first to the second generation master-painter, and when the signature of Kiyonobu often appeared with the seal of Kiyomasu. Also the style of the print agrees with the date. Unfortunately the exact date of Kamon's arrival in Edo is not known.

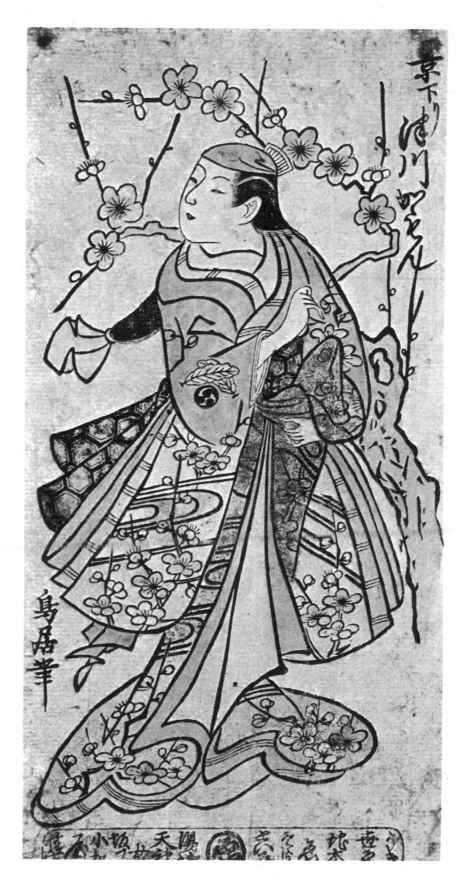

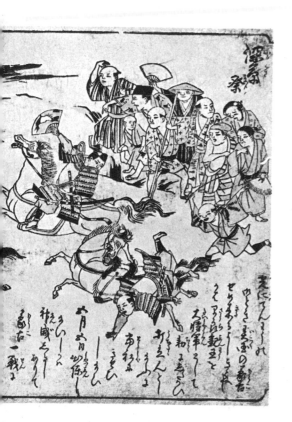

6. a—b) Sukenobu: 'A Court Lady and a Courtesan'

Frontispice of the 1st and 2nd volume of 'The Studies of One Hundred Women' (Hyakunin Jorō Shinasadame). Tan-e, 28.5×19.5 cm, 1723.

Nishikawa SUKENOBU (1671—1751) studied painting under Kanō Einō and Tosa Mitsutsuke, who taught him self-confidence in drawing and exquisite sense of proportion. Though courtesans and other subjects from *ukiyo-e* provided themes for his picture albums and books, he classed himself as *Yamato-eshi* ('Master of the Yamato-e style'), and his pictures are frequently reminiscent of the compositions and shapes of the classical *yamato-e*.

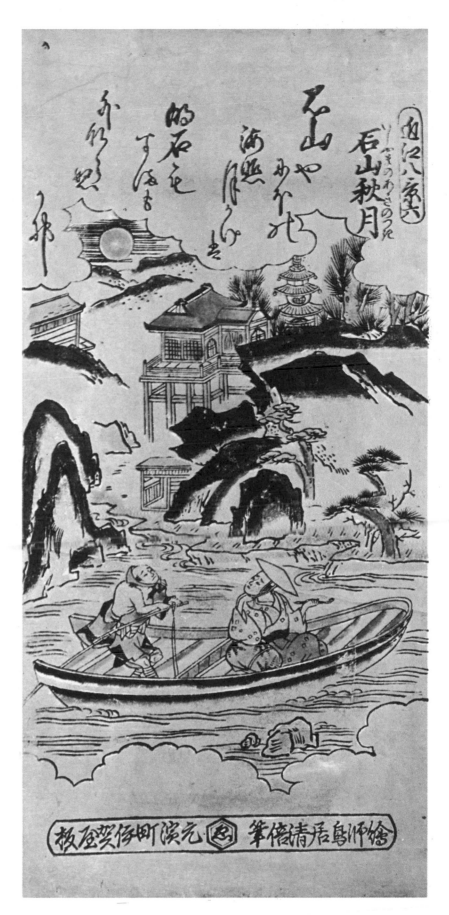

7. Kiyomasu: 'The Autumn Moon Above Ishi Mountain',
(Ishiyama no aki no tsuki)

Sheet from the series 'Eight Views of the Ōmi Province' (Ōmi Hakkei). Signed — 'Eshi Torii Kiyomasu hitsu'. Publishing house Igaya (Motohama-chō). Beni-e, hosoban, c. 1725.

Several landscape series were published in the 1720s, mostly by Kiyonobu, Kiyomasu, and Shigenaga. The composition of the landscapes, which had been inherited from *yamato-e*, recalled the ancient Chinese landscape-painting of the 8th and 9th centuries; yet it was inhabited by contemporary people. This specimen belongs to the 'Eight Views' variety (see the chapter on 'The Cycles'), which is closely related to the theme of the cyclical changes of the year and day within the topography of a certain area. In this case, the poem is even more eloquent than the picture itself:

Ishiyama ya	'Over Ishiyama mountain
Nio no umi teru	The moon is shining
Tsukikage to	On lake Biwa
Akashi mo Suma mo	Isn't it as beautiful a view
Hoka naranu kana	As of Akashi and Suma?'

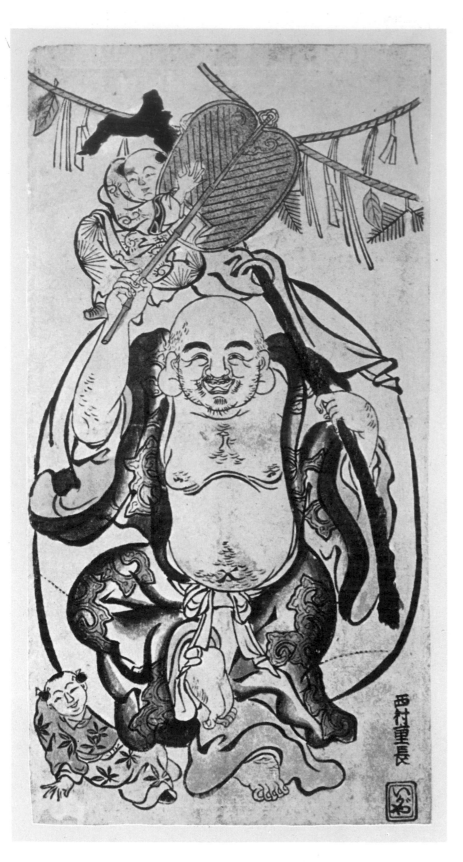

8. Shigenaga : 'Hotei, the God of Luck'

Signed — 'Nishimura Shigenaga'; Publisher's seal Igaya. Hosoban, urushi-e, c. 1725.

One of the Seven Gods of Good Luck *(Shichi Fukujin)*, the ever-smiling Hotei, is carrying a huge bag full of auspicious objects over his shoulder, to the great delight of the two frolicking boys. The subject matter and the stylization is derived from the figurative painting of the Kanō school. Nishimura SHIGENAGA (1695—1756, date unconfirmed) was a property owner, and later a book-dealer, but it was obvious he had not received any training in classical painting. His compositions were derived from some famous albums, or from Masanobu.

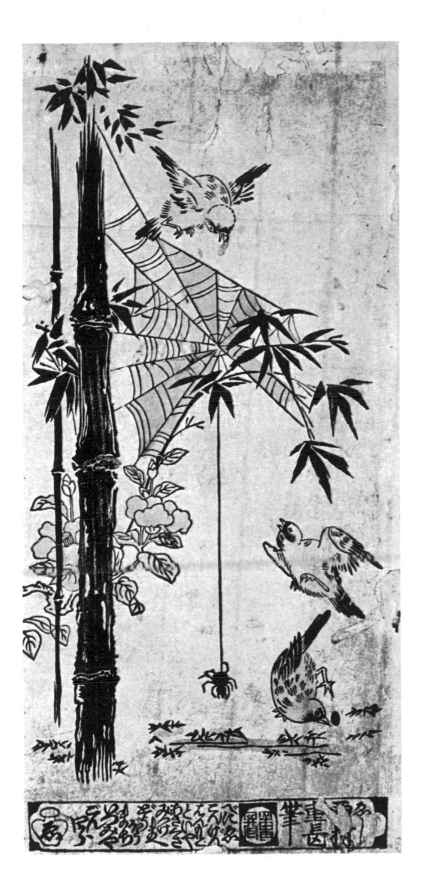

9.—10. Shigenaga: 'A Cobweb and Sparrows by the River'

9. Signed — 'Eshi Nishimura Shigenaga' (Shigenaga's seal); publisher Izumiya Gonshirō (the publisher of beni-e from Asakusa), hosoban, beni-e, 1725—27.

10. Signed — 'Yamato-e Nishimura Shigenaga hitsu'; publisher Urokogataya. Hosoban, beni-e, 1727—30.

Within several years following 1720, the protagonists of the Nishimura and Okumura schools moulded the knowledge gained from wood-cut reproductions of the traditional Chinese and Japanese paintings into a new stylistic convention. This formed the basis of the thematic line, *kachō-e*, i.e. the pictures of flowers and birds.

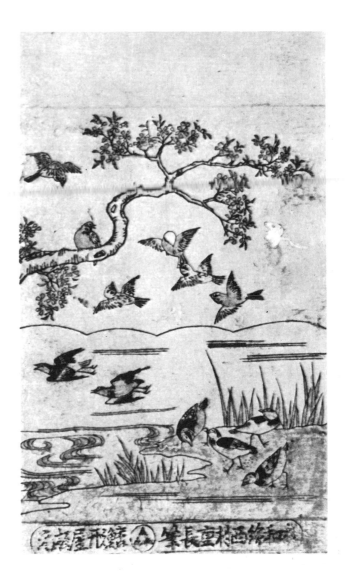

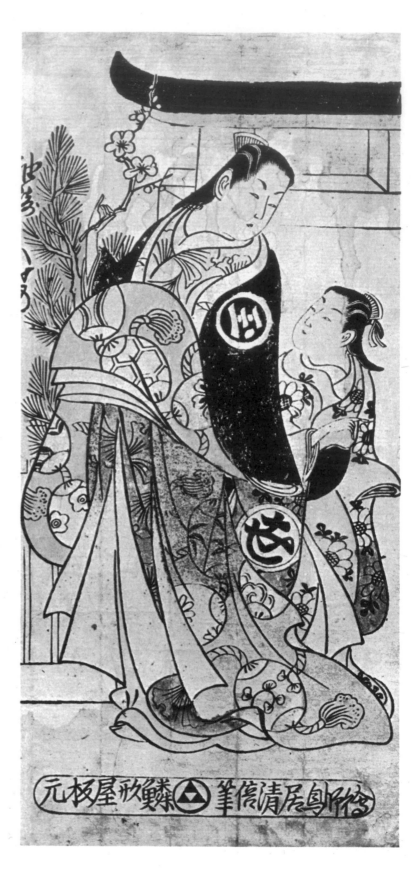

11. Kiyomasu: 'Sodezaki Iseno in the Role of Lady Sakura'

Signed — 'Eshi Torii Kiyomasu hitsu', publisher Urokogataya. Hosoban, urushi-e, c. 1727.

Sodezaki Iseno (died 1735) took the part of Lady Sakura in the play 'Wedding by the Waterfalls of Otowa' *(Konrei Otowa no Taki)*, which was performed in the theatre Nakamura-za in 1727. Uemura Kichisaburō, who is pictured here, played the role of her lady companion.

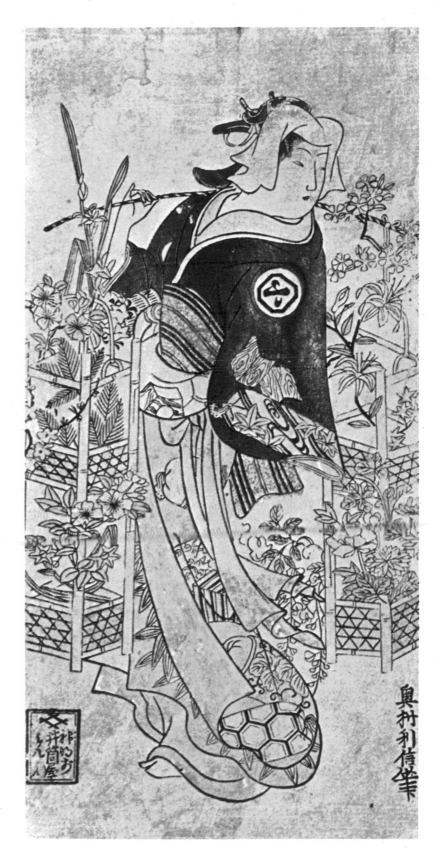

12. Toshinobu: 'Arashi Wakanō, the Actor, in the Role of a Florist' (Hanauri)

Signed — 'Okumura Toshinobu hitsu'. Publishing house Izutsuya (address Shiba, Shinmei-mae, Edo). Hosoban, urushi-e, c. 1725.

Okumura TOSHINOBU (dates unknown), might have been a brother of Okumura Masanobu. The pictures of actors and beauties which he painted in the Okumura studio in the 1720s and 1730s bear the stamp of highly concentrated, unhurried production, which is visible in the careful execution of detail.

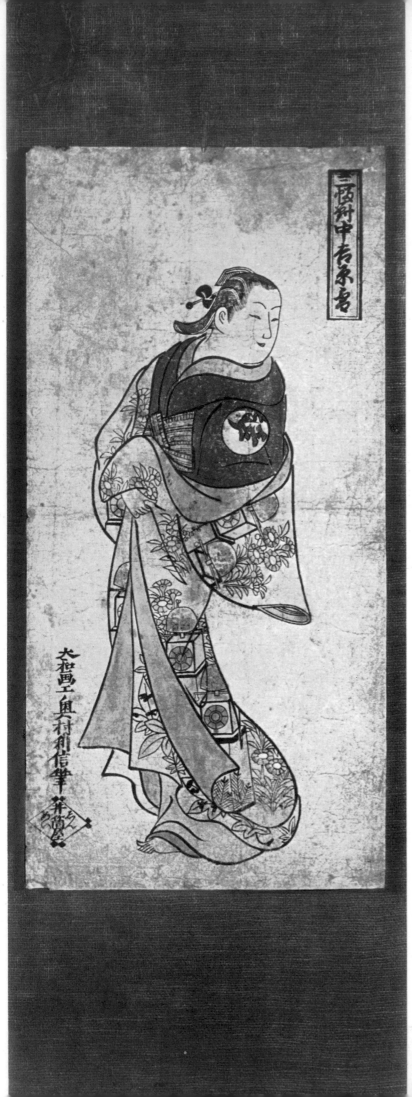

13. Toshinobu: 'The Principal Courtesan in Edo'

'The middle sheet of a Triptych, Yoshiwara, Snow' (Sanbu-kutsui, Chū, Yoshiwara, Yuki). The character for Edo in the mon on the kimono. Signed — 'Yamato Gakō Okumura Toshinobu hitsu', publisher Izutsuya. Hosoban, urushi-e, 1725—30.

The portraits of the principal courtesans of Kyoto and Osaka formed a part of the triptych. Masanobu also used the same subject matter.

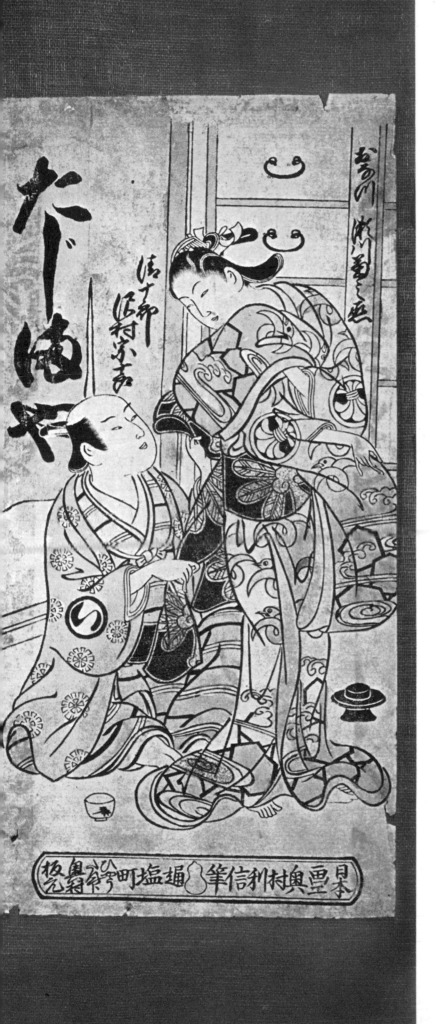

14. Toshinobu: 'The Lovers Onatsu and Seijurō'

The roles are played by Segawa Kikunojō I. (1691—1748) and Sawamura Sōjurō (died 1756). Signed — 'Nihon Gakō Okumura Toshinobu hitsu', publisher Okumuraya (address Tōri Shijo-chō). Hosoban, urushi-e, c. 1735.

According to the story by the famous 17th century novelist Saikaku, Seijurō was an Osaka merchant and a known admirer of the local courtesans from the pleasure quarter Shinmachi. Onatsu, a beautiful but spoiled daughter of his client, fell in love with him and they ran away together and stole away aboard a ship. By coincidence, a police patrol found her father's stolen treasure chest on the same ship. Seijurō was charged with theft and enticement, and was executed. Onatsu went mad with grief. This popular, dramatic story was soon adapted for various *Kabuki* plays. Kikunojō, who was a famous dancer and interpreter of female parts, played the role of Onatsu in a dance-drama version of the story (*shōsagoto*).

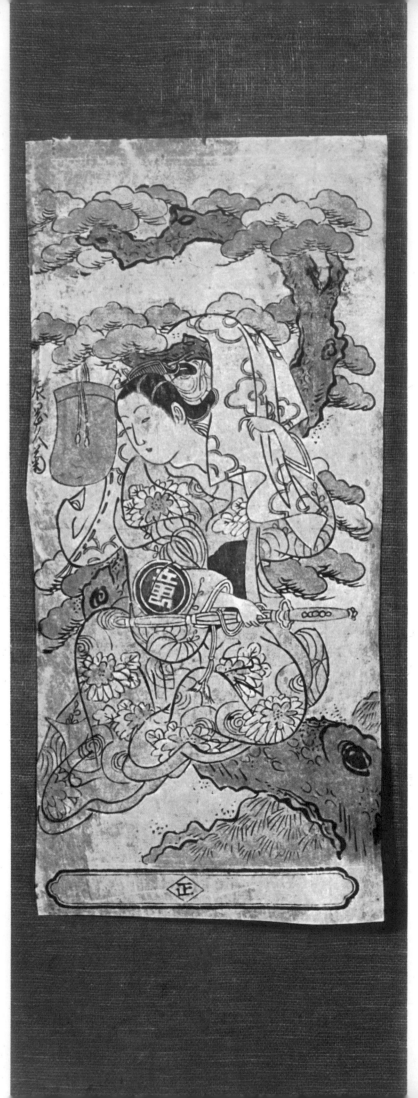

15. Masanobu (?): 'Tatsuoka Hisagiku in the Role of Matsukaze'

The sign 'Masa' in the oblong vignette is identical with the first letter of Masanobu's name, and indicates that he is either the author, or that this comes from his workshop, or from his publishing house Okumuraya. Hosoban, urushi-e, c. 1739.

The spirit of a fisher-maiden, Matsukaze, tells a wandering priest on the shores of Suma how the poet Ariwara Yukihira (9th century), when exiled to those very shores, was cheered and amused by the two lovely sisters, Matsukaze and Murasame. When recalled back to the capital, he left behind him — hanging on the branch of a pine tree — his cloak, his hat, and a promise to return. But he never did, and the spirits of the fisher-maidens remained for ever to haunt the place of their passionate love affair. The plot of this well-known *Nō* play was later adapted for the *Kabuki* theatre, and the dance drama *(shōsagoto)* version of the story, as mimed and danced by Matsukaze, became the highlight of every performance. The actor Hisagiku performed this dance before the Edo public on his arrival from Kyoto in 1739.

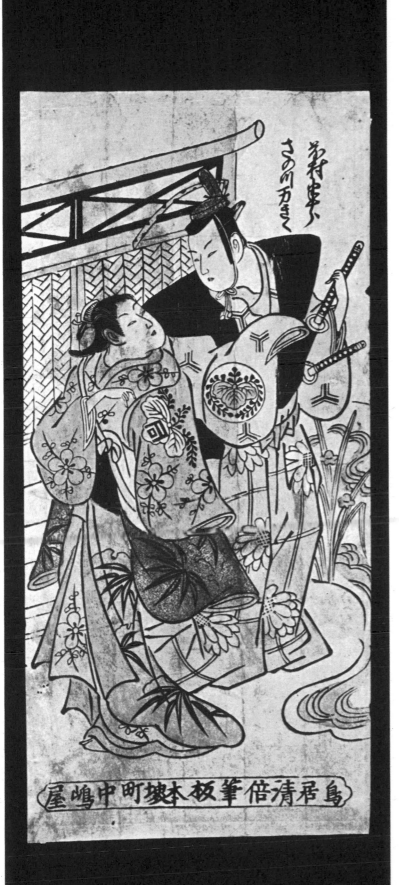

16. Kiyomasu: 'The Actors Sanogawa Mangiku and Fujimura Hanjurō'

Signed — 'Torii Kiyomasu hitsu', publisher Nakajimaya (of Motohamachō). Hosoban, urushi-e, c. 1741.

Sanogawa Mangiku (1690—1747), a popular actor of Osaka and Kyoto *Kabuki* scenes, played in Edo three times — in 1718, 1729 and 1741. This picture was probably based on a scene during his last performance in Edo.

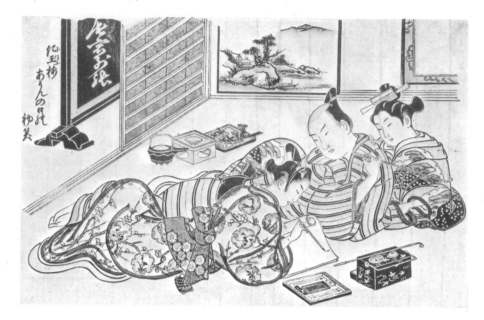

17. Masanobu: 'Fragrance'

Sheet from the album 'The Mountain of Passion — Designs for the Sleeping-room' (Some Iro no Yama, Neya no Hinagata). Ōban, beni-e, 1739.

The words of the New Year poem the reclining girl is composing appear in the background of the picture:

Niou ume	*'The fragrant plum blossom*
Aran no kuchi no	*With what strange lips*
Hatsu warai	*To smile at the New Year'*

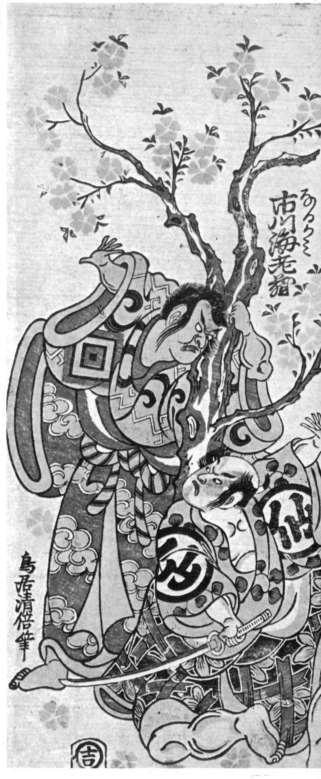

18. Kiyomasu: 'Ichikawa Ebizō in the role of the Holy Recluse Narukami'

Signed — 'Torii Kiyomasu hitsu', publisher Uemura. Hosoban, benizuri-e, 1750—60.

Ebizō, who used the name of Danjūrō until the year 1739, was the head of the famous Ichikawa family of actors, and so had the prerogative of playing the principal parts in the basic repertoire of the family from which the famous 'Eighteen Pieces' *(Jū-hachi-ban)* were later selected by one of his successors, Danjūrō VII (1791—1859). One of such roles was the part of the holy recluse, Narukami, from a play of the same name. Narukami had captured the God of Rain to avenge himself for a rejected petition to the Emperor. Princess Taema-hime succeeded in seducing him, broke the spell, and the country, which had been on the verge of drought, had the God of Rain back. The partner of Ebizō in this picture is Nakamura Sukegorō.

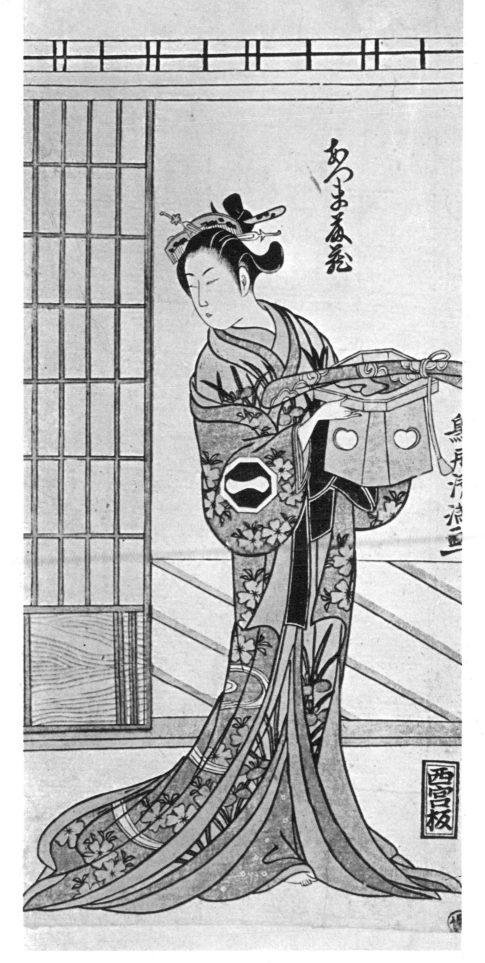

19. Kiyomitsu: 'Azuma Tōzō Playing a Female Part'

Signed — 'Torii Kiyomitsu ga', publisher Nishinomiya, collector's seal Hayashi. Hosoban, benizuri-e, c. 1760.

Torii KIYOMITSU (1735—1785), the son and pupil of Kiyomasu, took over as the head of the Torii studio in 1752, and so led the third generation. Most of his portraits of actors and beauties are drawn in slow, deliberate lines with emphasized verticals, and are printed in the polychrome technique, *benizuri-e*. The picture of Azuma Tōzō may have been composed as a sort of a polyptych linked by the uniform background.

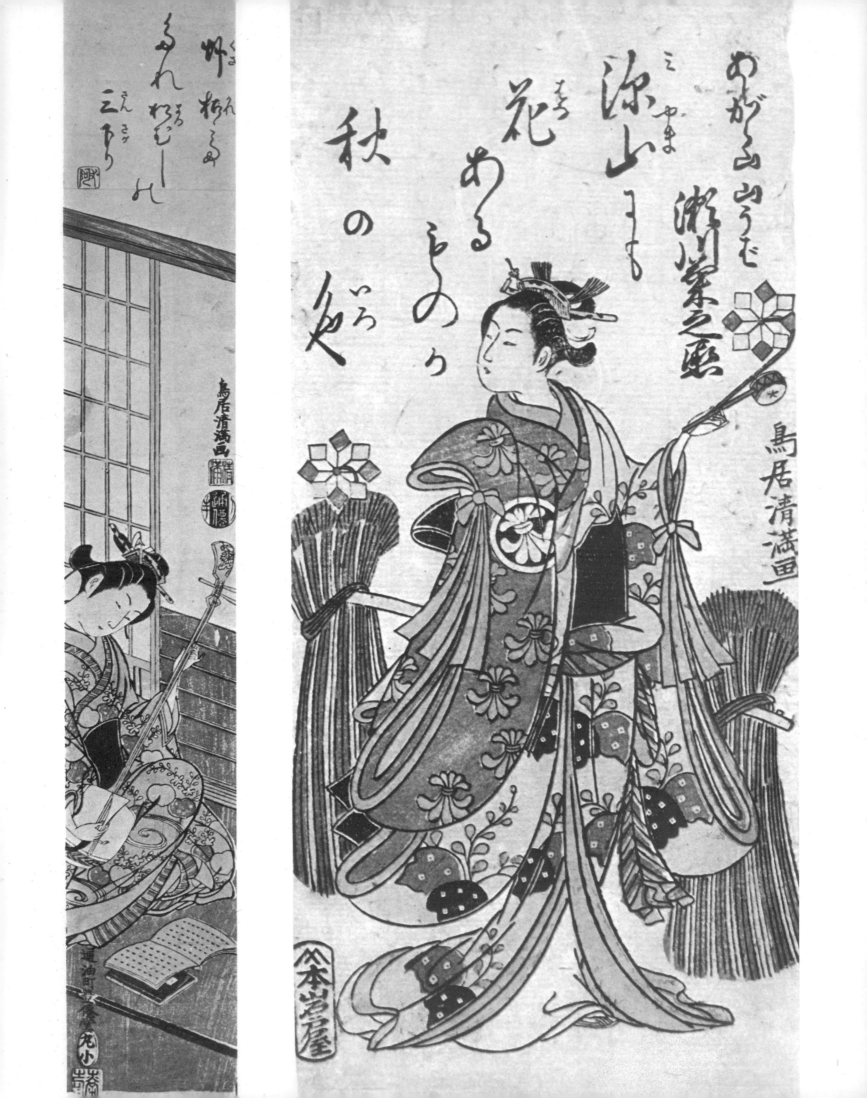

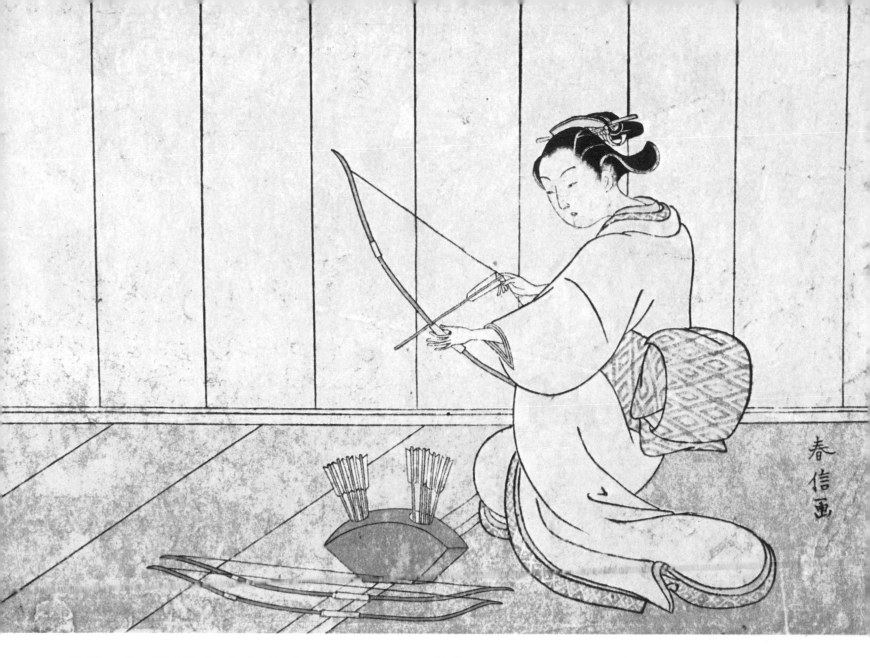

20. Kiyomitsu: 'Girl Playing the Samisen'

Signed — 'Torii Kiyomitsu ga', personal seal Torii Kiyomitsu, publisher Maruya Yamamato Kohei. Hashira-e, benizuri-e, 1750—55.

The *haiku* in the upper part of the picture reads:

Kusa kareta	'The grass leaves are drying
Tare Matsumushi no	Which cicada is trying
San sagari	To strum a tune?'

This last verse is the voice of the melancholic sound of the samisen, with the stress on the depth of tone of the third string.

21. Kiyomitsu: 'Segawa Kikunojō II Dancing the Part of Ya-mauba'

Signed — 'Torii Kiyomitsu ga', publisher Iwatoya. Hosoban, benizuri-e, 1760—65.

Miyama ni mo	'On mountain Miyama
Hana aru mono no	All flowers are wearing
Aki no iro	The sad colours of autumn'

The inscription dancing on the background, alludes to the home of Yamauba, the monster-woman from the mountains and the wet-nurse of the strongman Kintoki — a legendary figure of Japanese fairy tales. Kiyomitsu painted this tough mountain woman as a slender girl whose gentle beauty anticipated the typical fair grace of Ha-runobu's belles.

22. Harunobu: 'Shooting Gallery' (Yaba)

Signed: — 'Harunobu ga'. Chūban, yoko-e, nishiki-e, c. 1765.

There were about seven shooting galleries in Edo with professional women archers, highly frequented by the male populace of Edo, lured there, no doubt, by the irresistible charms of those ladies. One of the archers is depicted in this diptych, and the target and arrows are pictured on the opposite, left side. This picture was first published at the beginning of 1765 as a calendar print with the characters indicating the 'long' and 'short' months (of 30 and 29 days respectively) hidden in the belle's sash. The commercial edition of the print without the calendar signs and with various colour combinations was published probably the same year. This sheet therefore is one of the earliest multi-coloured prints known in the history of art as 'brocade pictures' (*nishiki-e*). In comparison to *benizuri-e*, which used two to five colour blocks, the emergence of *nishiki-e* was, in a sense, more of a technical development, depending mainly on the initiative of the printer and the publisher. The renowned Suzuki HARUNOBU (1725—1770), whose part in the introduction of 'brocade prints' is often over-estimated, had perhaps even no say in such matters as the selection of the kind of wood, paper, and colour. But there is no doubt as to his merit in the discovery of the large monochrome areas which form the background of human figures and which have added so much beauty to art.

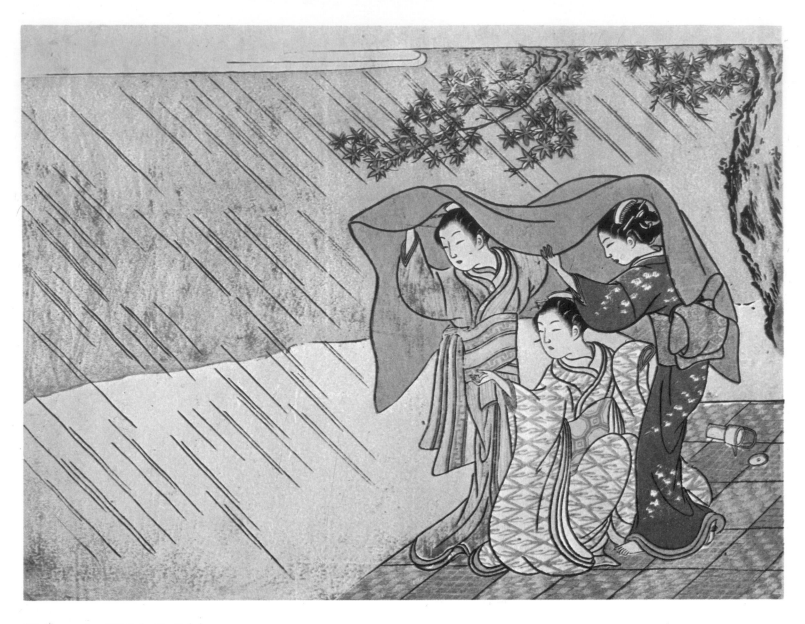

23. Harunobu: 'Girls in the Rain'

No signature. Chūban, yoko-e, nishiki-e, 1765—66.

In this picture — as in several ensuing ones — Harunobu copied a composition of Sukenobu. He hardly changed the black-and-white picture from the fourth page of *Ehon Nezamegusa* ('The Book of Reeds') as far as the details of the drawing were concerned, yet it was quite obviously transposed to meet the demand of the abstract interplay of colour areas and geometric ornaments, which is typical both of Harunobu's painting and of the decorative painting of the Rimpa school. Perhaps Harunobu had chosen Sukenobu's model just because it suited his own concept so perfectly.

24. Harunobu: 'The Crystal River of Hagi' (Hagi no Tamagawa)

No signature. Chūban, nishiki-e, 1767—68

Six rivers from six provinces are the theme of one of the most popular poetic and artistic cycles entitled 'The Six Crystal Rivers' *(Mu Tamagawa)*. The river Noji is one of the beauty-spots of the province of Ōmi. Here it is called 'the Crystal River of Hagi', after the fragile flowers of the *hagi* bushes (lespedeza), which bloom along its banks in autumn. The reflection of the moon on the water in the beautiful province of Ōmi illustrates the poem composed in the 12th century by Minamoto Toshiyori (also called Shunrai):

Asu mo komu	*'Tomorrow I'll come again*
Noji no Tamagawa	*Said the moon and went to sleep*
Hagi koete	*Into the crystal waves*
Iro naru nami ni	*Of the Noji river flowing*
Tsuki yadorikeri	*Along the blossoming hagi'*

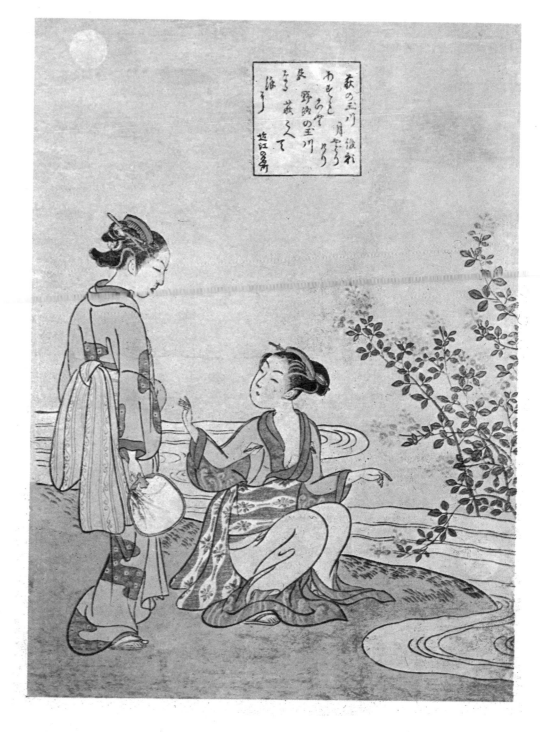

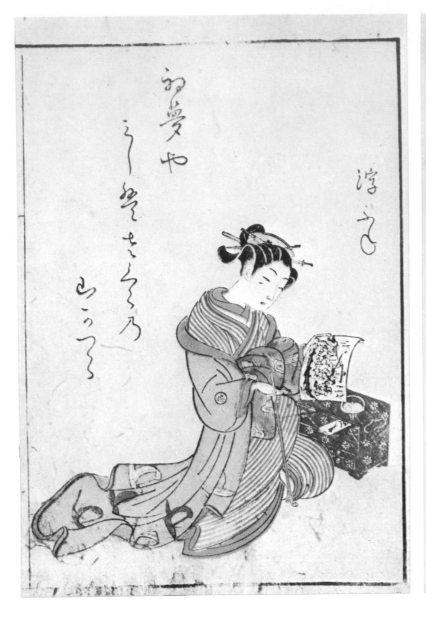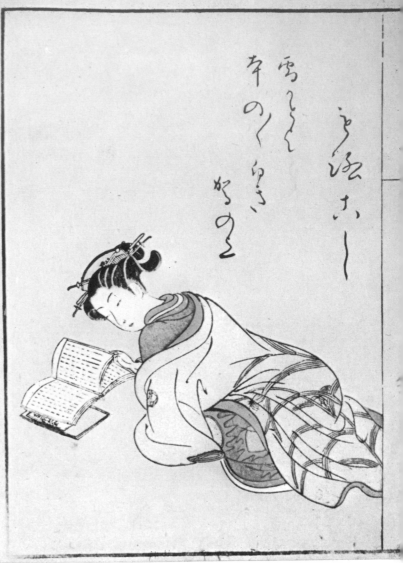

25. a—b) Harunobu: 'Courtesans Ukifune and Morokoshi'

Two pictures from the album 'Collection of Yoshiwara Beauties' (Yoshiwara Bijin Awase), published in five volumes by Muraya Jinpachi in Edo, 1770.

Prior to 1765, Harunobu's artistic production was somewhat mediocre though he had his fortieth birthday that year. Besides conventional actor sheets, he painted other conventional prints, such as 'The Treasure Ship with the Seven Gods of Good Fortune' (*Takarabune*), which can be seen in Ukifune's hands in this picture. The portrait of Ukifune is from the second sheet of the first volume dedicated to the theme of 'Spring and Sakura'. The adjoining poem *haiku* reads:

Hatsu yume ya	*'Is this the year's first dream?*
Mienu sakura no	*The mountain wears a wig*
Yama katsura	*Of blossoming cherry trees'*

During the five following years, Harunobu produced his best work, but he aged and died. Though published posthumously, *Yoshiwara Bijin Awase* represents the peak of his artistic career. This album of five volumes and 166 pictures is a grandiose apotheosis of feminine beauty — it is, in a way, a colour counterpart to Sukenobu's masterful variations on the same eternal theme. The courtesan Morokoshi, on the 81st sheet of the fifth volume dedicated to the theme of 'Winter and Snow', browses through a book signed by Harunobu; the attached *haiku* reads:

Yuki ka to wa	*'Could this be snow*
Honobono shiroki	*in lily-white pillars*
Kana no yuki?	*between the letters?'*

26. Harunobu: 'A Paraphrase of the Theme Shimizu Komachi'

Sheet from the series 'Seven Graceful Komachi, modern version' (Fūryū Nana Komachi Yatsushi). Signed — 'Suzuki Harunobu ga'. Hashira-e, nishiki-e, 1767—69.

Legends about Ono no Komachi, the beautiful poetess of the 9th century, were the theme of the famous cycle of seven *Nō* plays called 'Seven Komachi' *(Nana Komachi)*. During the 18th and 19th centuries, many graphic artists gave their interpretation of this figure. Shimizu (or Kiyomizu) Komachi tells the story about a wandering priest who finds in the Kiyomizu Temple a manuscript of a poem written by Komachi in her old age. All of a sudden an old woman appears and leads him to the plain of Ichiharano where he beholds Komachi expressing in mime and dance the story of Narihira's pilgrimage to Tamatsushima. Komachi, whose beauty, like her numerous lovers, had vanished, is — in this print — ascribed a plainly erotic poem:

Nani wo shite	*'Is it that I loosen*
Mi wo itazura ni	*My tight sash*
Obi token	*In vain?*
Take no keshiki wa	*Even bamboos remain*
Kawaranu mono wo	*Unmoved and still'*

27. Harunobu: 'The Crystal River of Ide' (Ide no Tamagawa)

Sheet from the series 'The Six Crystal Rivers, A Popular Version' (Fūzoku Mu Tamagawa). Signed — 'Harunobu ga'. Hashira-e, nishiki-e, 1769—70.

For the *chūban* edition of *Ide no Tamagawa* from 1767—68, Harunobu had borrowed a composition of three girls from an album by Sukenobu *(Ehon Chitose Yama)*. Two years later, when designing the narrow *hashira-e* set of the same series, he used only a half of the original Sukenobu's composition without diminishing its effect. He was probably inspired by the evocative technique of the *tanka* poet, Fujiwara no Shunzei (1114—1204), whose portrait and poem is placed in the upper part of the picture:

Koma tomete	*'Halting my horse*
Nao mizu kawan	*By the pearly rapids*
Yamabuki no	*Of the river Ide*
Hana no tsuyu sou	*I will quench his thirst again*
Ide no Tamagawa	*With the dew from yellow roses'*

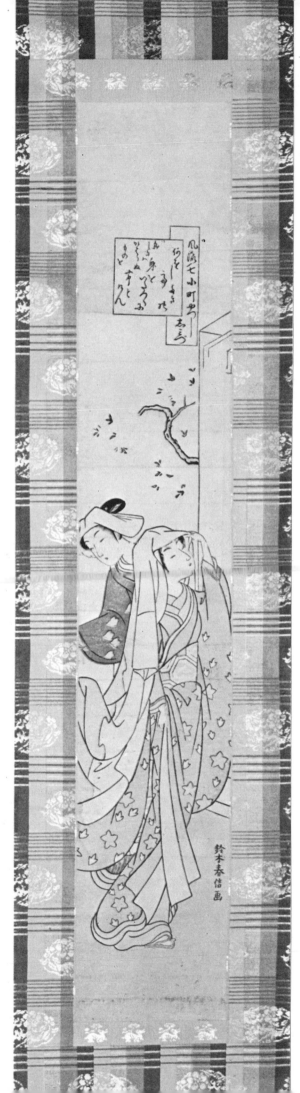

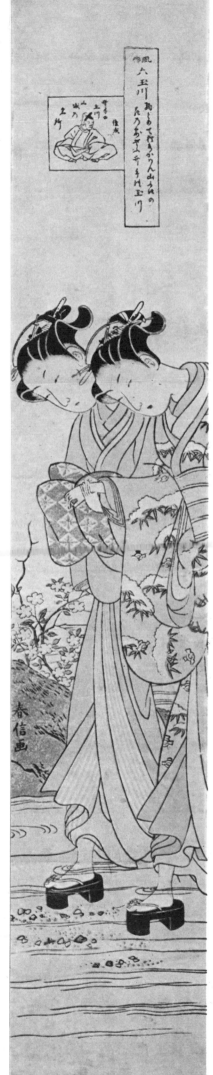

28. Ryūsui: 'The Fish Iboze, Wakasagi, and Kohada'

The 17th sheet of the second volume from the picture album 'Treasures of the Sea' (Umi no Sachi) in two volumes. Engraved by Sekiguchi Jinchirō, printed by Sekiguchi Tōkichi, published by Kameya Tahei in 1762.

Katsuma RYŪSUI (1711—1796) was a town official, seal engraver, and *haiku* poet. It is not known how he acquired his painting skill, but he certainly devoted much of his energy to the lifelike sketches of all the creatures of the sea. This famous book is one of the most beautiful examples of early Japanese polychrome printing.

29. Shiseki: 'A Lake with Lotus'

The eighth sheet from the second volume of 'Sō Shiseki's Picture Album' (Sō Shiseki gafu). Engraved by Tanaka Heibei and Tanaka Chūshichi in Kyoto, published by Suwaraya Mohei in Edo. Twenty two sheets, 27. 5×18cm, 1765.

Sō SHISEKI (1716—1780) studied under several Chinese painters living in Japan. Two parts of this three volumed album present wood-cut reproductions of Chinese masters; only the second volume gives Shiseki's own works. Most prints are black and white, but in a few pictures the polychrome technique of the Chinese type is used.

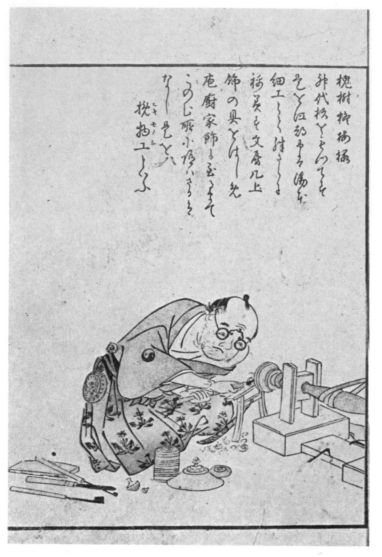

30. Minkō: 'The Chisel Grinder' (Rokurō)

The 22nd and the 23rd sheet from the album 'Classification of Artisans Portrayed in Colour Pictures' (Saiga Shokunin Burui). Two volumes bound in one, 28 sheets, 28 × 18.5 cm. Engraved by Okamoto Shōgyō. Published by Uemura Tōzaburō and Sawa Isuke in Edo, 1770.

Many a Japanese painter, Moronobu and Hokusai included, took an interest in artisans, but nobody built them such a monument as Tachibana MINKŌ in this album. And also to himself, for this album is his only known work. There is little else known about his life, except that he is said to have been a block-engraver, embroiderer, and writer. He learned painting under Tachibana Morikuni in Osaka, and he came to Edo in 1768, two years before the publication of this famous album.

31. a—b) Bunchō and Shunshō: 'Fan-shaped Portraits of Actors'

Two sheets from the 'Picture-book of Theatrical Fans' (Ehon Butai Ōgi) in three volumes. Engraved by Endō Matsugorō, published by Kariganeya Ihei, Edo. Hosoban, nishiki-e, 1770.

Ippitsusai BUNCHŌ (active c. 1765 to 1780) and Katsukawa SHUNSHŌ (1726—1792) were among the first painters to follow in the footsteps of Harunobu and his *nishiki-e* prints after 1765. The year when Harunobu's compendium of the Yoshiwara beauties was published, they jointly produced a similar cycle presenting portraits of 106 actors of the contemporary *Kabuki* theatre. Moreover, in this work they had surpassed the limitations of previous painters including Harunobu in the following respect: they tried to break with the convention of stylized portraits, and drew the faces in such a way as to resemble the actual features of the individual actors. This illustration shows Bunchō's portrait of Ichikawa Monosuke (from the second edition of 1772), and Shunshō's portrait of Nakamura Nakazō.

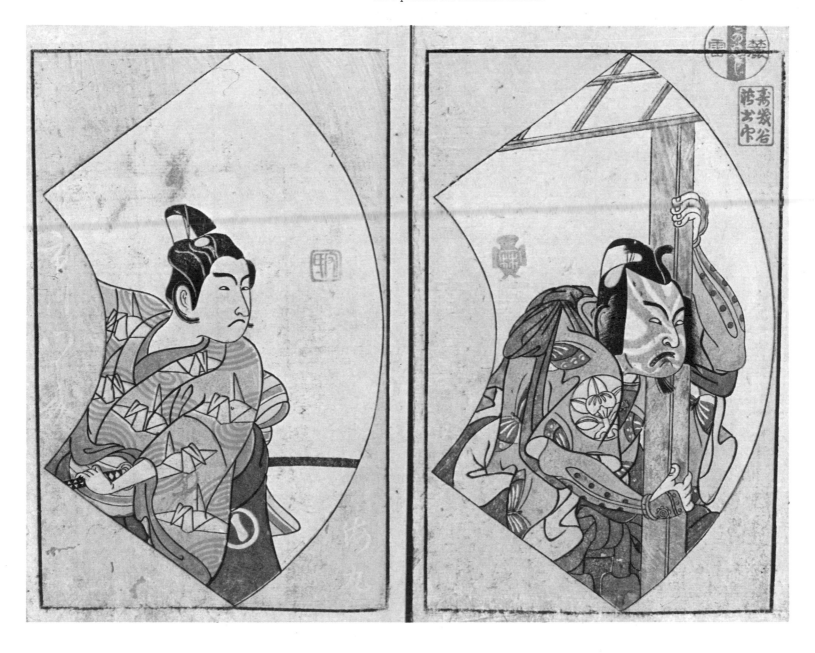

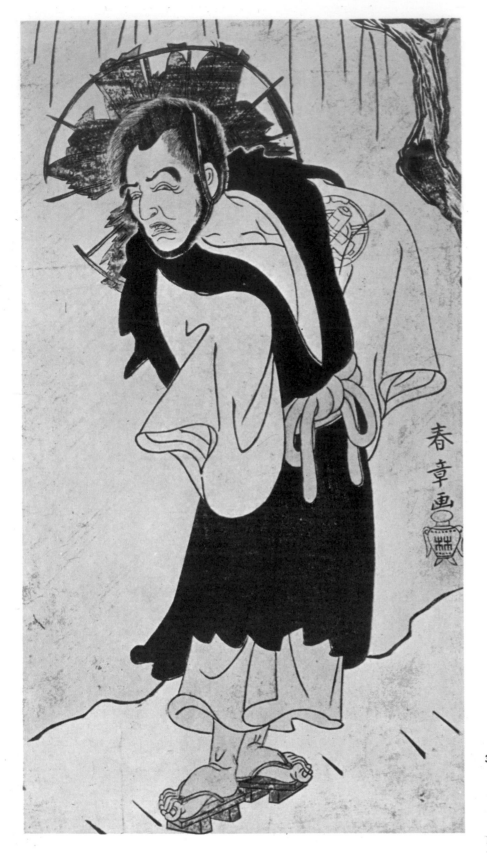

32. Shunshō: 'Nakamura Utaemon I in the Role of a Monk'

Signed — 'Shunshō ga', personal seal 'Hayashi' in the gourdshaped vignette (tsubogata). Hosoban, nishiki-e, c. 1768—70.

Nakamura Utaemon I was a famous actor from Osaka who performed as a guest star in a series of performances for the Nakamura-za theatre of Edo between 1768 and 1770. His introductory performance was the role of the degenerate renegade priest Seigen, and this is how Shunshō has portrayed him. Utaemon's acting and Shunshō's portrait gained great admiration. There is another edition of this picture with a black background, instead of blue, to suggest night-time.

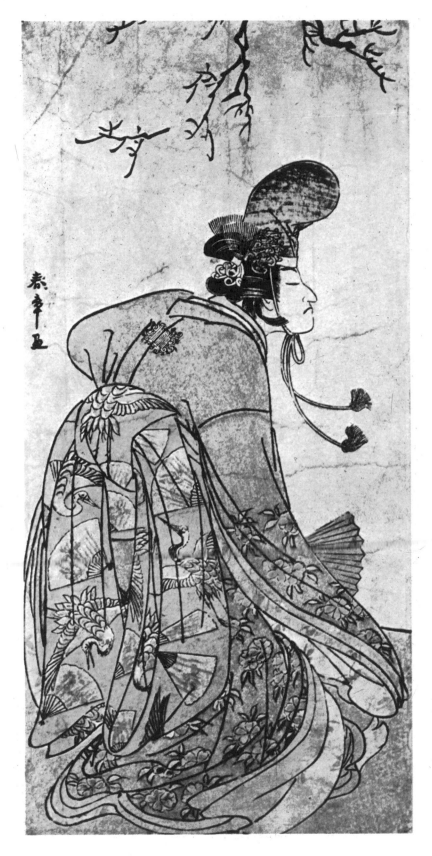

33. Shunshō: 'Serpent Dance' (?)

Signed — 'Shunshō ga'. Collector's seal Hayashi Tadamasa. Hosoban, nishiki-e, c. 1783.

Shunshō's delight in stage art shows in his drawing more than in the pictures of any other Japanese artist, with the exception of Sharaku. It was at least fifteen years after portraying Utaemon that he painted this dancing pose. Its dynamic tension is visible on the shoulders, the neck, and the big toe, on the sleeves, the folds of the garment, even the ribbon of the hat. All conventions had suddenly ceased to exist: the stereotyped half-profile of *ukiyo-e* portraits was substituted by plain profile. The figure of the actor is painted from the rear, which is an extreme that even the eccentric Sharaku ventured only twice. The actor, probably Ōtani Hiruji II, must have been an excellent dancer. Here he may be dancing the part of Kiyohime in one of the *Kabuki* versions of the classical *Nō* plays *Dōjōji*. During the dance, Kiyohime changes her costume nine times, just like a serpent shedding its skin, to reveal her serpent-demon nature.

34. Shunshō: 'The Poetess Murasaki Shikibu'

The 29th sheet from the album 'The Eastern Brocade of One Hundred Poets' (Nishiki Hyakunin Isshu Azuma Ori). Calligraphy by Sayama Chikuyuki, engraved by Yamamoto Genshirō. Published by Kariganeya Gisuke, 1775.

The widely known anthology of 'One Hundred Poems by One Hundred Poets' (*Hyakunin Isshu*), which is said to have been compiled by the supreme authority on classical poetry, Fujiwara Teika, in 1236, provided popular topics for many pictorial series. The fifty-seventh poem of this anthology was written by Murasaki Shikibu, the famous poetess of the turn of the 10th century:

Meguri aite	'Meeting you
Mishi ya sore tomo	For a while I beheld the light
Wakanu ma ni	Upon your face
Kumo kakurenishi	But then you hid in clouds
Yowa no tsuki kana	Oh, Moon in the night'

35. Shigemasa: 'Cock-fighting'

The tenth and eleventh sheet from the first volume of 'The Mirror of the Competing Beauties from the Green Houses' (Seirō Bijin Awase Sugata Kagami). Engraved by Inoue Shinshichi, published by Tsutaya Jūzaburō in Edo, 1776.

Courtesans Ureshino, Hanaōgi, Takikawa, and Nanakoshi, all from the Green House Ōgiya, are watching cock-fights — an amusement of the Festival of Dolls *(Hina Matsuri)* that falls on the third day of the third month of the lunar calendar; at the same time they are modelling spring costumes. When in 1776, Tsutaya Jūzaburō brought this album out, the other influential publisher of the day, Nishimuraya Yohachi, reacted immediately by launching Koryūsai's series of 'The First Fashion Designs for the Spring Sprouts' (i. e. 'The Young Beauties') *(Hinagata Wakana no Hatsu Moyō)* in the large, ōban-size edition. Tsutaya's choice of the same size paper but used horizontally *(yoko-e)* seems to have been a more effective and a happier choice. The first two volumes of spring and summer costumes were designed by Kitao SHIGEMASA (1739—1820), one of the distinguished painters of that time, and the autumn and winter models were drawn by Katsukawa Shunshō.

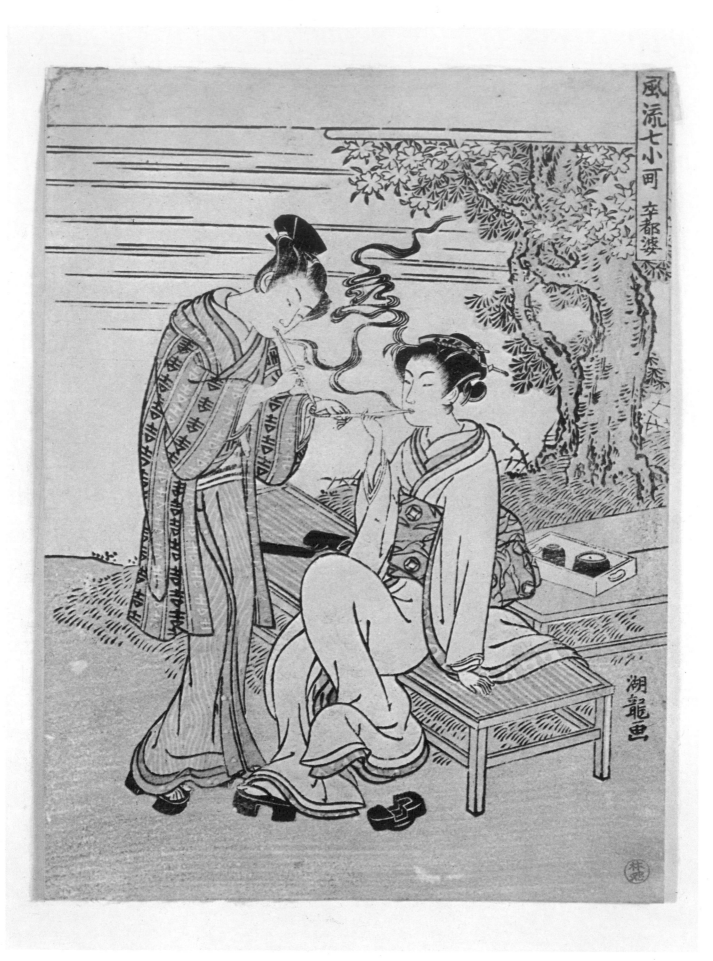

36. Koryūsai: 'A Paraphrase on the Theme of Sotoba Komachi'

Sheet from the cycle 'Modern Version of Seven Komachi' (Fūryū nana Komachi). Signed — 'Koryū ga', collector's seal Hayashi Tadamasa. Chūban, nishiki-e, 1774—75.

'Sotoba' is the Japanese word of the Buddhist cult structure *stūpa*. In the corresponding *Nō* play (see Plate no. 26), the former beauty Komachi, now old and withered, is sitting on a *stūpa*-like tree and is arguing with two monks about the true Buddhist teaching. In the end, she is possessed by the spirit of her deceased admirer Fukakusa, whom she had left waiting in front of her door for ninety-nine days and nights, thus causing his death. Koryūsai's picture suggests that during his time the relationship between the young beauties and their admirers was less formal and strict.

37. Koryūsai: 'The Spied Letter'

Signed — 'Koryū ga', publishing house Eijudō (Nishimuraya Yohachi) Hashira-e, nishiki-e, c. 1778.

This specimen paraphrases an episode common in all the literary and theatrical versions of the famous vendetta story about the exemplary loyalty of forty-seven *rōnin*-retainers who sacrificed their lives to avenge the unjust death of their master. This incident actually happened at the beginning of the 18th century, and soon after the story took the country by storm under the name of *Chūshingura* ('The Treasury of Loyalty'). In this picture, the courtesan Okaru is mirror-reading a secret letter sent to Oboshi Yuranosuke, the leader of the forty-seven loyal retainers; at the same time the spy Ono no Kudayū is examining the bottom end of the letter under the verandah. This subject, which is befitting the narrow, *hashira-e* format of composition, received similar treatment by several artists of the second half of the 18th century. None of them, however, could match Isoda KORYŪSAI (active from 1760 to 1780), especially in the composition of 'pillar' prints.

38. Kiyonaga: 'Low Tide at the Island of Enoshima'

Signed — 'Kiyonaga ga', publishing house Eijudō (Nishimuraya Yohachi). Hashira-e, nishiki-e, c. 1785.

Enoshima-e
Fuji ga te wo hiku
Shiohi kana

'Oh, the low tide at Enoshima,
Which has drawn Fuji mountain
Closer to her shore'

Only the verse and the costumes place this picture in Japan, while the 'European' composition of the figures, and the 'Junoesque' form of the women against the background of a realistic landscape in perspective go beyond all the traditional concepts of Japanese painting.

39. Kiyonaga: 'Winter Evening' (Bantō kōetsu)

Sheet from the series 'Eight Views at the Four Seasons' (Shiki Hakkei). Signed — 'Kiyonaga ga', publisher Nishimuraya Yohachi. Chūban, nishiki-e, c. 1779.

Torii KIYONAGA (?1752—1815) was a pupil of Kiyomitsu, and after his death took over the leadership of the Torii studio, which had already for four generations specialized in work closely connected with the theatre. The world of beauties was, however, the main domain of his artistic creativeness. At the end of the 1770s he continued progressive work in this theme, which had been started by Harunobu, then was developed by Koryūsai; some ten years later, other artists, like Utamaro and Eishi carried on the same trend. The *Shiki Hakkei* series is another variation of the 'Eight Views' type (see the chapter on 'The Cycles'), where the fluctuations of amorous feelings and moods are reflected in the changes of Nature.

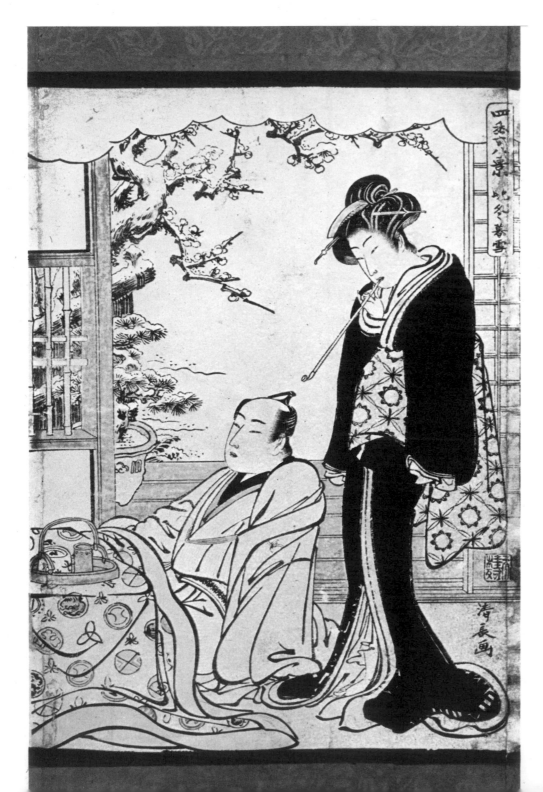

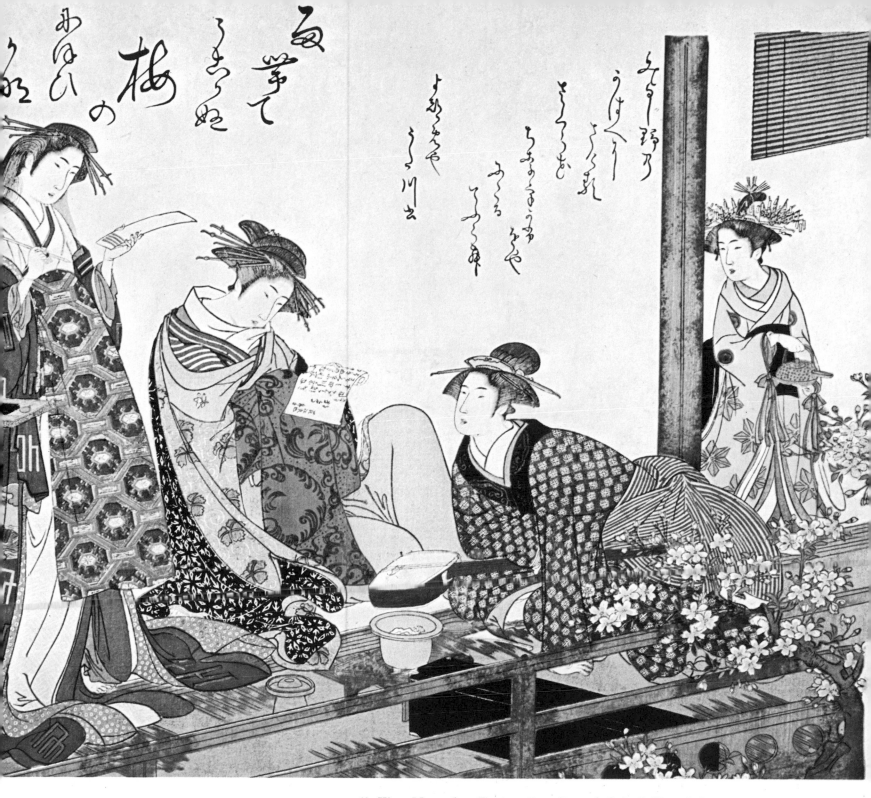

40. Kitao Masanobu: 'Famous Beauties and their Calligraphy'

Sheet from the album 'A New Collection of Beautiful Yoshiwara Courtesans and Mirror of their Handwriting' (Yoshiwara Keisei Shin Bijin Awase Jihitsu Kagami). The seventh and the fifth sheet, signed — 'Kitao Masanobu ga', seal Soseki, and the title: 'Collection of Autographs of Famous Beauties from the Green Houses' (Seirō Meikun Jihitsu Shū). Published by Tsutaya Jūzaburō with an introduction by Yomo Sanjin. Double ōban, tate-e, nishiki-e, 1784.

Kitao MASANOBU (1761—1816) was a promising pupil of Shigemasa. In graphic sheets of rich figurative composition he was second only to Kiyonaga, as is proved by this album. He found even greater enjoyment in literary activities (he published highly successful novels under the pseudonym Santō Kyōden) and also in marketing pipes. This album, which is one of the best examples of Jūzaburō's publishing career, contains seven double-size pictures with portraits and calligraphy of two prominent courtesans from each of the seven renowned brothels. Between 1782 and 1783, the sheets were probably published individually. This illustration depicts two main courtesans from the Matsubaya brothel, Utagawa and Nana-zato, amusing themselves on the verandah with musical and literary acts apt for the season of spring.

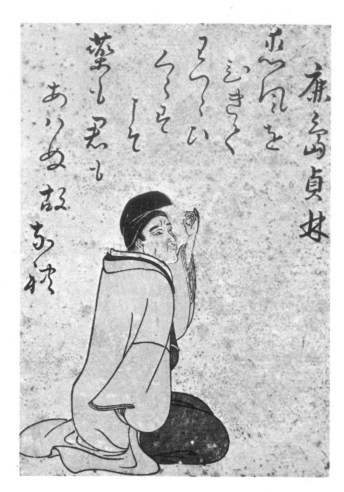

41. Kitao Masanobu: 'The Kyōka Poet Kashima Teirin'

The ninety-second sheet from the album 'A Sackful of Old and Modern Humorous Poems by One Hundred Poets, Newly Engraved in the Tenmei Era' (Tenmei Shinsen Hyakunin Isshu, Kokon Kyōka Fukuro). Published by Tsutaya Jūzaburō. 25×15.3 cm. 1787.

Koi kaze wo	'*I have caught*
Hikite wazurai wa	*The cold of love*
Kurasu ni zo	*And aching*
Kusuri mo kimi mo	*I realize that to survive*
Awanu yue nare	*I lack both you and medicine*'.

In the year 1786, an anthology of fifty humorous poems, *kyōka*, written by contemporary poets (i.e. by the poets of the Tenmei era, 1781—89) was collected by Yadoya no Meshimori and illustrated by Kitao Masanobu for the publisher Tsutaya. A new enlarged edition, with fifty additional poems composed by earlier poets was prepared for publication by the same authors the following year. This edition of poems was meant to paraphrase the famous classical anthology *Hyakunin Isshu* (see Plate 34).

43. Shunchō: 'An Outing with Boys'

Signed — 'Shunchō ga', published by Wakasai Yoichi, censor's seal 'kiwame'. Ōban, nishiki-e, c. 1790.

Katsukawa SHUNCHŌ (dates not known) was a pupil of Shunshō, but was more inclined to the Kiyonaga style of portraying beauties. In the background of this picture he applied also the principles of Toyoharu-type perspective. This gives the print an unusual exotic atmosphere and a new graphic accent.

42. Shiba Kōkan: 'A View of a Tea-house' (Go cha suikei)

Signed — 'Shiba Kōkan sō sei', dated 1784, coloured copperplate engraving, 27 × 39 cm.

Shiba KŌKAN (1743—1818) was a scholar, author and painter, who was engaged only briefly as a wood-block designer round the year 1770. But his main interest was in European learning (*rangaku*), and also in European painting. After his journey to Nagasaki, described in his travel book (*Saiyū nikki*, 1788), he published a series of copperplate prints in which he applied European techniques of perspective and chiaroscuro.

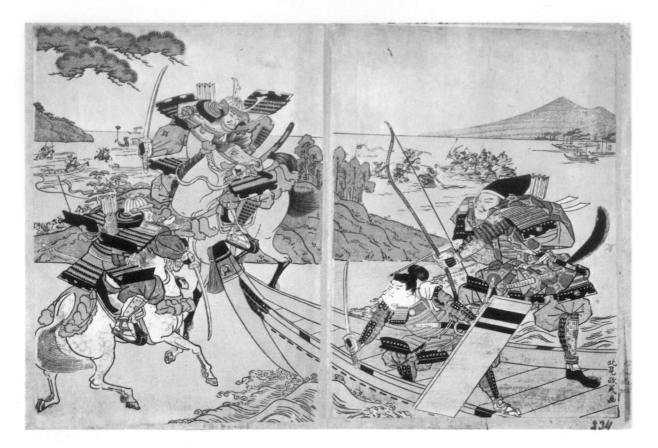

44. Masayoshi: 'The Battle of Yashima'

Signed — 'Kitao Masayoshi ga'. Ōban diptych, nishiki-e, 1785—1790.

The application of European perspective opened up new posibilities also in the thematic field of great battles and warriors (*musha-e*). Kitao Shigemasa and his pupil Kitao MASAYOSHI (1761—1824) thoroughly explored this field. In several prints, they employed the rules of perspective to serve an unusual purpose (unusual for those who are not familiar with the tradition of picture scrolls) — to mark an axis for the dimension of time rather than that of space. In this illustration of the seashore battle of Yashima, where the armies of Taira and Minamoto clashed in the year 1185 — according to the brief description in the seventh book of *Heike Monogatari* (see also the Plate on page 8) — three subsequent episodes are depicted on three different planes. In the foreground there is a boat belonging to the escaping Taira army, with Taira Noritsune, the best archer of the clan, on board, ready to shoot the approaching leader of the Minamoto army, Yoshitsune, the brave younger brother of the future shōgun Yoritomo. Yoshitsune's faithful companion, Satō Tsuginobu, rushes to his master to save him from the arrow, only to die himself. In the background of the picture is another episode about Yoshitsune risking his life to pick his fallen bow out of the sea. The third story is illustrated on the left sheet; the top archer of the Minamotos, Nasu no Yōichi, hits a distant target — a scarlet fan, with the imperial rising sun emblem — secured high up to the mast of Taira's boat.

45. Eishi: 'Prince Genji Dressing for the Flower Festival'

The first sheet of the triptych 'Flower Festival' (Hana no En), from the series 'Dandified Genji' (Fūryū Yatsushi Genji). Signed — 'Eishi ga'. Ōban, benigirai-e, c. 1788.

Hosoda EISHI (1756—1829) had strong leanings towards classical themes. He was of noble birth, and served at the shōgun's court, and was taught by the aristocratic Kanō school of painting. In the famous triptych series about the adventures of prince Genji *(Genji Monogatari)*, written by the lady of the court, Murasaki Shikibu, around 1010, he ventured a dramatic juxtaposition of the classic court culture of the Heian period and the contemporary town culture and fashion. Prince Genji is preparing for the Flower Festival (an allusion to the eighth chapter of *Genji Monogatari*), and is putting on the traditional formal robe of the courtier: the wide trousers *(naga-bakama)*, the cloak *(daimon)*, and the cap *(eboshi)*. The ladies of the court are dressed in the current fashion of Eishi's period.

46. Eishi: 'Courtesans under Wistarias in Blossom' (Fuji no Shita Tayū no Zu)

The middle sheet of a triptych. Signed — 'Eishi zu', publisher's seal Eiju-han (Nishimuraya Yohachi); censor's seal 'kiwame'. Ōban, nishiki-e, c. 1795.

Classical Japanese painters and poets — as if fascinated by the concept of time and its cycles — created a rich iconography on the theme of the four seasons *(shiki-e)* and the twelve months *(tsukinami-e)*. This iconography combined the natural characteristics of the respective season with the genre characteristics of the appropriate and customary human activities. The *ukiyo-e* oriented graphic artists enjoyed modifying the iconographic implications. In this picture, Eishi tries to actualize the traditional late-spring wistaria festival by drawing it together with a parallel annual celebration in the pleasure district of Yoshiwara.

47. Utamaro: 'A Grasshopper and a Cicada on a Gourd' (Kirigirisu — semi — hechima)

The fifth and the sixth sheet of the second volume of the picture book 'The Selection of Insects' (Ehon Mushi Erami). Published by Tsutaya Jūzaburō, 1788.

Kitagawa UTAMARO (1754—1806), a pupil of Toriyama Sekien, had already begun to publish his work around the year 1775, but it was not until the last fifteen years of his life that he achieved the position of the most acknowledged painter of *bijin-e*. Prior to 1790, he lived in the shadow of Kiyonaga and the artists of the Kitao school. Nevertheless, during that period he created a certain kind of a masterpiece in his studies of nature, when illustrating Meshimori's anthologies of *kyōka* poetry published by Tsutaya Jūzaburō. 'The Book of Insects' was the first of the series. Collecting singing insects was an ancient aristocratic custom; it provided a welcomed excuse for young women and men to meet and play games of love freely in the open air. Thus it is not surprising that the *kyōka* poems accompanying Utamaro's illustrations, mention insects, but talk mostly of love.

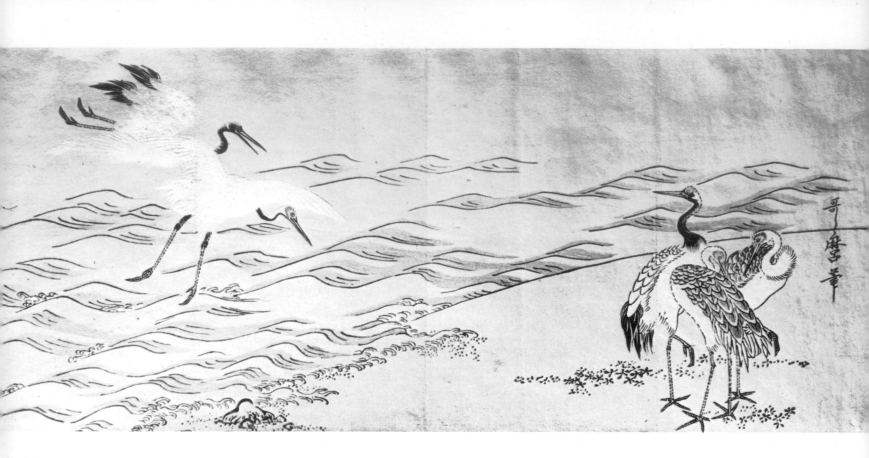

48. Utamaro: 'Red-crested Cranes' (Tanchō)

Signed — 'Utamaro hitsu'. Surimono, nishiki-e with blind embossing (karazuri). 16.5×38 cm, c. 1800.

After the 'Book of Insects' (see Plate 47), Utamaro published the 'Contest of Humorous Poems on Hundreds and Thousands of Birds' *(Momochidori Kyōku Awase*, 1798), which turned out to be a great success. The *surimono* with cranes is reminiscent of this 'Book of Birds'. The sacred red-crested crane (Grus japonensis), the traditional symbol of old age, suggests that this *surimono* was designed as an occasional print. The unrivalled master of multicoloured prints demonstrates his familiarity with the principles of monochrome ink-painting, and displays his ability to draw the two modes of expression together.

49. Utamaro: 'Hand Wrestling' (Udezumō)

Signed — 'Utamaro ga', published by Iwatoya Kichisaburō. Aiban, yoko-e, benigirai-e, c. 1790.

This form of 'tug of war' is not a depiction of Edo women's pastime, but a caricature of the rivalry between two famous beauties of the Kansei era (1789—1800). Both worked at tea-houses known for taking their male clients to brothels *(hikite-jaya)*. On the right is Okita, 'The Champion of the West', from the tea-house Naniwaya in the western quarter of Edo, Asakusa. Her rival from the tea-house Takashimaya, 'The Champion of the East', is Ohisa, the daughter of a rich confectioner from the eastern district of Edo by the Ryōgoku bridge. The referee of this contest is Segawa Kikunojō III. (1751—1810), the well-known actor of female parts.

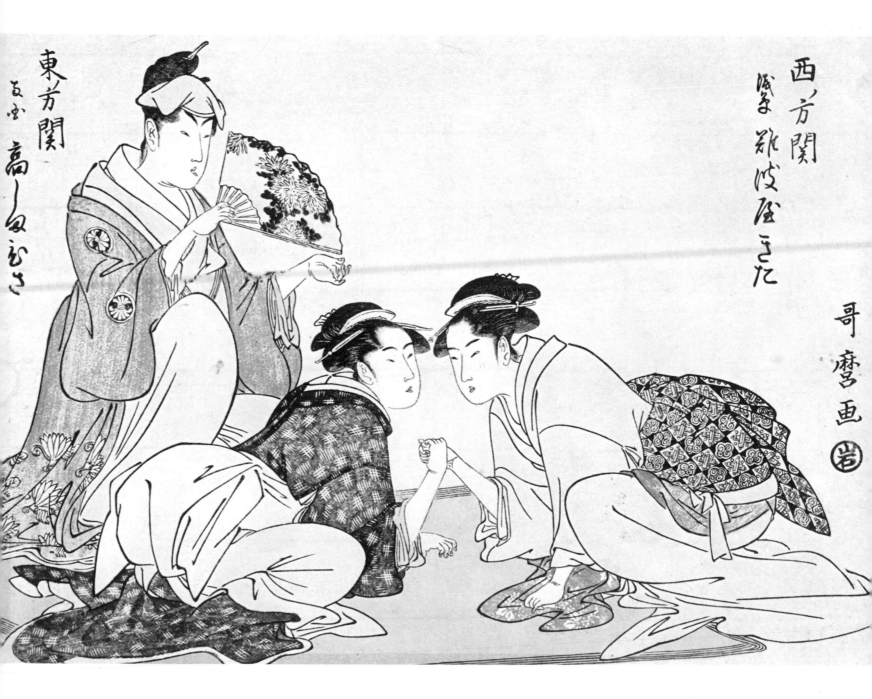

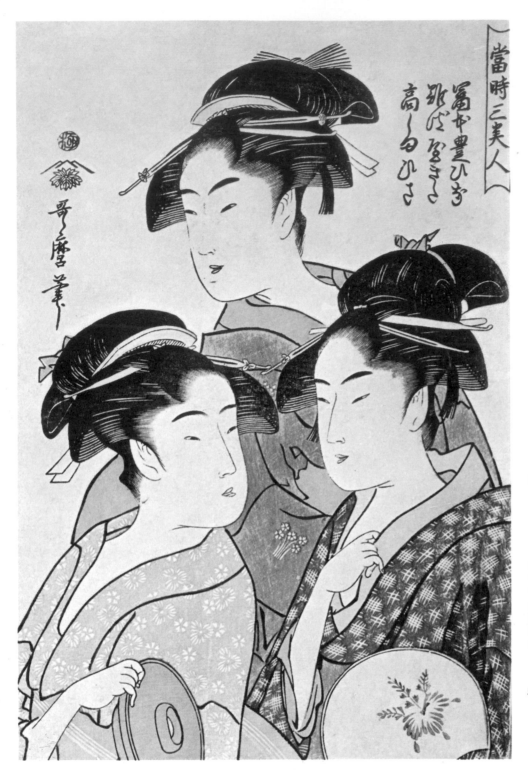

50. Utamaro: 'Three Contemporary Beauties' (Tōji San Bijin)

Signed — 'Utamaro hitsu', published by Tsutaya Jūzaburō, censor's seal 'kiwame'. Ōban with yellow background (kizuri), 1790—95.

Ohisa and Okita, the two young women from tea-houses Takashimaya and Naniwaya (see Plate 49), together with Tomimoto Toyohino, the female singer, form the trio of the 'Famous Beauties of the Kansei Era' (*Kansei San Bijin*). Utamaro's composition, mounting the three beautiful heads, was such a success that Jūzaburō published several editions of the picture with slight modifications.

51. Utamaro: 'Courtesan Hinazuma as an Allegory of Lü Tung-pin'

Sheet from the series 'The Garden of Eight Immortals' (Enjū Hassen). Signed — 'Utamaro hitsu', published by Tsuraya Kiemon, censor's seal 'kiwame'. Ōban, nishiki-e with yellow background (kizuri), 1790—95.

The Chinese Taoist cycle of the 'Eight Immortals' *(Pa Hsien)* evolved from legendary biographies of various sages around the 14th century. Lü Tung-pin lived at the beginning of the 9th century, and was an official and a poet at court. He was also alleged to be familiar with the secrets of the 'Inner Elixir', and of 'Heavenly Fencing'. The allegorical connection between the courtesan and the eight immortals had to be very subtle, and was probably based on the fact that the contemporary observer could also read the title as: 'The Eight Beauties Roused by Love'. The picture of Hinazuma offering a bowl to the dragon probably has erotic connotations alluding to Lün Tung-pin's famous sword called 'The Blue Serpent'.

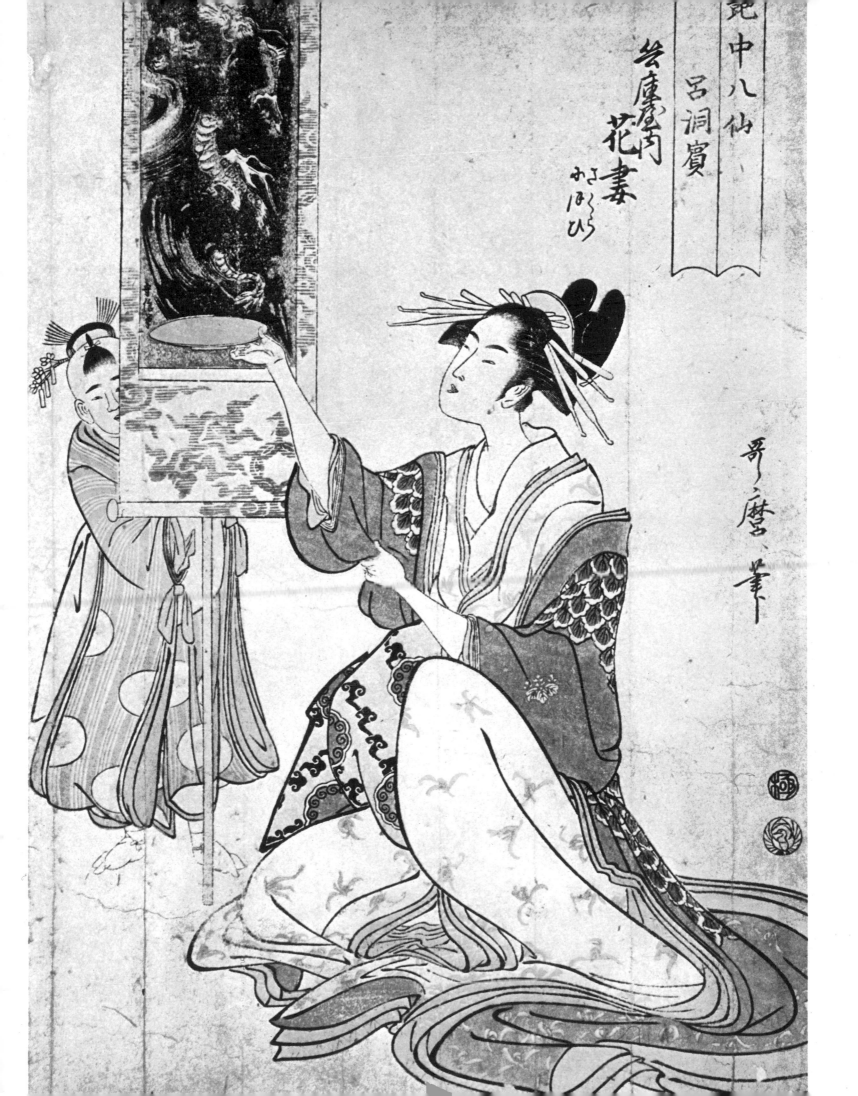

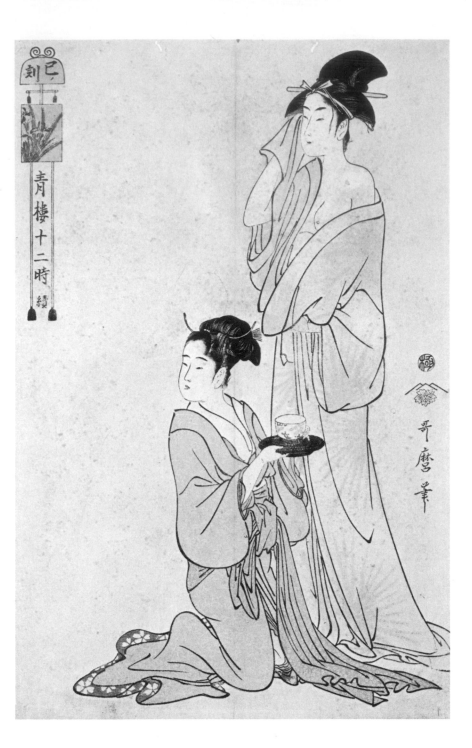

52. Utamaro: 'The Hour of the Serpent'

The sixth sheet from the series 'Twelve Hours in a Green House' (Seirō Jūni Toki). Signed — 'Utamaro hitsu', published by Tsutaya Jūzaburō. Ōban, nishiki-e, c. 1795.

Day and night is divided into twelve time sections named after the signs of the Chinese Zodiac. 'The Hour of the Serpent' falls late morning, between nine and eleven o'clock. The courtesan has just taken a bath and as she is drying herself, her servant, who is also somewhat untidy, is passing her a cup of tea.

53. Kikumaro: 'Geisha Ichikawa from the Matsub-aya House with her Girl Attendants Kintō and Suimen'

Signed — 'Kikumaro hitsu', published by Tsutaya Jūzaburō. Ōban, nishiki-e c. 1800.

Utamaro's pupil KIKUMARO was active from the 1790s to the 1820s. He changed his name to TSUKIMARO either in 1797 or 1804. There is little else known about him, except that he successfully continued portraying the Utamaro-type beauties throughout the first quarter of the 19th century.

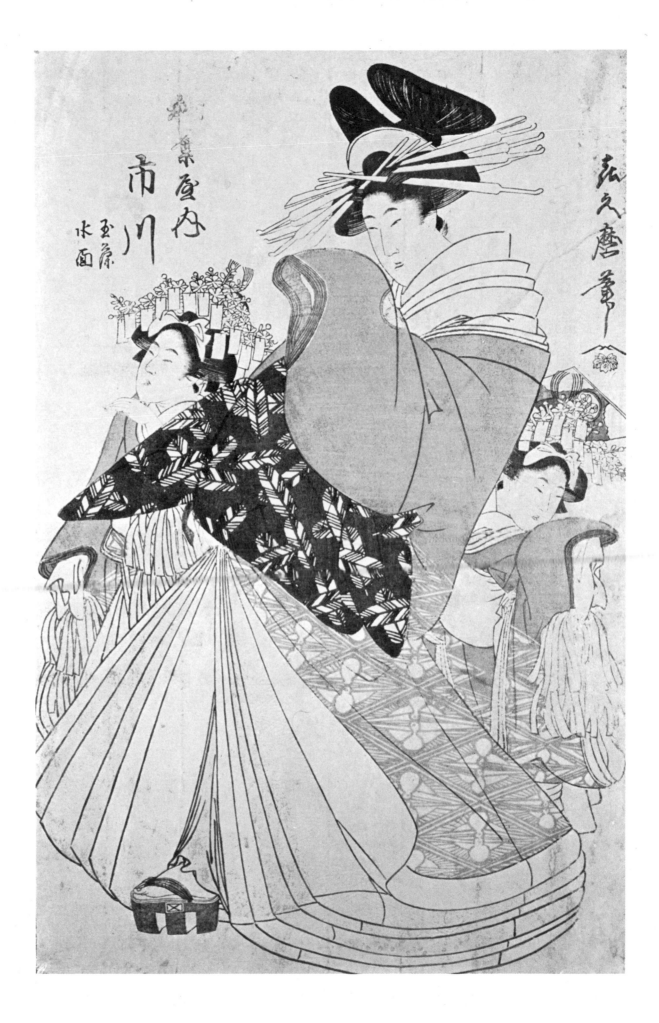

54. Utamaro: 'The Lost Letters'

Signed — 'Utamaro hitsu', publishing house Eijudō; Nishimuraya Yohachi, censor's seal 'kiwame'. Ōban diptych, c. 1795.

One of the three girls in the right part of the picture dropped — probably on purpose — some letters hidden in the low-cut bodice of her kimono, just when a couple of youths were passing by. While one of them stooped to pick up the letters, the other two girls seemed shocked by the daring behaviour of their girl-friend.

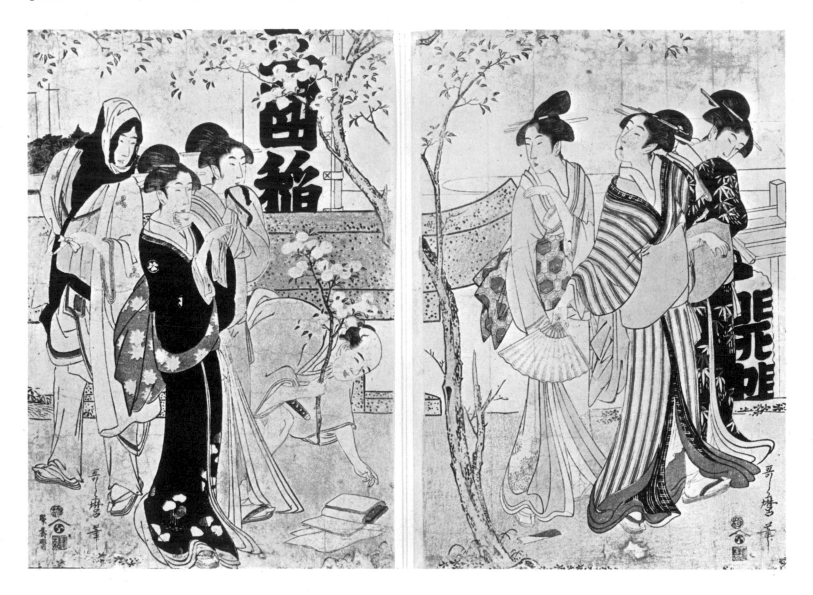

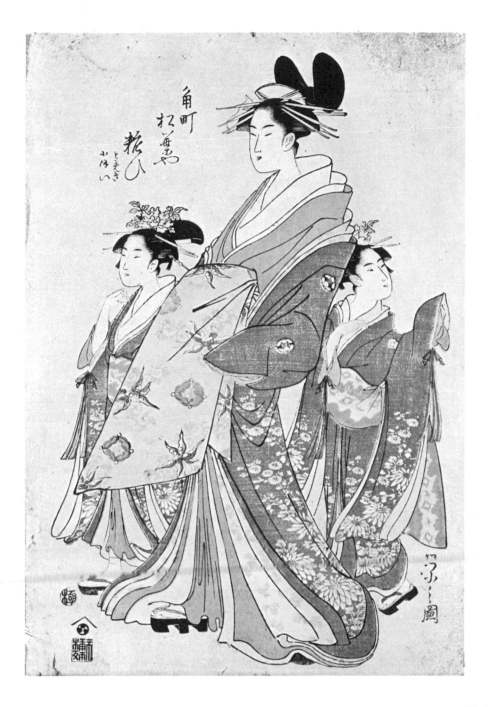

55. Eishi: 'Courtesan Yosoi'

Signed — 'Eishi zu', publishing house Eijudō, Nishimuraya Yohachi, censor's seal 'kiwame'. Ōban, diptych, c. 1795.

The inscription gives the name and address of the brothel — Matsubaya, Kadomachi, and the names of the two girl attendants *(kamuro)*, Tomeki and Nioi. Perhaps only the noble samurai Koryūsai and the aristocratic Eishi knew how to promote a courtesan to a lady of the court. Courtesan Yosoi, garbed in the formal cloak *uchikake* and a brocade *obi*, looked like a queen at her coronation.

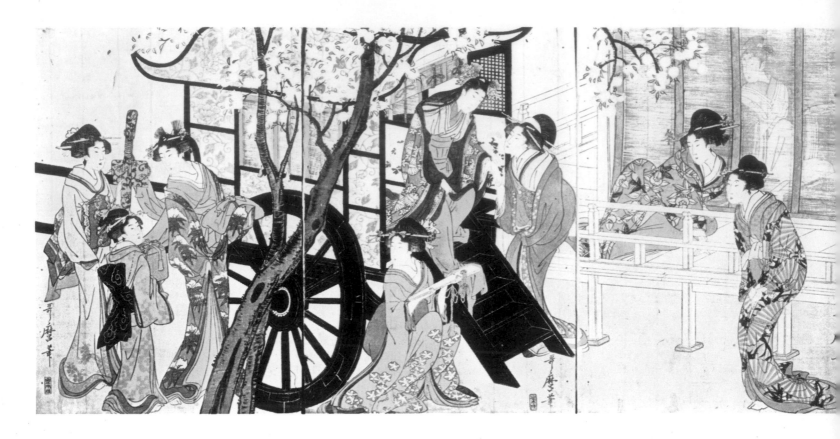

56. Utamaro: 'A Princess Coming to Genji'

Signed — 'Utamaro hitsu', publisher's seal 'Sen-ichi-han' (Izumiya Ichibei). Ōban triptych, nishiki-e, c. 1800.

On the right sheet, a prince sits behind a transparent curtain, composing a poem. On the middle sheet, a princess dressed in the traditional court costume is stepping out of a two-wheeled chariot. Only the chariot calls to mind the story of Genji, illustrated by the ancient painters of *yamato-e* centuries ago.

57. Shunman: 'Admiration of the Flowering Plum-tree'

Sheet from the album 'Colours of Spring' (Haru no Iro). Signed — 'Shōsadō Kubo Shunman ga', personal seal Shunman. Ōban, yoko-e, benigirai-e, c. 1795.

During the 1790s, Tsutaya Jūzaburō published several volumes of poetry illustrated with occasional colour prints by Shunman, Rinshō, Hokusai, and others. These poetry booklets were, in fact, collections of the New Year *surimono* in book form, and all the pictures were of exceptionally high technical and graphical quality. Kubo Shunman (see Plate 58) chose for his picture the theme of the traditional spring ceremony when blossoming plum-trees are viewed with great admiration, with two appreciative court ladies in a boat. This sheet represents the typical graphical rendering of the Tosa style of painting dominated by black and grey colours in five different shades.

58. Shunman: 'Butterflies'

*Sheet from the 'Picture Album of Butterflies' (Gunchō Gafu). Signed —
'Shunman sei', poetic pseudonym Guren. Surimono, c. 1795.*

Kubo SHUNMAN (1757—1820) was a pupil of both Kitao Shigemasa
and Torii Kiyonaga; moreover, he studied the rudiments of the Kanō
school of painting. In the 1780s, he published several masterly *ukiyo-e*
prints like his coleague Masanobu, and also applied his energies and
talent to painting, poetry, literature, and the occasional *surimono*
prints. If it were true he trained as a goldsmith and a lacquer-ware maker, this
would explain the striking delicacy of his *surimono*. The two sheets on the
subject of butterflies are one of his most magnificent graphic creations.

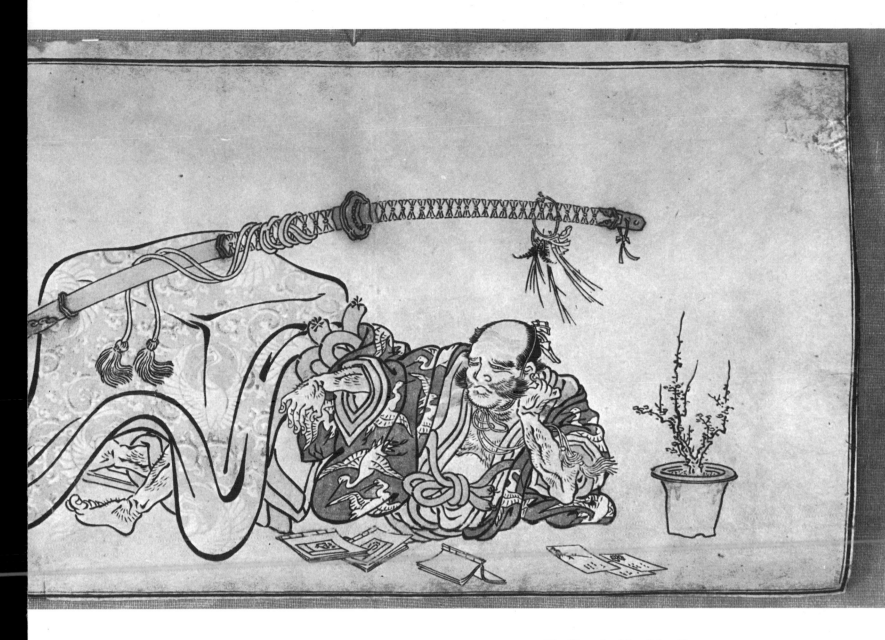

59. Tōrin: 'The Hero Asahina Saburō'

Signed — 'Tōrin gaku', personal seal 'Sessan'. Ōban yoko-e, nishiki-e, c. 1795.

Tsutsumi TŌRIN I., who was active around the middle of the 18th century (till the year 1781), was one of the followers of the renowned painting school founded by Ōgata Kōrin. His pupil of the same name (active 1789—1830) and painting in the same style designed several prints illustrating contemporary poetry either in the form of *surimono* or as a part of delicately printed almanachs of the type Tsutaya Jūzaburō used to publish in the 1790s (see Plate 57). Tōrin's portrait of one of the heroes from the Soga brothers story does not represent the usual fierce warrior type, but a cultivated poet.

60. Chōki: 'The Lovers Ochiyo and Hanbei'

*Sheet from the series 'Ten Glimpses of the Current Manners' (Tōsei Fūzoku Jūkei). Signed —
'Shikō ga'. (Shikō is the artistic pseudonym of Chōki), published by Tsuraya Kiemon. Koban,
nishiki-e, 1795—1800.*

Eishōsai CHŌKI (dates not known), like Utamaro, was a pupil of Toriyama Sekien. In the
1790s, he published many remarkable prints, which are notable for their strange emotional
intensity. This print was inspired by heroes of an authentic tragedy which was also dramatized
by Chikamatsu in 1722. Hanbei was a greengrocer from Osaka who married Ochiyo, a village
beauty. His spiteful mother Omine tormented the new wife with scorn and disdain, so much so
that the young couple chose to commit suicide, though Ochiyo was with child.

61. Sekijō: 'The Lovers Ohan and Chōemon'

Sheet from the series 'Journey along the Passing Waves of the Shallow Rapids' (Michiyuki Segawa no Adanami). Signed — 'Sekijō hitsu', publishing house Iwai-ya. Aiban, nishiki-e, c. 1800.

Toriyama SEKIJŌ (dates not known) was a samurai and also a pupil of Toriyama Sekien. About 1780, they co-operated on the illustrations of books. Twenty years later, his name appeared on several prints in the style of Utamaro.

62. Utamaro: 'The Lovers'

Sheet from an erotic album (shunga). Unsigned. Nishiki-e, 39.5×26 cm, c. 1800.

It is against the publishing norm to reproduce erotic prints, though as a whole they are far less obscene than the pornographic movies and photographs of our time. Erotic prints usually displayed less routine and more intensity than many actor prints, and are often considered exceptional graphic works of art. This can be said especially about the *shunga* album by Utamaro from about the year 1800.

63. Utamaro: 'Lovers Under the Mosquito Net'

Signed —'Utamaro hitsu', publishing house Ōmiya. Ōban, nishiki-e, before the year 1800.

Mosquito nets were cut and printed from two separate blocks over the complete picture of the figures and objects to be seen behind them. Utamaro knew how to take full advantage of this expensive artistic effect in his work at the turn of the 19th century.

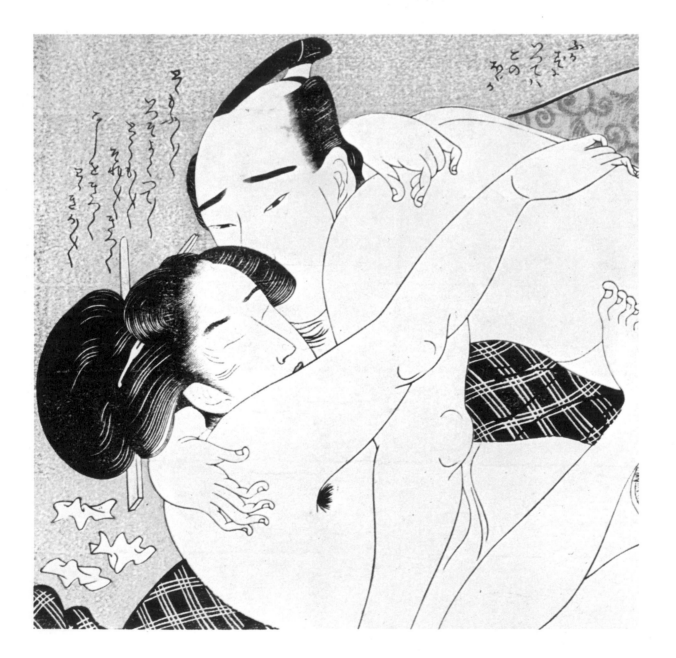

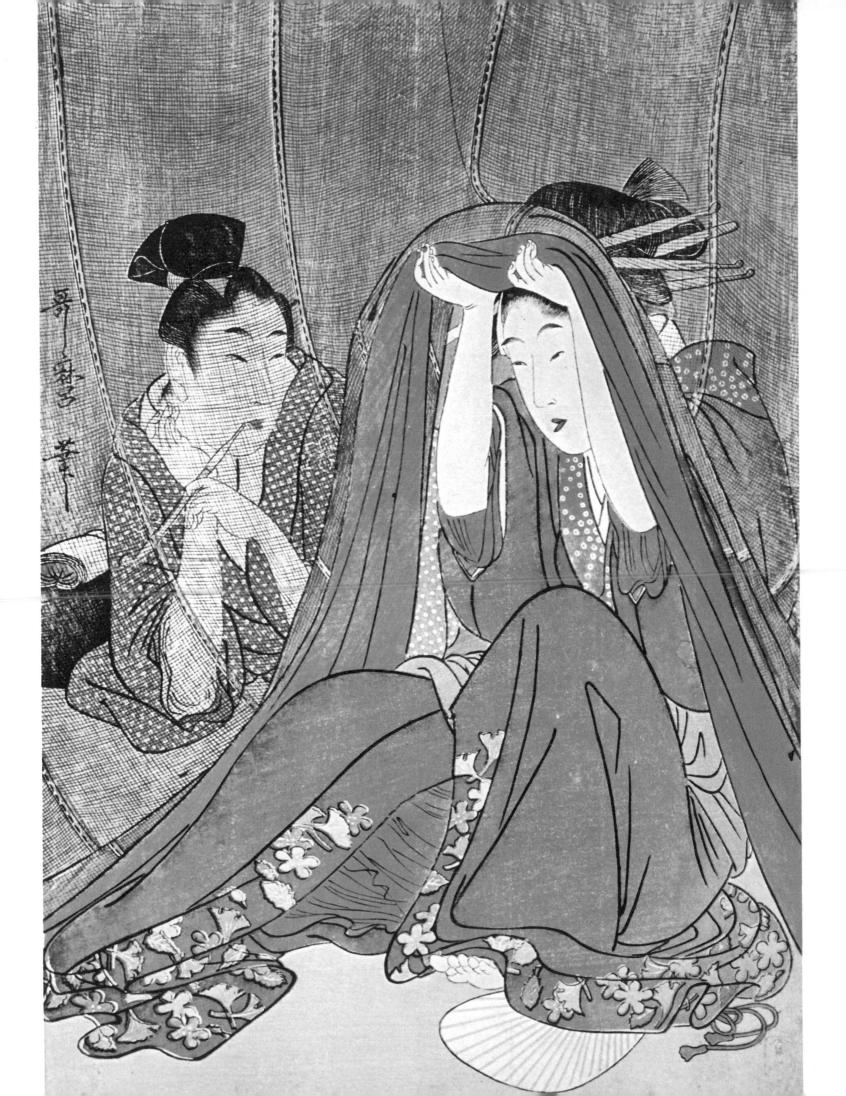

64. Sukenobu: 'Evening Bells from a Mountain Temple'

The fourth and the fifth sheet from the second volume of the 'Picture Book of Reeds' (Ehon Nezamegusa). Seven sheets printed with stencils (kappazuri-e), 22 × 16 cm. The publisher and the date are not indicated.

The album *Nezamegusa*, the first edition of which was published in Kyoto by Kikuya Kihei, became immensely popular in Edo in the 1760s as attested by the fact that Harunobu himself had borrowed some of its compositions for his *nishiki-e* prints (see Plate 23). Maybe this very fact encouraged some of the publishers in Kyoto to promote this re-edition of *Nezamegusa* in the technique of *kappazuri-e*, which endows the original black-and-white prints with a peculiarly different graphic emphasis. It may date from the third quarter of the 18th century. Each picture of the album is accompanied by a Chinese and a Japanese poem of a similar mood. The nostalgic atmosphere of the picture reproduced here springs from the theme of the 'Evening Bells from a Mountain Temple':

Yama tera no	'With every stroke
Iriai no kane no	Of vesper bells from a temple
Koegoto ni	In the hills
Kyō mo kurenu to	I fear this night a-coming near
Kiku zo kanashiki	And listen in sad reverie'

The theme belongs to the cycle of 'Eight Views of the Hsiao and Hsiang Rivers', which had been used as a pattern for Chinese ink-painting cycles ever since the 10th century, and which was later adapted by the Japanese as the 'Eight Views of the Ōmi Province' (*Ōmi Hakkei* — see Plate 7).

65. Shunkō: 'Ichikawa Ebizō (i.e. Danjurō V) in the Scene of Shibaraku'

Signed — 'Hayashi' in a cartouche shaped as a vase (tsubo). Ōban, nishiki-e, 1790—95.

Katsukava SHUNKŌ (1740—1812) made great strides in the tradition of actor prints, founded by his teacher Shunshō. Thus, together with Shunei, he paved the way for Sharaku.
Ebizō in the role of Kamakura no Gongorō Kagemasa saves Minamoto no Yoshitsuna from an unjust execution. When he cries 'Shibaraku' ('wait a moment!') at the climax of the play of the same name, the servants hold up the corners of his robe to display most effectively the large square 'rice measure' crest of the Ichikawa family. This is the most popular *aragoto* part of the Ichikawa's, and it has been traditionally performed by the leading actor of the family (Danjurō, later called Ebizō) as a new season performance (see Plate 71). Katsukawa Shunkō was one of the few artists of the 18th and 19th centuries who succeeded in transforming the striking gestures, costume and make-up (*kumadori*) of this scene into an equally dramatic graphic expression.

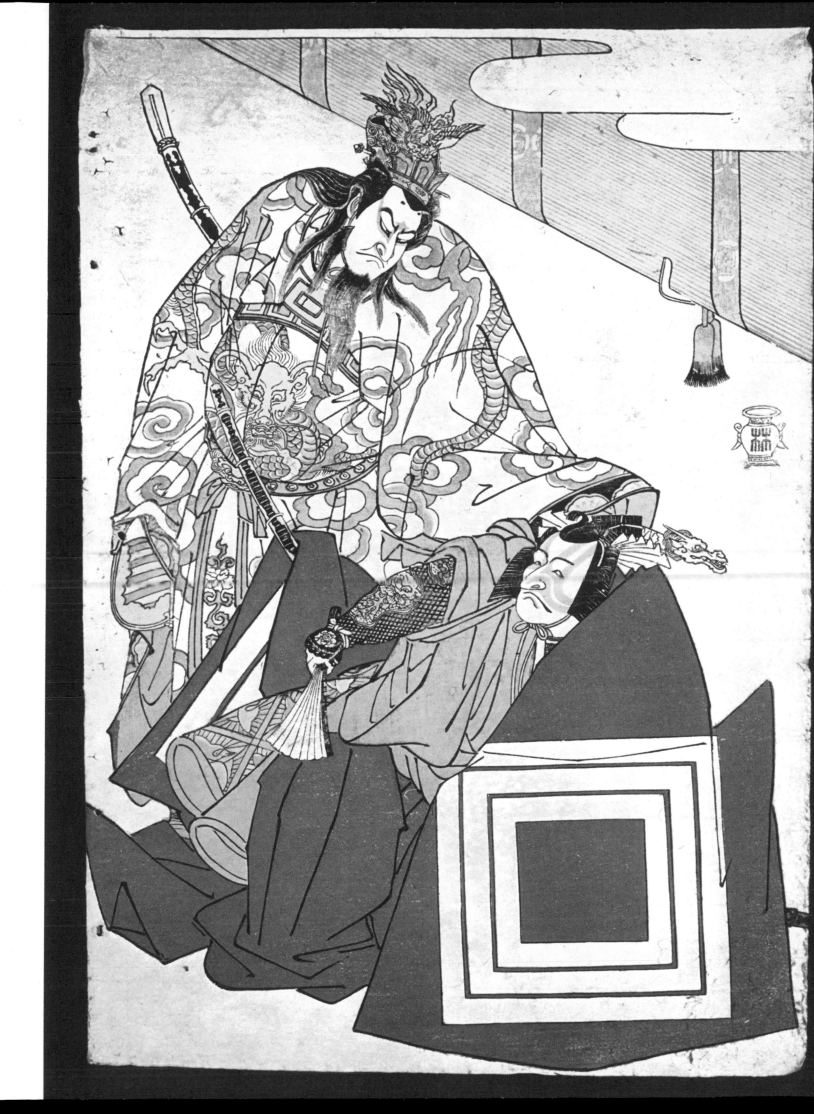

67. Sharaku: 'Segawa Kikunojō III'

Signed — 'Tōshūsai Sharaku ga', published by Tsutaya Jūzaburō, censor's seal 'kiwame', collector's stamp Wakai Oyaji. Ōban, with dark mica background, 1794.

The mysterious Tōshūsai SHARAKU painted over 150 actor portraits during 1794 and 1795, and then he disappeared. According to one theory, he was an actor of the classical *Nō* drama in the service of the Lord of Awa. This would explain his deep understanding of the quasi-schizophrenic point where the personality of the actor and the personality of the role merge and part — which is the creation of Drama. This, at least, is how his pictures appear to us today, after being scrutinized by generations of *ukiyo-e* specialists (because Sharaku is undoubtedly the most thought-provoking and ambiguous *ukiyo-e* painter). This print portrays Segawa Kikunojō III in the part of Oshizu, the wife of Tanabe Bunzō, from the play 'Soga — the Irises of the Bunroku Era' *(Hanaayame Bunroku Soga)*, performed in the theatre Miyako-za in May of 1794.

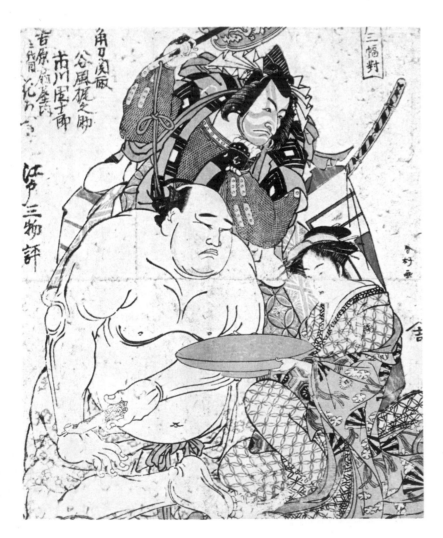

66. Shunkō: 'The Three Celebrities of Edo' (Edo Sambutsu Hyō)

Signed — 'Shunkō ga', published by Yamashiroya Tokei. Ōban, nishiki-e, c. 1790.

The actor Ichikawa Danjurō V, the *sumō* wrestler Tanikaze Onosuke, and the courtesan Koharu from the Ōgiya tea-house are presented here as the three most renowned people from the amusement districts of Edo. As Danjurō V had not yet changed his name to Ebizō, and the beauty Koharu was still more attractive than Okita and Ohisa (see Plate 49), the print must have originated before 1790.

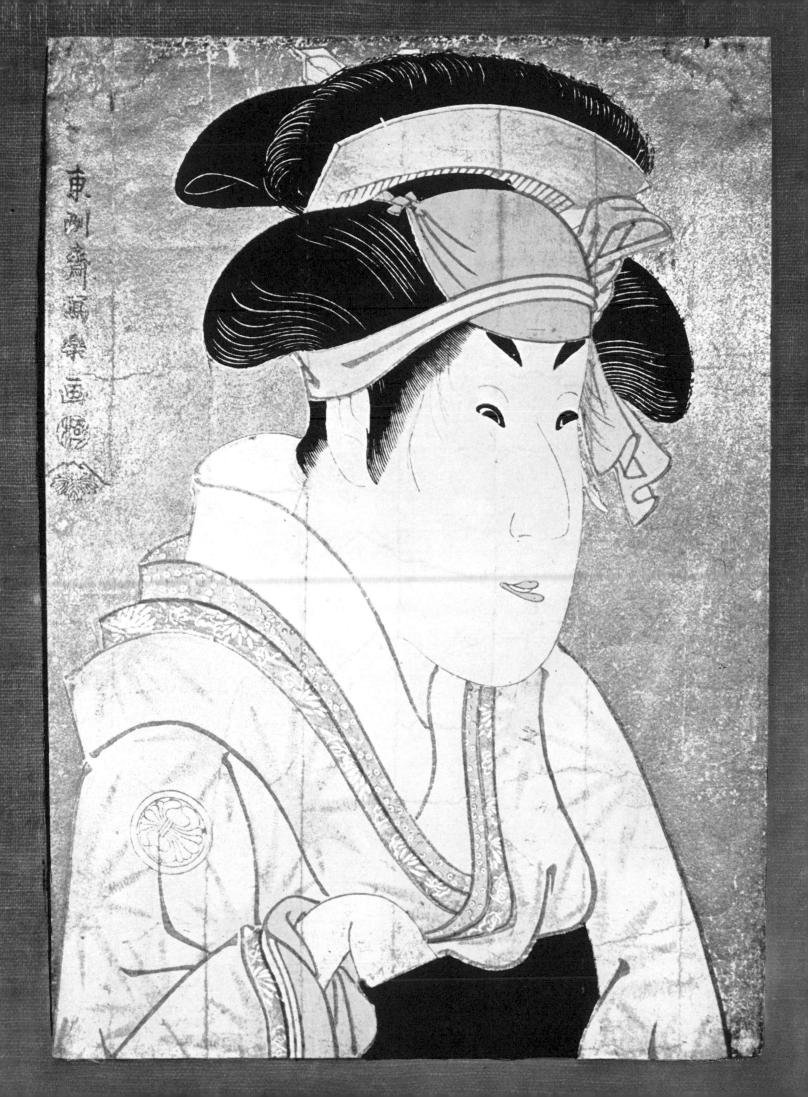

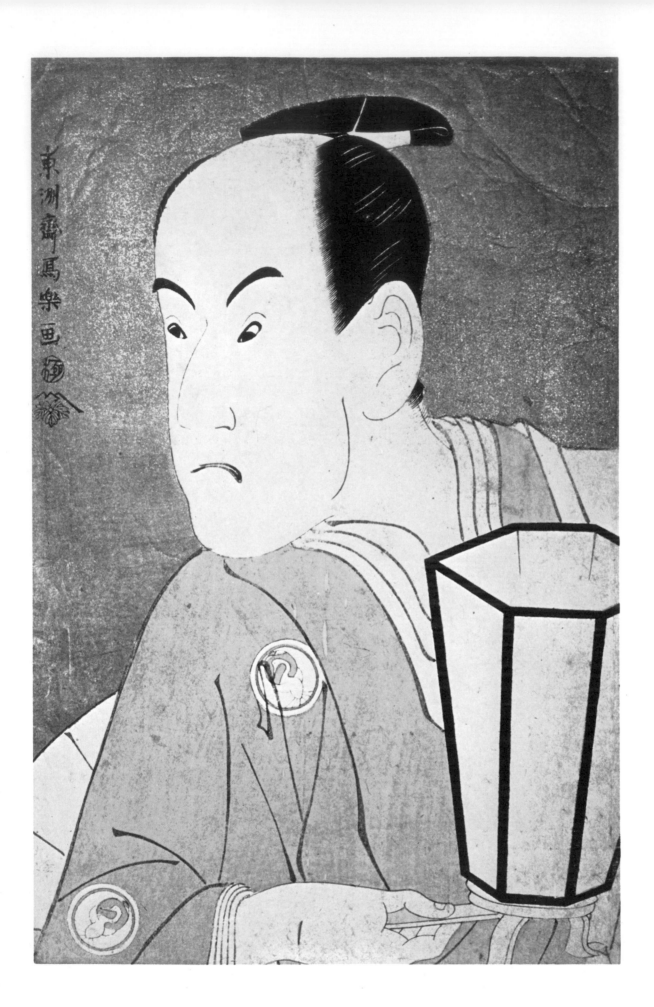

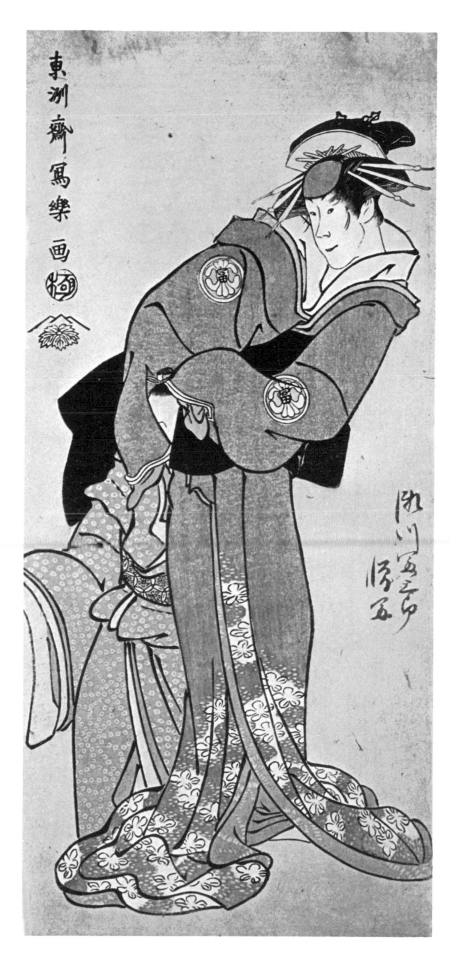

68. Sharaku: 'Bandō Hikosaburō III'

Signature and seals as in Plate 67. Ōban with dark mica background, 1794.

Hikosaburō III played the part of the warrior Sagisaka Sanai in the play 'The Reins of the Colourful Miscellany of Beloved Women' *(Koi Nyōbō Somewake Tazuna)*, performed in the Kawaraki-za theatre in May of 1794. It is said the publisher Tsutaya Jūzaburō obtained financial assistance from three Edo theatres in order to produce this costly Sharaku's series of large actor busts on a mica background. He violated the order of the Prime Minister Matsudaira Sadanobu, who had specifically forbidden the printing of costly publications, but in so doing he gave the world one of the most beautiful and the most prized series of graphic art.

69. Sharaku: 'Segawa Tomisaburō II'

Signature and seal as in Plate 67. Collector's stamp Emil Orlik. Hosoban, nishiki-e, with yellow background, 1794.

The actor's name and his derogatory nickname 'Hateful Tomi' *(Nikui Tomi)*, is scribbled by hand in the upper part of the print. The actor first played as an amateur under the name of Matsunojō; around 1785 he became a professional and was accepted by the theatre guild, Segawa, which, for several generations, specialized in female roles. Here he is portrayed in the part of Masaoka Tsubone in the play 'The Disputed Succession' *(Meiboku Sendai Hagi)* staged by Nakamura-za at the end of 1794. The part of Masaoka — the wet-nurse who protects the little Lord Tsurukiyo (also in the picture) against evil assassins — is among the most famous heroic female roles of the *Kabuki* repertoire.

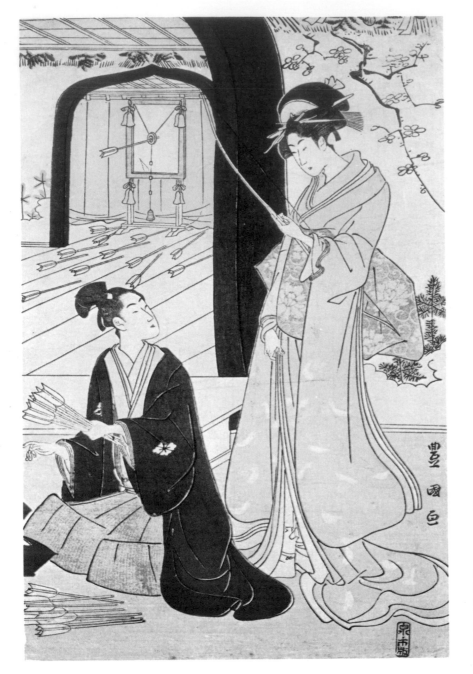

70. Toyokuni: 'Shooting Gallery'

Signed — 'Toyokuni ga', published by Izumiya Ichibei, blind-blocked, collector's seal Emil Orlik. Ōban, nishiki-e, c. 1789.

Utagawa TOYOKUNI (1769—1825) deserves high praise, for he was as good as the top artists of the 1890s both in the field of pictures of beauties, and in theatrical portraits. The theme of the picture reproduced here, which has been introduced before in print by Harunobu (see Plate 22), portrays a beauty from the shooting gallery with her guest, the famous actor Matsumoto Kōshirō IV. Such glimpses into the private lives of popular actors — mostly accompanied by noted courtesans from the amusement quarters in Edo — were very much in vogue in the 1790s. In these 'snap-shots' the two parallel genres of *ukiyo-e*, the pictures of actors and the pictures of beauties, had found a common ground.

71. Toyokuni: 'Bust portrait of Sawamura Sōjurō III'

Signed — 'Tokyokuni ga', published by Matsumoto Sahei. Ōban, nishiki-e, 1797.

In 1797, Toyokuni turned his hand to the taxing artistic problem of assessing the human face in actor bust portraits *(ōkubi-e)*. This field had first been explored by Shun'ei and Shunkō in 1790, and it reached its peak in Sharaku's 'caricatures' five years later. Toyokuni had never achieved the expressive intensity of Sharaku's portraits, but his portraits *(nigao-e)* brought a certain graphic solution to the problem which was drawn upon and continued by artists of the Osaka school for the next fifty years.

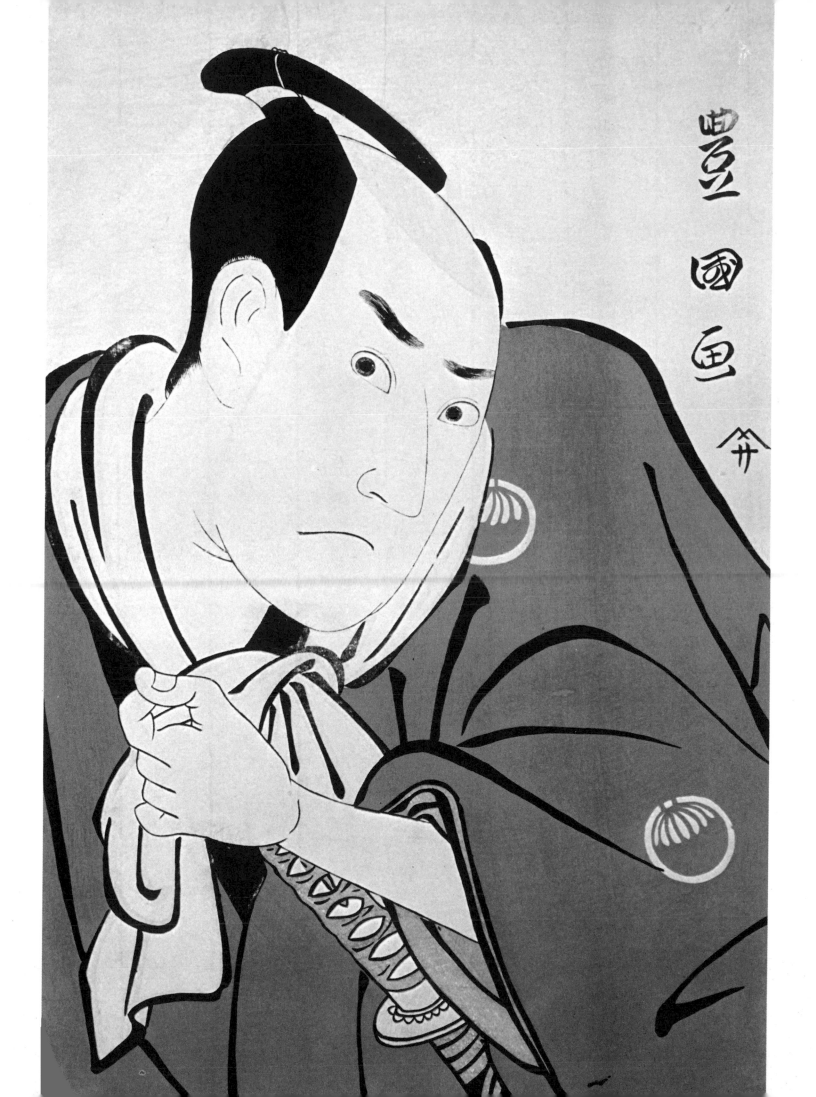

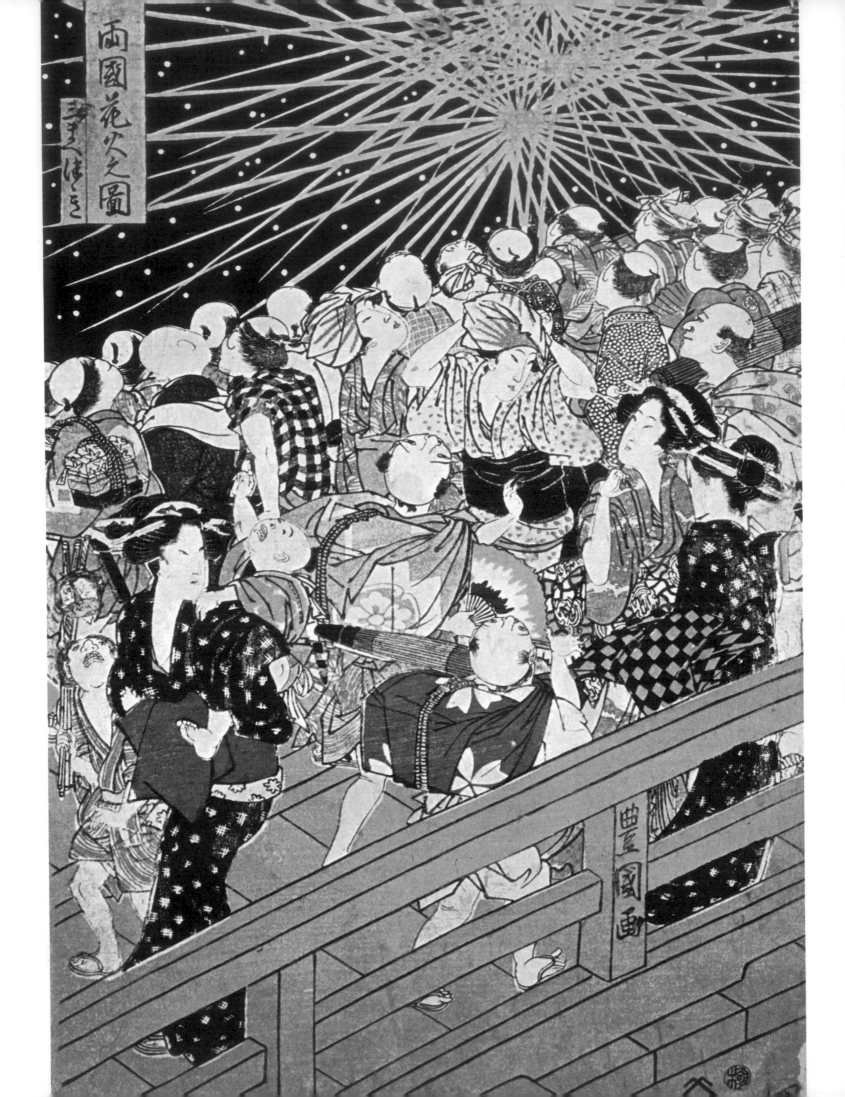

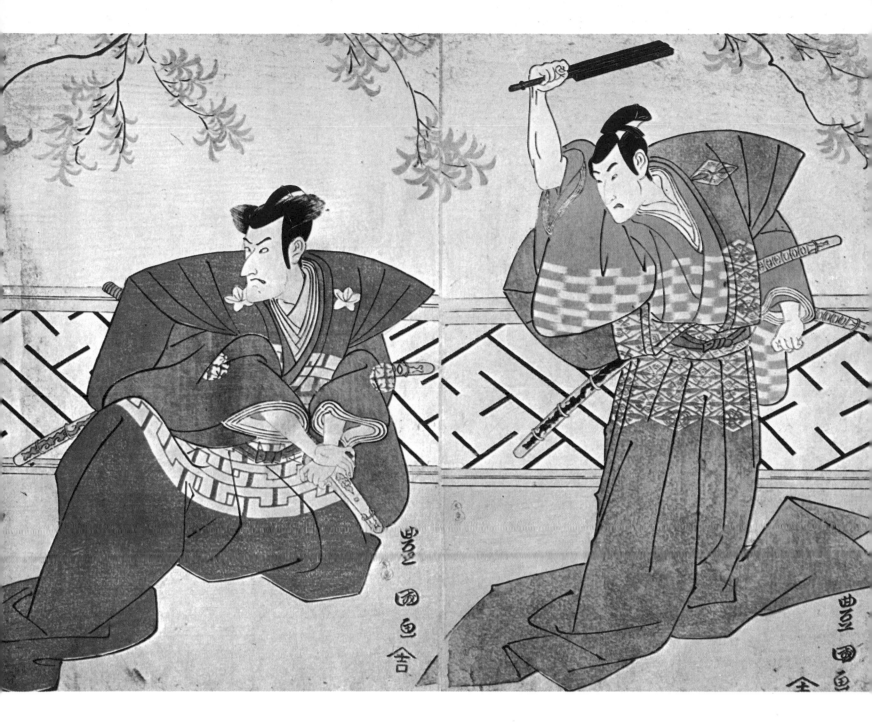

73. Toyokuni: 'Ichikawa Komazō and Bandō Mitsugorō III'

Signed — 'Toyokuni ga', published by Yamashiroya Tōkei. Ōban, diptych, 1795—1800.

The actors in the parts of Yasuchika Wakanosuke and his adviser Kakogawa Honzō, from the play 'The Treasury of Loyalty' *(Chūshingura)*, are dressed in ceremonial kimono *(kamishimo)* and wide-bottomed trousers *(nagabakama)*. Toyokuni's skill in the clever use of graphic ornament is unique — he has arranged the costumes and their abstract designs in this print into asymmetric areas that resemble compositions of the Rimpa school of painting.

72. Toyokuni: 'Fireworks at the Ryōgoku Bridge'

The left sheet of a triptych. Signed — 'Toyokuni ga', publishing house Eikyūdō, Yamamotoya Heikichi, censor's seal 'kiwame'. Ōban, nishiki-e, c. 1810.

The elegant arches of Edo bridge provided a suitable composition for several polyptychs of the 1780s and 1790s where such artists as Kiyonaga, Utamaro and Eishi introduced to their public the elegant Edo society. Whereas at the beginning of the 19th century, Toyokuni — and later also Hiroshige — did not present the bridges as the natural background of elegance, but filled them with the hustle and bustle of everyday mob. The chaos of the crowds is contrasted with the geometric order of the wooden construction of the bridge illustrated here, and the light of the fireworks.

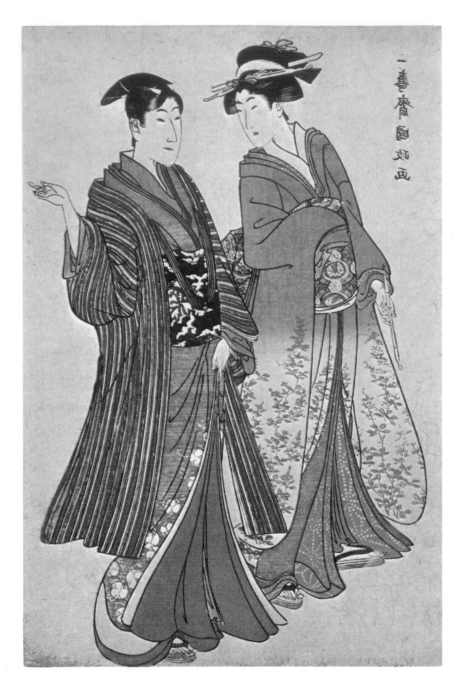

74. Kunimasa: 'Lovers Taking a Walk'

Signed — 'Ichiyūsai Kunimasa ga'. Ōban, nishiki-e, c. 1800.

Utagawa KUNIMASA (1773—1810) was among the most promising pupils of Toyokuni, and in the delicacy of his artistic feeling, he even surpassed his master. This beautifully executed sheet was probably issued as a private print.

75. Kunisada: 'Matsumoto Kōshirō V Returning to the Scene'

Signed — 'Gototei Kunisada ga', publishing house Eijudō, censor's seal 'kiwame'. Ōban, nishiki-e, c. 1821.

The actor Komazō changed his name to Matsumoto Kōshirō V in the year 1802. His expressive face with striking features — the small eyes, but a nose as big as Fuji mountain — suited 'evil' characters he played, and he is said to have played such villains superbly and naturally, and without the need of make-up and elaborate costumes. In this picture he is portrayed as the villain Miura Arajirō. According to the hand-written note, the print was issued to mark the occasion of Kōshirō's return to Edo after a long stay as a guest-star in Kyoto. In fact, he played in Kyoto only from the tenth month of 1820 to the eleventh month of 1821. Utagawa KUNISADA (1786—1864), the most prolific pupil of Toyokuni, must have admired this actor as much as his master and his older fellow students.

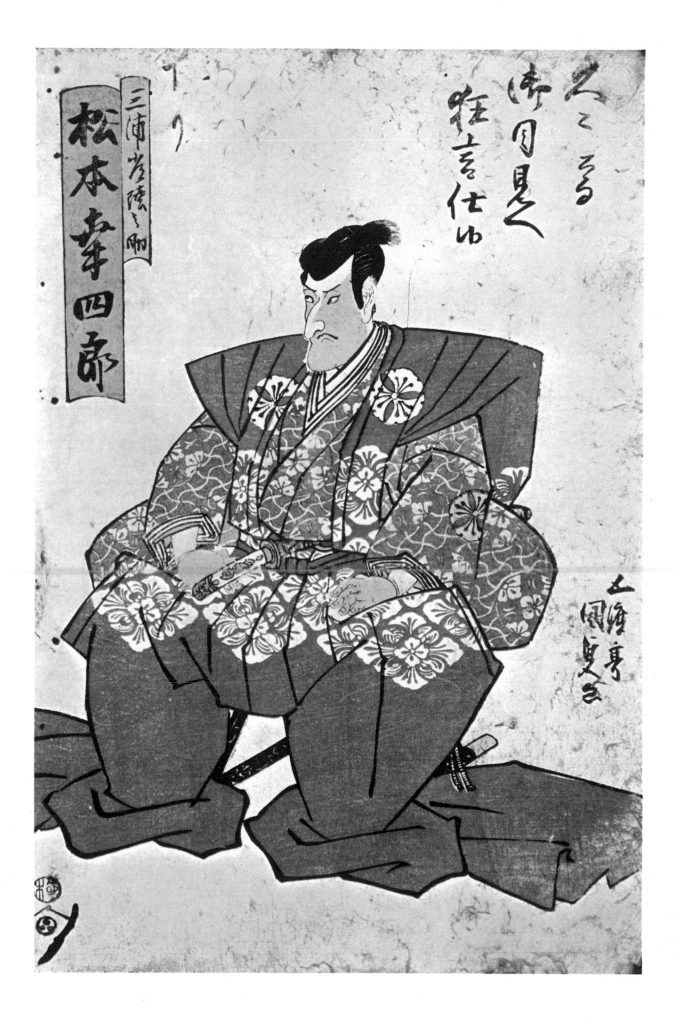

76. Hokusai: 'Kabuki Theatre from the District of Sakaichō'

The eighteenth and the eleventh sheets from the album 'Beautiful Views of the Eastern Metropolis' (Tōto Shōkei Ichiran). Engraved by Andō Enshi, published by Tsutaya Jūzaburō. Eleven full colour illustrations, 24×18 cm, 1800.

In his long and colourful artistic career, Katsushika HOKUSAI (1760—1849) painted actor portraits only when he worked in the Katsukawa studio under the name of Shunrō (1778—1786). In this picture, he painted only the actors' backs, so he could concentrate on the people in the auditorium. This, obviously, interested him much more than the play on the stage. In his illustrated books from around the turn of the century, we can find the roots of Hokusai's consuming passion for depicting every type of people. Richard Lane has aptly and accurately commented: 'Hokusai's work is so full of humanity as almost to obscure the true quality of his artistic genius'.

77—78. Hokusai: 'Two Classical Poetesses'

Two broad-sheets entitled 'Five Poetic Genii' (Go Kasen). Signed — 'Hokusai aratame Iitsu hitsu'. Surimono with metallic print, 21×19 cm, 1830—1835.

The many-sided genius of Hokusai would not eschew any brush experience offered by the tradition of painting. In these two *surimono* he tries his hand in the interpretation of the classical tradition of *yamato-e*, which allowed only little space for his erratic hand-writing. Technically, these prints are a genuine 'tour de force', but their excessively eloquent sentiment is as alien from the subtle poetry of the ancient *yamato-e* as the attached five contemporary poems are from the poems of the 'poetic genii'.

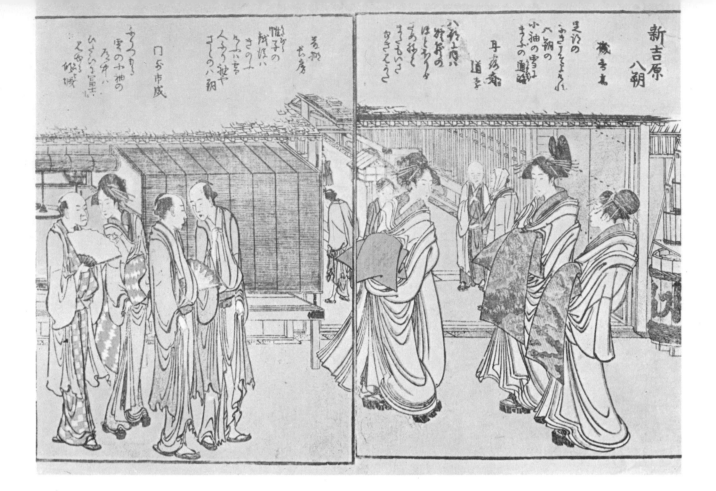

79. Hokusai: 'The Hassaku Festival in Yoshiwara' ('The First Day of the Eighth Month')

The twelfth and the thirteenth sheets from the second volume of the same picture album as in Plate 76.

Hokusai was not exactly the right painter to portray beauties, and the year 1800 was not exactly the right year for doing so. Nevertheless, the atmosphere which inspired Utamaro and Eishi several years before still lingered in the air, and Hokusai managed to capture its essence.

80. Hokusai: 'A Sudden Shower in Ōkido'

The first and the second sheets from the second volume of 'A Picture-Book of Kyōka — Range after Range of Mountains', (Ehon Kyōku — Yama Mata Yama). Published by Tsutaya Jūzaburō. Ten sheets, 26×17 cm, 1804.

Ōkido, like the other localities depicted in this book, lies in a mountain region to the north-west of Edo — hence the title of the book. At that time, Hokusai seemed not particularly interested in mountains themselves — at least not in this book. Instead he caught and captured the spirit of small-town scenes with the keen eye of a cameraman — such as in this illustration, of people running, caught in the rain. He created, in this series, perhaps the best colour illustrations to a book of poetry; in the opinion of the author they are superior even to the picture-book *Sumidagawa* published two years later, and preferred by some critics. *Yama mata yama* was the last illustrated book to come from the publishing house Tsutaya. In the same year, the wooden blocks were handed over to another publishing house, and soon afterwards were bought by Von Siebold (perhaps directly from Hokusai) who took them to Europe in 1830. Today, they are in the collection of the Leyden Museum.

81. Masayoshi: 'Scenes from the Annual Festivals'

Sheet from the 'Album of Figurative Sketches' (Jinbutsu Ryakugashiki).
Engraved by Noshirō Ryūko, published by Suwaraya Ichibei, 1795 and 1799.

A keenly observed, fleeting moment entrapped by the movement of a sensitive brush-tip — this has always been one of the favoured possibilities of artistic expression explored by Japanese painters for centuries. At the turn of the 18th century, this artistic mode came to bloom also in graphic art. Several diverse styles appeared almost immediately. One is represented by Hokusai and his school, another by the Nan-ga and the Mixed schools, and the third by Kitao MASAYOSHI (1761—1824). At the end of the 18th century he deserted the conventional type of graphic sheet design and turned to producing picture albums of sketches, or 'summary drawings' *(ryakugashiki)*. In the 'Album of Figurative Sketches' which was published in two volumes and re-edited several times, much space is devoted to the traditional theme of annual festivals and celebrations.

82. Koshū: 'Fishing Nets'

The thirteenth and the fourteenth sheets from the 'Picture Album by Koshū (Koshū Gafu). Published by Yoshida Shinbei from Kyoto. Thirty-three sheets, 25.5 × 18 cm, 1812.

Only a few drawings in this album show that Yata KOSHŪ belongs to the school of Maruyama Ōkyō. Unlike the other painters of this school, he does not seek the true reality of nature in plainly naturalistic studies. In his eyes everything is simple, yet not easy; everything is serious, yet smiling. Several brush designs for this album happen to be in the Prague collections. By comparison with the prints one can see that it was the engraver who slightly distorted the lines so that some pictures may seem to be too 'easy and empty'.

83. Anonymous painter of the Shijō school: 'Pine Trees and Fuji Mountain'

Sheet from an album. Colour wood-cut. First quarter of the 19th century.

Since the 15th century, Japanese ink-painting contained several methods of brush techniques, one of which was the so-called 'broken ink' *(haboku)* technique, which was marked by rugged, swift, and impulsive brush-strokes. Ardent adherents to this brush-style in the 18th century were the Nan-ga painters Ike no Taiga (see page 31), and Yosa Buson. They had many followers in the first half of the 19th century; the author of this print was probably one of them. It was certainly not easy to find an appropriate graphic expression for this highly idiosyncratic brush-style, yet in some cases — like in this one — the efforts bore fruit.

84. Bōsai: 'The Pine Tree Weeping Over a Thousand Ravines'

The seventh sheet from the album 'The Mountains of my Mind' (Kyōchū-zan). Published by Suwaraya Mohei. Nineteen sheets, 27.5×18.5 cm, 1809.

The pine tree really creaks, howls and weeps as it sways in the wind — in reality and in this picture. And the man — the one in the picture, and he who stands over life's thousand ravines — sometimes feels like the pine tree. This is an old cliché of Far East poetry and painting, yet many a classical artist would be thrilled if he was capable of giving it as pregnant expressiveness as Bōsai. Kameda BŌSAI (1752—1826) would, of course, appeal to every classically oriented mind through his versatility; he wrote serious works on philosophy, was well acquainted with the Chinese classics, and excelled in calligraphy, poetry and painting.

85. Anonymous, beginning of the 19th century: 'The Moon Over a River'

Sheet from an illustrated book of poetry 'The Anthology of the Full Moon' (Meigetsu Shū). Private publication. Twenty-five sheets, not numbered, 20×14.5 cm, 1815.

The *haiku* is a brief poetic form of seventeen syllables which is based on the art of evocative abbreviation. The equivalent expression in painting — frequently adjoining some calligraphy or verse — is called *hai-ga*. This art was cultivated by painters of the Nan-ga school (Buson, Bunchō), and of the Shijō school (Goshun). Its graphic equivalent can be found mostly in private prints and in *surimono*.

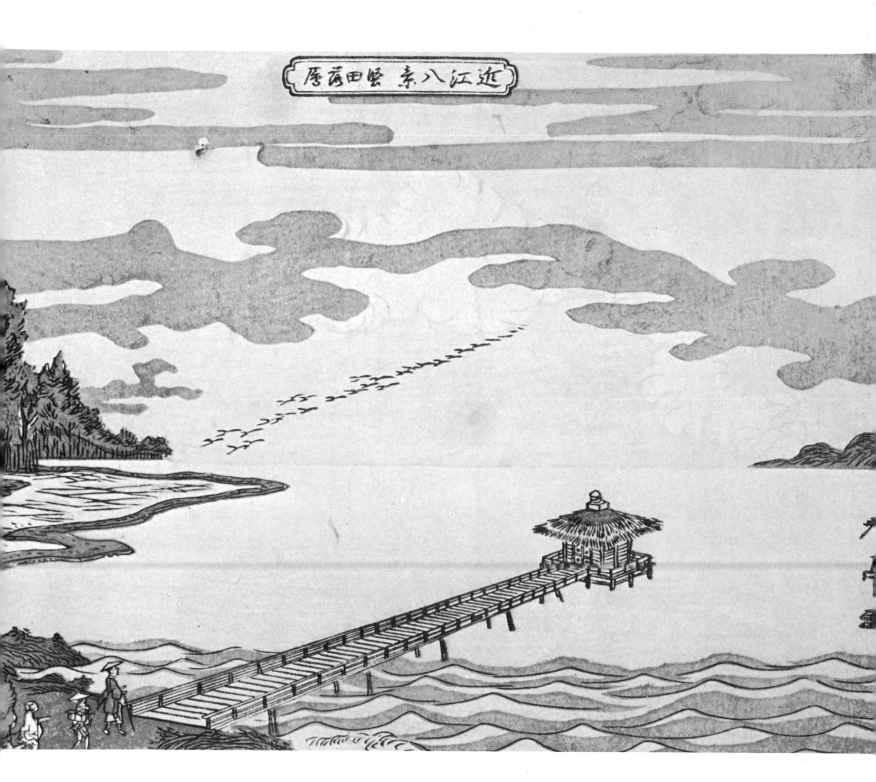

近江八景 堅田落雁

86. Shuntei: 'Wild Geese at Katada' (Katada no rakugan)

Sheet from the series 'Eight Views of the Ōmi Province' (Ōmi Hakkei). Signed — 'Shuntei-ga', publishing house Marutaya. Chūban, yoko-e, 1815—20.

The nostalgic theme of 'Wild Geese' is the fifth picture in the set of 'Eight Views of Ōmi'. Shuntei used the frame of abstract signs of clouds, waves, shore and a pier, as if asking: 'Where are we flying to?'

87. Hokusai: 'Fuji in a Storm — A View from Yamashita in the Province of Shirame'

The ninth sheet from the series 'Thirty-six Views of Fuji' (Fugaku Sanjū Rokkei). Signed — 'Hokusai aratame Iitsu hitsu'. Published by Nishimuraya Yohachi. Ōban, yoko-e, 1831 to 1833.

In several pictures of this series, Hokusai, the virtuoso of genre figures and the experienced landscape painter, displayed another dimension of his talent. The theme of the Fuji mountain — which keeps reappearing in innumerable works of generations of Japanese artists — is delivered in the form of a geometric pictogram that is of supreme graphical and evocative qualities.

88. Hokusai: 'A Large Wave by the Kanagawa Shore'

Sheet from the series 'Thirty-six Views of Fuji' (Fugaku Sanjū Rokkei). Signed — 'Hokusai aratame Iitsu hitsu'. Ōban, yoko-e, 1831—1833.

The view of Fuji mountain among the mounting waves is perhaps the most famous composition of Hokusai. The print here, with yellowish clouds, is considered to be the first edition. In the opinion of some scholars, the stylization of the signature ('Painted by Hokusai who has changed his name to Iitsu') suggests the date of around 1823. The author's view corresponds with more recent opinion that the whole series did not originate till the years 1831—33.

89. Hokusai: 'A Snake and a Frog on a Burdock Plant' (Detail)

Monotype with additional colouring on paper. Signed — 'Iitsu Rōjin'. Personal seal Manjin Rōjin, 1830—1835.

It would be an exaggeration to claim that Hokusai had invented the technique of monotype, but here, apparently Hokusai had made a transfer print of a burdock leaf, and then added with quick brushstrokes a snake and a frog.

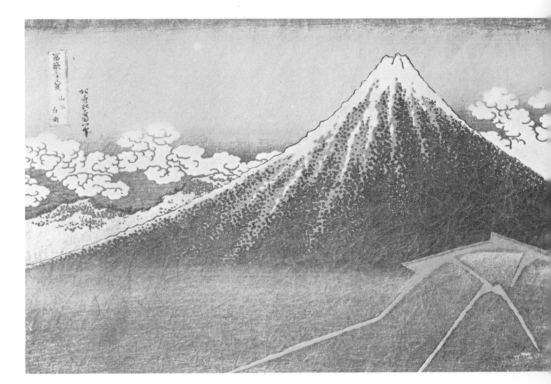

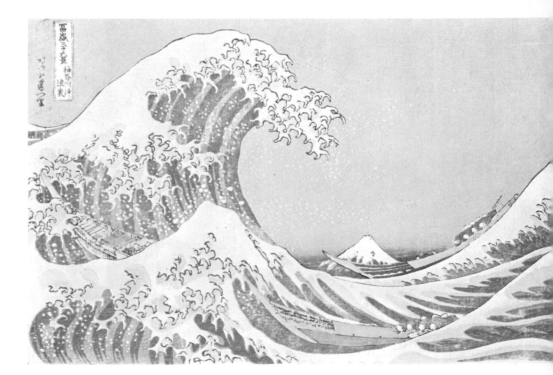

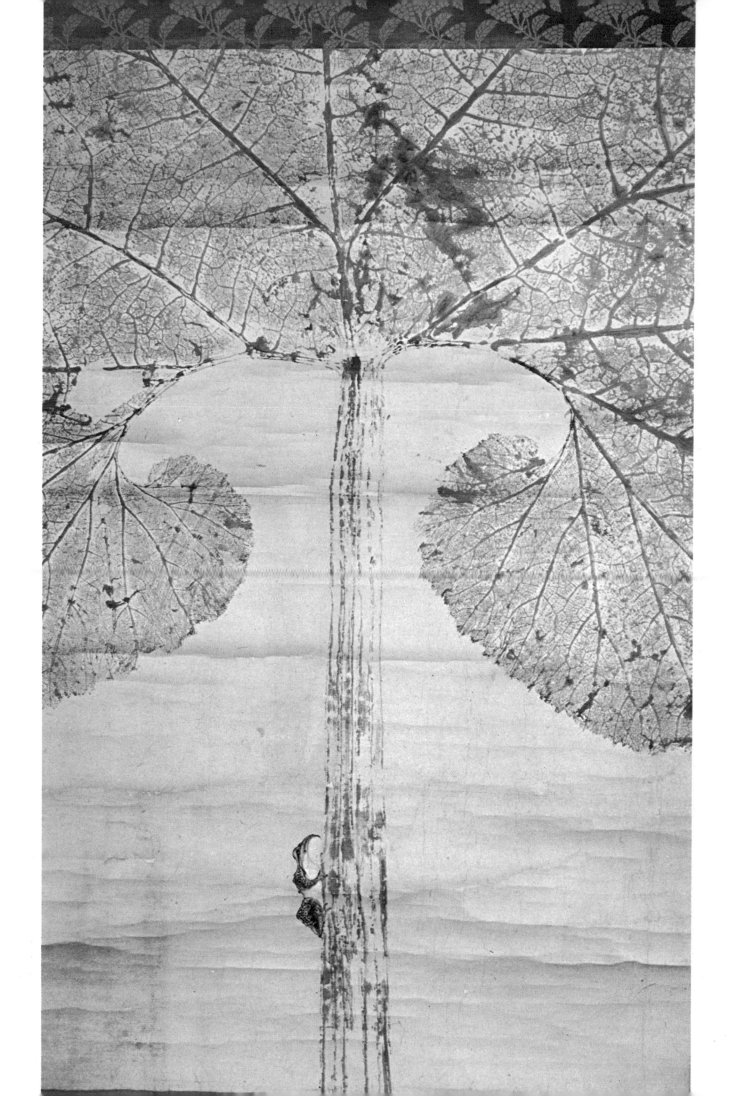

90. Bunsen: 'Fuji and the Wandering Monk'

The fifteenth and sixteenth sheet from the 'Album of Bunsen's Drawings' (Bunsen Gafu), volume one, nineteen sheets, 22×16 cm. Published by Kawachiya Kihei, 1855.

Seki BUNSEN was one of the numerous pupils of the coryphaeus of the Nan-ga school in Edo, Tani Bunchō. He was as much eclectic as his teacher, and he was also similarly fortunate in containing the easy coalescence of the antagonist ideals of Eastern intellectual painting and lively genre drawing.

91. Matora: 'A Villager'

The eighth and the ninth sheet from the second volume of the album 'Drawings of Hundreds of Things' (Soga Hyakubutsu). Published by Eiryakuya Tōshirō in Nagoya. Two volumes bound in one, eleven and twelve sheets respectively, 22.7×15.7 cm, c. 1832.

Ōishi MATORA (1794—1833) was born in Nagoya. He came to Edo as a young artist, but committed a petty crime, and had to flee to Osaka. There he studied under Genshō, and soon developed an individual style which expressed his understanding of natural themes, still-life, people and objects. This picture is from an album which was published in his native province of Owari, and is not dated. The editions from Osaka, published by Tsurugaya Kuhei, are stamped with the date of 1832.

92. Chinnen: 'Girl Playing the Koto'

The twenty-third and the twenty-fourth sheet from the 'Book of Paintings by Sonan' (Sonan Gafu). Published by Kobayashi Shinbei and Osakaya Genbei. Twenty-six sheets, 27×18 cm, 1834.

Onishi CHINNEN (1791—1851), known also by one of his pseudonyms, Sonan, was a rice-loft keeper in Edo. He was taught by several noted masters (Bunchō, Ganku, Nangaku). The sketches drawn for this album may still serve as perfect examples of the proper balance between strict concentration and easy casuality.

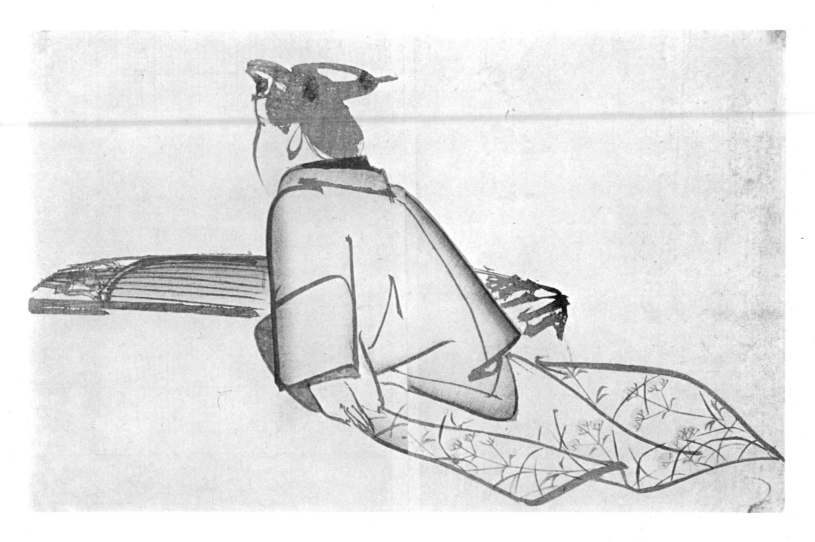

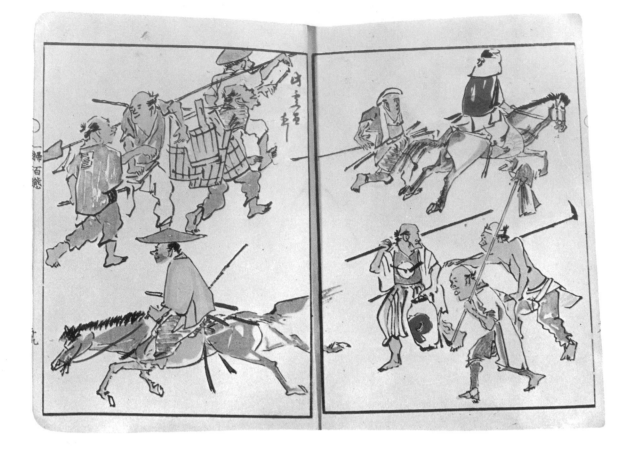

93. Kazan: 'Walkers and Riders'

Sheet from the album 'One Hundred Figures in One Stroke of a Brush' (Issō Hyakutai). Thirty sheets, 25.5×18.5 cm. Engraved by Hōgendō, published by Watanabe Kai. Preface dated 1818. 1878.

Watanabe KAZAN (1793—1841), a hereditary retainer and an official of the poor Tahara clan from Mikawa, made these pictures when he was still under the influence of Tani Bunchō, whose studio he entered in 1809. Later, he became an accomplished scholar specializing mainly in European economics and politics, but also in European art, which is clearly discernible in his later prints. In 1839 the government started repressing the protagonists of European learning *(rangaku)* and Watanabe fell victim. He was imprisoned, and after two years of exile he committed suicide.

94. Hiroshige: 'The Moon Above the Takanawa Bay'

Sheet from the series 'Genji and Violet Views of Famous Places in Edo' (Edo Murasaki Meisho Genji). Signed — 'Hiroshige ga'. Published by Ibaya Kyūbei. Censor's seal Hama. Ōban, nishiki-e, 1843—46.

In this little known series of excellent prints, Andō HIROSHIGE (1797—1858) paid more attention to the interpretation of the feelings of the figures and the atmosphere, than to the landscape itself. The series revolves round familiar episodes from *Genji Monogatari* (see Plate 45). In the shellshaped vignette there is an inscription 'The Paraphrase of Akashi' *(Mitate Akashi)* which implies that the picture should evoke the gloomy, melancholic mood Prince Genji used to feel when he gazed at the boats sailing away from the shores of his exile on Akashi.

95. Hiroshige: 'Tsuchiyama Mountain'

The fiftieth sheet from the series 'Fifty-three Stages of Tōkaidō' (Tōkaidō Godūsan Tsugi). Published by Sankoki and Kansendō. Chūban, yoko-e. 1835—1840.

The landscape cycle of the fifty-three staging posts along the road from Edo to Kyoto, the Tōkaidō, is, without doubt, the most successful series painted by Hiroshige. Although the *ōban yoko-e* series known as 'Large Tōkaidō' was always preferred by collectors, there are charming prints in the smaller-size series as well. This particular series is popularly known as '*Kyōka Tōkaidō*', since each picture is accompanied by a humorous poem, *kyōka*. On the Tsuchiyama sheet we can read a warning:

Isogu tomo	'*Beware of haste*
Kokoro shite yuke	*You pilgrims climbing the steep slope*
Suberi naba	*For if you fall*
Ato modorisen	*You will not return home*
Ame no Tsuchiyama	*From the rainy Tsuchi mountain*'

96. Hiroshige: 'The Procession of Women to the Benten Temple on the Island of Enoshima'

Signed — 'Ichiryūsai Hiroshige-ga' on the third sheet, 'Hiroshige-ga' on the first and second sheet. Publishing house Hōraidō, Sumiyoshiya Masagorō, censor's seal Murata and Mera. Ōban, triptych, 1847—50.

There is a parallel print to this triptych which depicts a procession of women climbing a steep rocky path to plead for fertility at a temple to which the path leads. The island of Enoshima, another beauty-spot in Japan, was accessible only at low tide (compare with Plate 38). This triptych was completed ten years before the famous trio of triptychs entitled 'Snow, Moon, and Cherry Blossom', and though it does not display the same mastery of brush-work, it certainly excels in graphic qualities.

97. Kunisada: 'The First Buds of Spring' (Shunshoku Haru no Sakigake)

Triptych. Signed — 'Ichiyōsai Toyokuni ga' on all prints, publisher's seal Tsutaya Kichizō, censor's seal Murata and Mera. Ōban, 1847 to 1850.

The man in the third picture is carrying a branch laden with sacred offerings across his shoulder, and is wearing an amulet on his head from the temple, which he must not touch. The traditional theme of the New Year celebrations, and the conventional stylization of the figures are projected here against an original background of a plum tree bursting into bud. Its twisted stem with the peculiar sword-shaped branches which unite all the three sheets betray that Kunisada had been influenced by the Kanō school screens.

98. Shuntei: 'Higuchi Jirō Fighting with an Ogre Serpent'

Signed — 'Shuntei ga', publisher's seal Itōya Yohei, censor's seal 'kiwame'. Ōban, nishiki-e, 1815—20.

Katsukawa SHUNTEI (active in the first quarter of the 18th century) is one of the most underrated graphic artists of Japan. Perhaps modern criticism cannot properly appreciate an artist who specialized in bloodshed, themes of war and fierce battles. These are sometimes horrific, surrealistic nightmares, presented by Shuntei in a graphic form; this work was later successfully continued by Kuniyoshi.

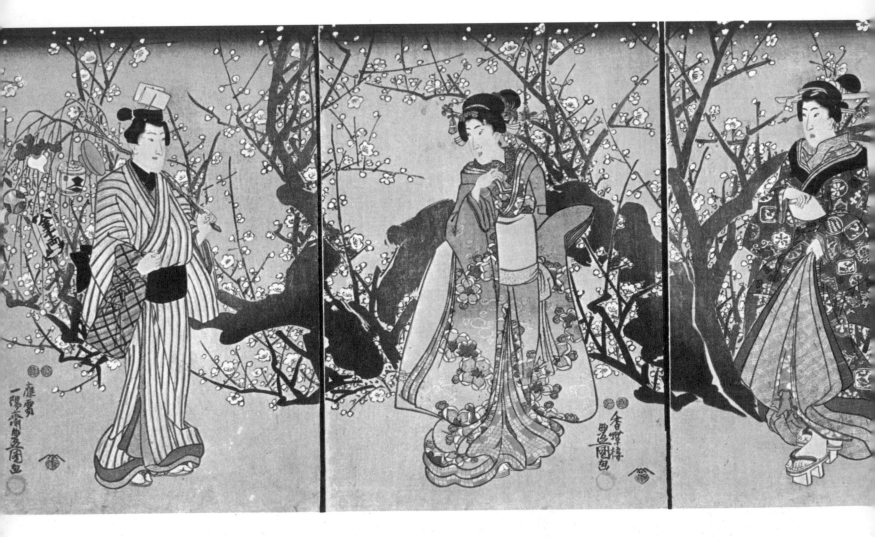

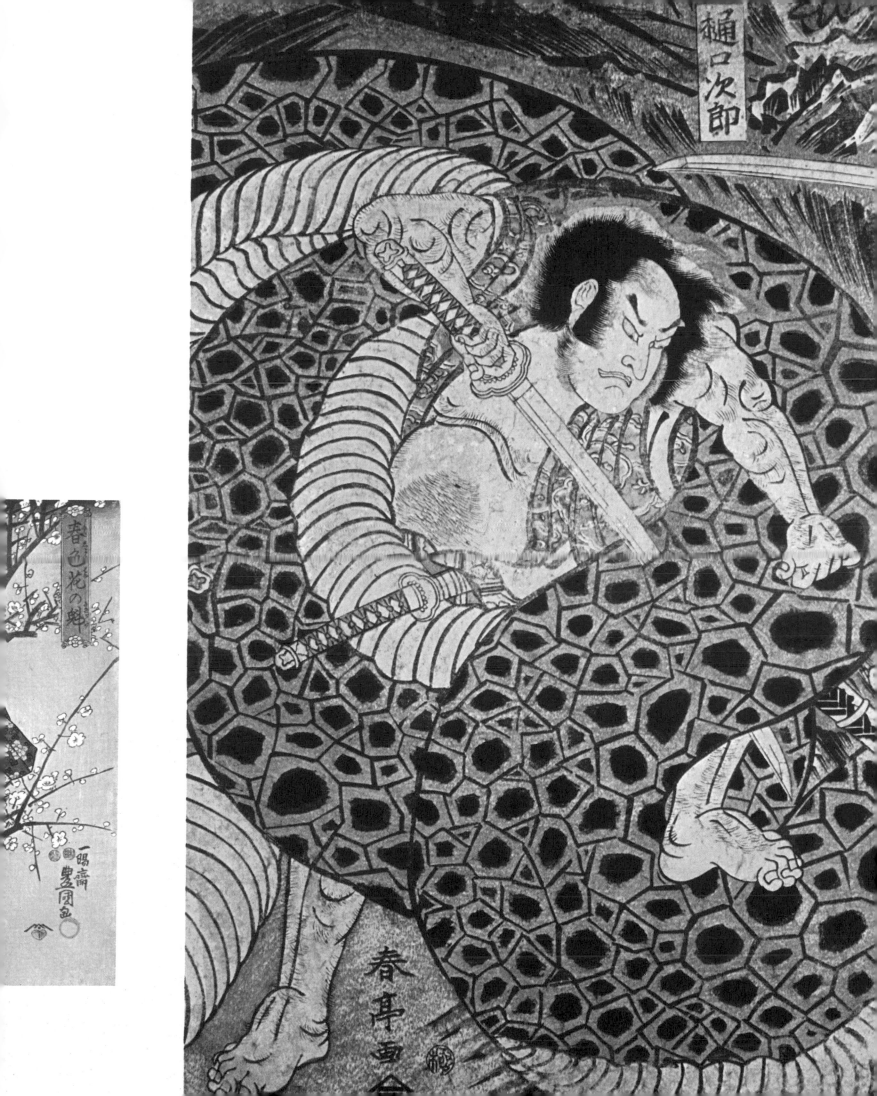

100. Kuniyoshi: 'The Triumph of Kan Shin' (Kanshin Kassen no Zu)

Signed — 'Ichiyūsai Kuniyoshi ga', publishing house Sanoki and the censor's seal 'kiwame' on all three sheets. Ōban, triptych, 1845—46.

By the end of the 1820s, Kuniyoshi had proved himself as a graphic artist by publishing his series of 'One Hundred and Eight Chinese Heroes' *(Suikoden)*. Already in these pictures he occasionally used a chiaroscuro technique similar to that found in European painting. Strangely enough he applied European techniques mainly when painting Chinese themes. Our picture with a somewhat 'European' slant also depicts a Chinese hero of the Han period (206 B.C. to 220 A.D.).

99. Kuniyoshi: 'Spirits Attacking a Ship'

Signed — 'Ichiryūsai Kuniyoshi ga', published by Izutsuya Ichibei (?). Ōban, nishiki-e, c. 1845.

Utagawa KUNIYOSHI (1797—1861), a famous disciple of Toyokuni, delighted in painting ghosts and monsters, and also in painting the sea—which was a rather exceptional feature among painters of the Far East. Ghosts of the seas were to him themes above all themes. He chose to depict the spirits of the slain Taira warriors attacking Yoshitsune's ship over and over again (1818, 1840, 1845 and 1851). In this picture, which is taken from the triptych of 1845, the group of ghosts is lead by Shigemori, the son of Taira Kiyomori, who was killed by the Yoshitsune navy in the battle of Dannoura in 1185.

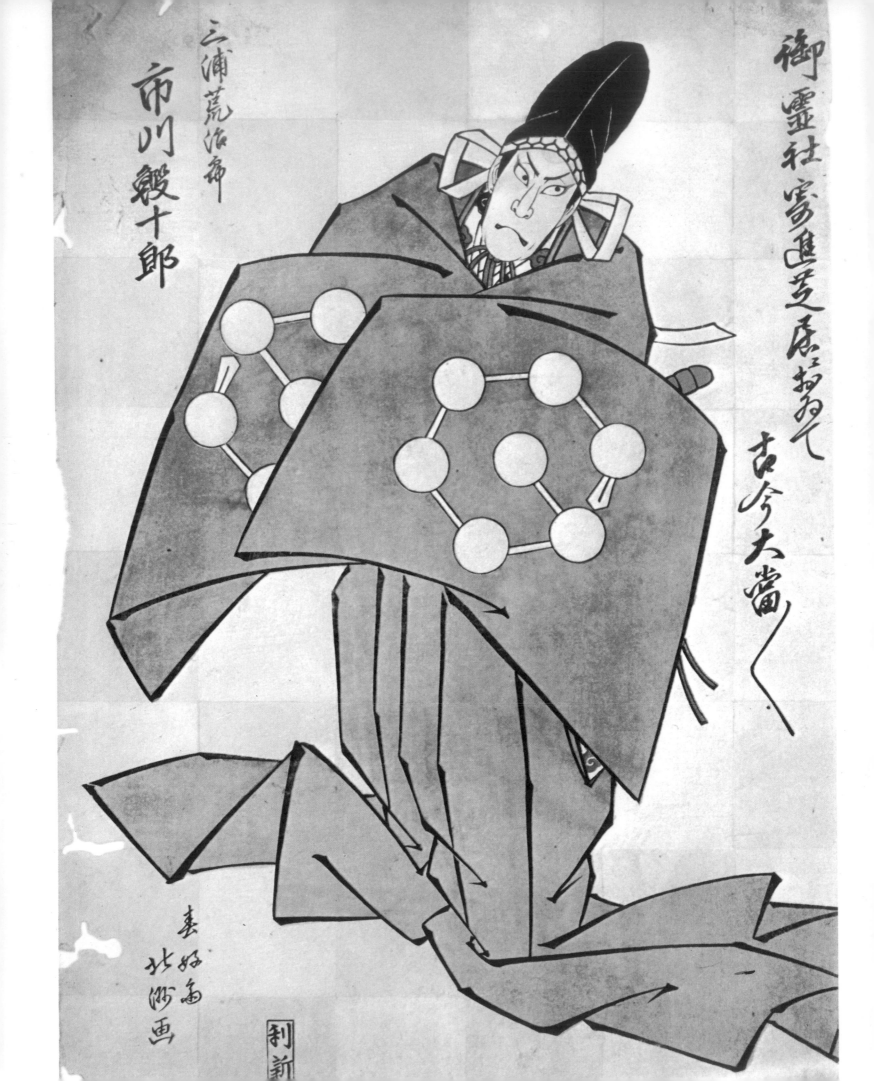

101. Hokushū: 'Ichikawa Ebijurō in the Role of Miura Arajirō'

Signed — 'Shunkōsai Hokushū ga', publisher Toshin. Ōban with yellow chessboard pattern background, 1822.

Miura Arajirō, who was active during the reign of the Prime Minister Tanuma, was a typical example of a corrupt state official. In the second sheet of this diptych, which is not reproduced here, there is a portrait of Sano Zenzaemon (stage name Genzaemon), who murdered Tanuma's son in 1784 and thus caused the downfall of the hated regime. He became a popular hero, so naturally his name soon appeared in the *Kabuki* repertoire. The scene depicted here is from the play *Keisei Sano no Funabashi* which was performed in May of 1822 in the courtyard of Goryō temple in Osaka, as a fund-raising performance. During his life, Shunkōsai HOKUSHŪ (active from 1810 to 1832) was the most popular Osaka painter of actor prints. He was one of the creators of the so called 'Osaka style' of Japanese graphic art.

102. Tamikuni: 'Ichikawa Takijurō in the Role of Miura Arajirō'

Signed — 'Kōgadō Tamikuni ga', publishers Honsei and Senki. Ōban with a yellow background, 1823 to 1824.

The second principal exponent of the 'Osaka style' was a painter who published actor prints around the middle of the 19th century under the name of Hirosada (see Plate 105). Roger Keyes does not dismiss the possibility that Tamikuni (whose signature appeared on prints from 1823 to 1826) may be a former name of Hirosada. In that case we should be able to find the same treatment of theme in the works of the two great Osaka artists. This picture, however, depicts a scene from a completely different performance than the previous one, as the part of Arajirō is played by Takijurō, who was Ebijurō's junior by ten years, and took the name of Ebijurō III as late as in 1830.

103. Hokushū: 'Nakamura Utaemon III'

Sheet from the series (?) 'The Competition of Present Day Dandies in the Fan-shaped Pictures' (Kokusen Tōyo Kurabe). Signed — 'Shunkōsai Hokushū ga', engraver's seal Kasuke hori. Ōban with grey background, c. 1825.

Utaemon III, a poet and a dramatist, but also the best and the most revered actor of his era, was forced through illness to give up the stage at the beginning of 1825. In the third month of that year he appeared in his last performance. To mark the occasion of his retirement, Hokushū and his exceptional engraver Kasuke produced several fan-shaped portraits of this actor. Utaemon, however, later recovered, and continued his acting career until his death in 1838.

104. Hokuei: 'Arashi Rikan II in the Role of Asahina Tōbei'

Signed — 'Shunkōsai Hokuei ga', publisher's seal Kichi. Ōban with black background, c. 1830.

On a stormy night, the deaf Tōbei stumbles over a blind man who fell in the street, and asks him for a loan of the money he is carrying in his purse. When refused, Tōbei extorts the money by using his sword. Only later does he learn that the victim was his own half-brother, Terakoya Hyōsuke, who had in fact obtained the money for the same noble purpose that Tōbei wanted it for: to pay the ransom of the courtesan Oshima and thus enable her to marry the samurai Seijurō, who had been disinherited. At the time Arashi Rikan II played this part, he was one of the leading actors of the Osaka stage. And HOKUEI, a pupil of Hokusai, was the most prominent artist of actor portraits. He painted Rikan many times and they both died in the same year, 1837.

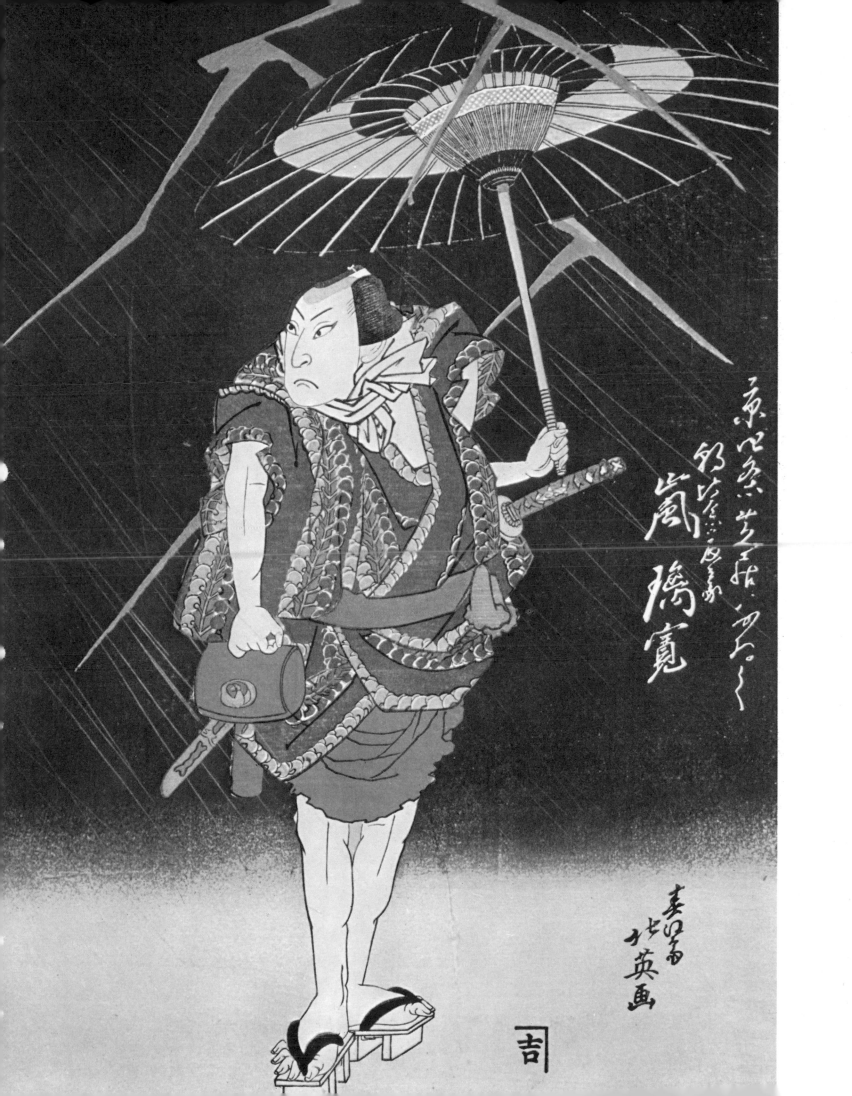

105. Hirosada: 'Nakamura Tamashichi Greets his Audience'

Signed — 'Hirosada'. Chūban, negative inscription on black background, c. 1852.

Gosōtei HIROSADA (died 1863) was a central figure in the revival of actor portraiture in Osaka around the middle of the 19th century. Between 1847 and 1852 he published hundreds of prints. Recent research shows, however, that he was active long before that time under the names of Tomikuni or Tamikuni (see Plate 102), Sadahirō, and Hirokuni. He was also a talented poet, and, from 1850, a proprietor of the Ten-ki publishing house. Tamashichi is portrayed here in the company of the ghost of Utaemon IV, who was his recently deceased master.

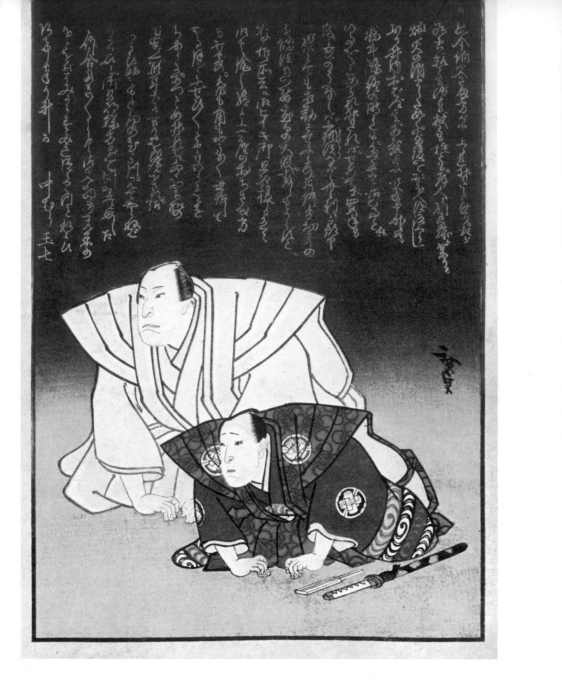

107. Yoshitoshi: 'The Fire of Edo, 1876'

Signed — 'Saito Yoshitoshi hitsu', publishing house of Kumagaya Shō-shichi (address Kobune-machi, Sanchōme, 14), engraved by Shūtō; 35.5×24.5 cm, dated the 9th year of Meiji (1876).

Taiso YOSHITOSHI (1839—1892), a pupil of Kuniyoshi, was a contemporary of Yoshitaki, and could be considered his Edo counterpart. He also began to publish his prints from an early age, but in contrast to Yoshitaki, he specialized first in historical themes, then turned to current events, and from 1878 worked as a graphic designer for a newspaper. The picture of the great fire which raged through one district of Edo at the end of 1876, is a good example of the type of *nishiki-e* which is called 'The Nishiki-e News'. Yoshitoshi illustrated this event in a whole series of documentary pictures.

106. Yoshitaki: 'Glamour Competition in the Cool Twilight in the Capital' (Tsuya Kurabe Miyako no Suzumi)

Signed — 'Yoshitaki ga' on every sheet, censor's seal 'aratame' on two sheets. Chūban, polyptych, 1870—80.

Ichiyōsai YOSHITAKI (1841—1899), the last great painter of actor prints, was already an eminent portrait artist of the Osaka stage at the age of twenty, and retained his position until 1880. For this picture, he chose a naturalistic night scene — which was widely used by all graphic artists of the Meiji period — as a continuous background for the silhouettes of the individual actors. Their names and roles are not indicated, since: 'The figures could be easily recognized by their faces and their family crests *(mon)*, displayed on their costumes'. This statement appeared in a commemorative article published by Yoshitaki's son, Kawasaki Kyosen, in 1938. He further commented that the series of ten prints had usually been designed as a dance-drama illlustrations. According to this information, we can assume that our series belong to this category, as the nine prints are numbered 1—5, and 7—10.

108. Kyōsai: 'Amid Monsters'

Signed — 'Kyōsai', publishing house Joshūya Kinzō, censor's seal 'aratame' with the date of the year of the Rat, the third month (1864). Ōban, the middle part of a triptych.

Shōfu KYŌSAI (1831—1889) was another pupil of Kunisada, who came to his studio as an eight year old boy. Later he studied painting of the Kanō school and the style of Hokusai. Pictures of various monsters and caricatures were the main part of his graphic creations, and, in the closing years of the shōgunate, they earned him imprisonment three times; again, during the new regime of the Meiji restoration, he found himself in jail.

109. Hiroshige III: 'Railway Line in Yokohama'

Signed — 'Hiroshige ga', publishing house Maruya Jinpachi, censor's seal 'aratame' with the date of the year of the Cock (1873). Ōban, triptych.

After the country opened up to the outside world, Yokohama — a former small fishing village near the Tōkaidō major station of Kanagawa — was built into a principal international port and connected to the capital by the railway line. Railways, ocean-going ships and visiting Europeans provided a wealth of themes with romantic atmosphere, which attracted many artists. Yoshitora and Yoshikazu, two pupils of Kuniyoshi, and Hiroshige's descendant, HIROSHIGE III (1842—1894) were some of the most prominent ones. The present day spectator finds in these pictures a strange, ambiguous flavour — the nostalgia for the old fashioned machines, and the fresh, positive approach Japanese graphic artists felt upon seeing those 'Western miracles' for the first time.

横濱往返鐵道蒸氣車ノ海上之圖

110. Sessai: 'Torpedo, Electric Ray' (Raigyo)

*Signed — 'Hatori Sessai', cyclical date jin-shin (1872).
Ōban, yoko-e, nishiki-e.*

Even during the Meiji period when everything was in
turmoil, subjects such as flowers, birds and animals
enjoyed comparative stability of style. From the point
of view of descriptive realism, our picture, chosen from
a natural history series, is not inferior to a photograph —
although there is no more chiaroscuro modelling than in
Kuniyoshi's pictures of fifty years ago (see Plate 100).
From the standpoint of traditional stylization, on the
other hand, it did not divert very much from the older
prints by Ryūsui and Utamaro (see Plate 28, 47). Even
the English inscription has the same graphic validity
always reversed for Chinese and Japanese calligraphy.

TORPEDO, ELECTRIC RAY.

111. Kunimasa: 'The Silver Anniversary of the August Presence of the Emperor and the Great Council' (Ginkon Go-taiten Go-rinkō no Zu)

*Signed — 'Ko Kunimasa hitsu', published by Fukuda Shōjirō. Ōban
triptych, 1894.*

After the Meiji revolution, which abolished the military dictatorship of
the Tokugawa shōguns, the Japanese Emperor moved from his traditional
seat in Kyoto to Edo. The twenty-fifth anniversary of his arrival provided
a great occasion to publicize the modernization of the country—including
the army which proved to be effective the very next year in the war
between Japan and China. Kunimasa V (studio name Kaidō), the artist
who depicted the Imperial procession, was also supposed to have shown
both in the theme and in the form of his painting how far ahead he had
progressed beyond the native Utagawa school tradition and thus the
'obsolete' artistic tradition of Japan in general.